W9-BZV-870

16. Shoot the moments in between.

160. When in doubt, hold them upside down.

44. Move into the action.

THE UNFORGETTABLE PHOTOGRAPH

228 Ideas, Tips, and Secrets for Taking the Best Pictures of Your Life

GEORGE LANGE WITH SCOTT MOWBRAY

WORKMAN PUBLISHING • NEW YORK

Library of Congress Cataloging-in-Publication Data is available.
ISBN 978-0-7611-6923-9

Cover and interior design by Janet Vicario

Photos of Aszure Barton dancers courtesy of Aszure Barton & Artists: pages 15 and 161, William Briscoe; pages 42 and 69, Cléa Owens; pages 46 and 47, Banning Roberts; pages 46 and 200, François Damville; page 78, Lesley Kennedy; pages 130, 199, and 207, Aszure Barton; pages 132 and 290, James Gregg and Cherice Barton; page 185, Andrew Murdock; page 207, Tummo; page 210, Emily Oldak; and page 254, Wayne Wilson and Cherice Barton.

Workman books are available at special discounts when purchased in bulk for premiums and sales promotions as well as for fund-raising or educational use. Special editions or book excerpts can also be created to specification. For details, contact the Special Sales Director at the address below, or send an email to specialmarkets@workman.com.

Workman Publishing Company, Inc.
225 Varick Street
New York, NY 10014-4381
workman.com

WORKMAN is a registered trademark of Workman Publishing Co., Inc.

Printed in the United States of America
First printing August 2013

10 9 8 7 6 5 4 3 2

This book is dedicated to a door that opened in Nashville ten years ago.
Stephanie walked through it and changed my life forever —G. L.

For Kate, Emily, Rosa, Annie, and Emmy—
lots of beautiful girls for me to love and photograph—S. M.

ACKNOWLEDGMENTS

George Lange would like to thank: My mother, Aline; Andrew Lange; Janet and Steve Cook; Scott Mowbray and Kate Meyers; Wendy Snyder-MacNeil; Duane Michals; Aszure Barton; Aaron Siskind; Jeni Britton Bauer; Christine Kullberg; Critt Graham; Annie Leibovitz; Kay Unger; Maggie Hamilton; Glenn Beck; David Mishler; Jeremy Sachs-Michaels; Monika Dabal; Dan Cavey and Karen Smith; Sarah Paz-Hyde; Barbara Griffin; Jane Huntington; and especially my father, who always encouraged me, amused me, and showed me how to get people to disarm in front of a camera. These pictures are a document of our family's love. I thank Stephie, who taught me love in ways I had only dreamed of, and then gave me Jackson and Asher, who fill my cup every day with even more love. That we can share that love with one another is a dream come true. That we can share it with you is a gift.

Scott Mowbray would like to thank: For their help, support, and instruction over the years: Kate Meyers, Rick Staehling, Peter Sikowitz, Jim Baker, Carla Frank, Tom Brown, Dirk Barnett, and Dan Okrent.

Both authors would like to thank: Mark Reiter; Suzie Bolotin, Janet Vicario, and their talented colleagues at Workman; and Peter Workman, who was so enthusiastic and supportive when we first began talking about the book and who we hope would be so proud of what he inspired us to bring into the world.

CONTENTS

Introduction • ix / How to Use This Book • xiii

WAYS OF SEEING

Chapter I

Shoot the Moment,
Not the Subject2

Chapter 2

Keep It Real.......................................26

Chapter 3

Embrace Intimacy...............................40

Chapter 4

Move Your Eye....................................60

Chapter 5

See the Light98

Chapter 6

Feel the Rhythm126

MAKING YOUR IDEAS REAL

Chapter 7

Get a Tiny Bit Technical...................... 156

Chapter 8

Work with People............................... 182

Chapter 9

Playing with Babies and Children 224

Chapter 10

Use Props and Backdrops.................. 252

Chapter 11

Have Fun.. 280

Appendix

A Bit of Nitty-Gritty............................ 314

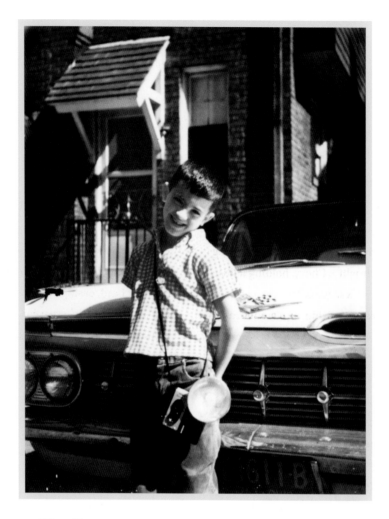

When I have a camera in my hands, good things happen. This was my first camera. It was the key that would open doors to places I could never have otherwise entered.

INTRODUCTION

EVERYTHING CONNECTS

It all started here, at the age of seven, in my parents' driveway in Pittsburgh, standing against their white Chevy, holding a little box camera. I was lucky to have a childhood filled with love, friendship, and community, and from the beginning, I wanted to capture that joy in my photography. From the first pictures I took with that box camera, through the ones I shot for my high school newspaper and yearbook, to the ones I made in art school and throughout my professional career—all my best pictures were born of that early joy. Sometimes I think I have simply tried to re-create with my camera what made me so happy growing up.

My camera has taken me all over the world but, much more than that, it has taken me into myself and allowed me to share what I am feeling. Photography has been a great ride (which isn't over), but for me, the final pictures are never what it is all about. More important, always, is the process of listening, seeing, touching, holding, moving, being still, pushing hard, easing in gently. Photography, I've learned, can be an excuse to say things you would edit out of a normal conversation, do things you would hold back from doing. It taps into my urgent need to live a life that treats every moment like a gift. Photography is, as I'll explore in this book, all about moments.

After graduating from the Rhode Island School of Design, I showed my portfolio to a teacher and brilliant photographer I loved, Aaron Siskind. He paged through my pictures and said, "These are not nearly as good as you are." That set the bar for me—the idea that pictures had to be as good as *I* could be.

In New York I apprenticed with my heroes. Duane Michals, the great art photographer from Pittsburgh, famously said,

"This photograph is my proof. . . . Look, see for yourself." Ideas, he taught me, were much more important than exposures. I worked for a German still-life photographer, Michael Geiger, who taught me to be on time for everything: If I arrived one minute early or one minute late I would be fired. You strive, in other words, to always be there for the moment. Then I assisted Annie Leibovitz. During her year between shooting for *Rolling Stone* and *Vanity Fair*, I traveled all over the world with her. That was amazing. Annie was passionate, obsessive, an artist. I learned choreography from Annie. Working, communicating: She had a special rhythm. Throwing myself completely into her work eventually allowed me to discover my own rhythm; this book is also about finding your rhythm.

The day I left Annie I knew I would never assist again. I would either make it as a photographer in New York or find something else. I would go to the top of the Condé Nast building and stop on every floor until I reached the lobby. I never got to the street without an assignment. I learned this crucial lesson: Whenever I really put myself out in the world, I got work. This, I believe, is just as true for personal photography—for you, in other words: You have to put yourself out in the world. You have to connect.

Taking pictures every day (both personally and professionally), I have created a body of evidence that proves, if nothing else, why I am never bored. The pictures of my family become both my memory and gifts to my children, who will always know how much I have loved every breath they've taken.

This book, at its heart, is about photographing how things *feel* rather than what they look like; it is about appreciating all the beauty and passion and love in our everyday lives. It is about seeing that even the most mundane detail can be extraordinary and full of feeling. Yes, photographs that are real and direct in an emotional sense risk being corny, but they can feel like timeless gifts as well. I think of photographs of this kind as kisses: They exist in a brief ecstatic moment and then take on a life of their own.

Being a professional photographer opens doors for me, introduces me to fascinating strangers, takes me out into the world. Many of my most treasured pictures were not taken on assignment, though. Even if they did emerge from my professional work, they were usually shot around the edges of assignments. I take some of my best pictures when everyone breaks for lunch and I keep shooting. When lights are being set up, I am already shooting, looking to discover something new. I am always on the

move—and that simple idea, *moving*, is the subject of one of the chapters in this book.

At home, on the train, at the beach, I'm constantly shooting, wanting to capture what I am experiencing, whether it's with my camera or my iPhone. Of course, so is almost everyone else in the world. I'm convinced that the billions and billions of pictures taken today, the ones straining Facebook's servers, show a hunger to live life more richly. Yet I also see that many people are shooting the surface of things, the way things *look*. The risk is that by staying on the surface, and using easy digital effects to make our pictures pretty, we risk trivializing how we really experience our lives.

It may seem like a contradiction: that picture-taking can take you deeper into life rather than removing you from it. Doesn't the camera get between you and the thing you are experiencing? Well, it can, but not if you are truly present, as I believe you must be to take beautiful pictures. Philosophers and psychologists use the term *being present* to describe the experience of consciously living life in the moment, rather than passing through an experience with one's mind on something else. In this time of digital overload, it's easy not to be present; it's easy to hide, even live, behind the lens, or the screen, in the virtual world. My collaborator on this book, Scott

Mowbray, describes spending so much time taking bad pictures of a total eclipse of the sun in India many years ago that he was left with tiny-speck shots of a magnificent celestial event that he had, essentially, missed. Next time, in Indonesia, he put the camera away and just took it all in. That's why I rarely take pictures of experiences like that. The camera, except in the hands of geniuses like Ansel Adams, is not good at taking in the gargantuan. I'm much more interested in the millions of in-between moments that make up the real fabric of our lives. If I did shoot an eclipse, I'd shoot the person who was watching it in awe.

If I had to pick one word to describe the things I shoot, it would be *connections*. I'm interested in the connections among all the people in my life: grandparents, teachers, children, strangers. Among everyone who ever sat on our porch, or swung in our hammock. Between dogs and their owners, between the shoes and the dance, between the tuxedo in the back of my father's closet and what he looked like on his thirtieth wedding anniversary. Between how I feel and what the doctor just told me, between my first kiss (and who I kissed) and my last kiss. Everyone has these connections, and finding new ways to see them is, I believe, finding new ways to live them.

What about technology and technique? They have their place, but you don't have to bone up on f-stops, focal lengths, ISO, and *bokeh* and risk falling into the obsessions of a certain kind of hobbyist. Your pictures will improve simply by trying some of the ideas in this book: getting comfortable with shooting intimacy, moving your eye to new viewpoints and angles, getting to know the light in your own home, and learning to work with people. True, I use high-end camera equipment much of the time, and it would be silly to say the quality of the equipment and my lifetime of experience as a photographer don't affect my pictures. However, you have a couple of things going for you.

First, most of the ideas in *The Unforgettable Photograph* are about seeing and feeling, not f-stops. The technical bits that are here pertain to things like deliberately using slow shutter speeds or taking pictures in very low light just to see what happens—not difficult things for anyone. Second, keep in mind that you live in the best time in history to be taking pictures: The power of the new digital cameras—in smartphones, in point-and-shoots—is fantastic. A little knowledge pays off in spades.

The unforgettable photograph, in this context, isn't the most technically proficient or most "artistic" shot but the one that makes the deepest connection to the moment you're experiencing and the person you're photographing. The unforgettable photograph is one that makes that intimate connection understood—*felt*—by the viewer. It will always jump out at you from the hundreds you take.

In the end, your unforgettable photographs will come mostly by employing the essential ideas of this book: Shoot from the inside out. Shoot what you feel, every connection. Shoot lots. Shoot your life.

—*George Lange*
Boulder, Colorado

HOW TO USE THIS BOOK

The chapters are organized around basic concepts, ways to capture moments and feelings that are true to your experience, and ways to develop a relationship between you and your subjects in which both sides can play and explore. These are, really, pictures that anyone could take: less about technical skill than persistence and feeling and attention to light and space. It doesn't matter whether you start at the end of the book, the middle, or the beginning; dip in and out; or plow right through. There are hundreds of ideas, as well as pointers on composition and lighting, plus a chapter that dives a little deeper into simple technical issues. Some photos reinforce one simple idea worth trying and feature almost no explanatory text. Others are grouped to suggest an approach or exercise that may lead to a great shot. Many include a back story that helps to explain where a shot came from creatively.

Taken together, the pictures illustrate my belief in emotional directness and the need to get close to the subject. The only other "must" is the never-ending need to find new angles, new light, new ways to break through to a true experience. Although my approach is not, at its core, technical, it may seem emotionally risky. You're called to use the camera in situations where you might have lacked the nerve before; to move past predictable poses to something more relaxed, intimate, and inspired with your subjects; and above all, to become that photographer who is always on the move, always taking pictures in daily life, sometimes disappearing into the background, sometimes directing, always engaged. As already noted, most of my shots are from daily life, although I have included some professional and studio work, and even a few celebrity shots that illustrate an important idea. Most shots are

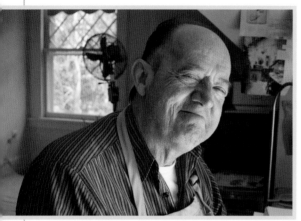

1/60 · f/11 · ISO 800 · 50mm

Be ready for the right moment (see Chapter 1).

personal, though, or taken for personal reasons around the edges of a professional shoot.

Pictures, as Chapter 1 asserts, are not as much about the "subject" as they are about your experience inside a moment. Finding your own breakthroughs will come from picking up your camera and diving in, perhaps inspired by a photo that you see here and use as a jumping-off point for your own creative play. Along the way, there is no shame in directly copying an idea, an angle, or a trick as a way to find your own approach.

I shoot with a point-and-shoot camera quite often, and with my iPhone daily, but most of the photos here were taken with my pro SLR. That's because I almost always have it around and it's second nature for me to use it. But the ideas and the feelings in my pictures can,

with a few exceptions, be captured with a good phone camera or a point-and-shoot. The best pictures come from true experiences creatively documented, not from the machine.

ABOUT THE PICTURE DATA

Most of the photos in this book include data about the camera settings. Feel free to ignore the numbers. You can set your camera on auto and do just fine, but if you want to play around with manual settings, it may be helpful for you to know how my camera was set when I took a particular picture—especially if you have an SLR. If you do read the data, you'll quickly see that my pictures are mostly shot with a slightly wide-angle or "normal" (50mm) lens in everyday light, or a slight zoom. I don't use long lenses very much, nor do I crop much after shooting. I frame the picture in the camera, get in close to my subjects, get in their faces, and use shutter and aperture settings that are available on most cameras. Getting close—physically and emotionally—and using the light that's available is pretty much the foundation of what I do. The studio shots, and a few shots taken with very sophisticated pro cameras, are included not to illustrate fancy studio techniques but to show an approach to telling a story. Those shots may not offer picture data, because it's not really relevant there.

Understanding the Picture Data

Aperture ISO

1/60 · f/1.4 · ISO 640 · 50mm

Shutter Speed Lens Focal Length

Shutter Speed. The speed with which the camera's shutter opens and closes to let light in. The slower it is, the steadier the hand has to be; at slow shutter speeds, you'll need to prop the camera against a wall or table, or use a tripod. And just to be clear: A *lower* shutter speed (say, 1/30th of a second) is actually *longer* than a higher speed (say, 1/125th of a second).

Aperture. The size of the adjustable opening in the lens, which regulates the amount of light that gets in. The lower the number, the wider the opening, and the more light the lens lets in; also, the lower the number, the shallower the depth of field (the area in focus, from front to back).

ISO. The setting that adjusts the sensitivity of the camera's sensor to light. The higher the ISO number, the less light you need—but the more pixelated, or "noisy," that picture may be (if you set the ISO too high).

Lens Focal Length. Zoom lenses move through various lengths from wide (say, 35mm) to long (say, 20mm). Some cameras have fixed-length lenses. The lower the number, the wider the scope of view; the higher, the more it zooms; 50mm approximates the view of the eye.

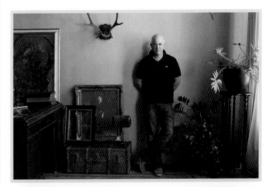

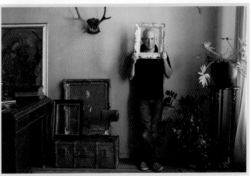

▲ 1/50 · f/4.5 · ISO 800 · 50mm

Two self-portraits: Have fun with props (see Chapter 10).

A FEW PRINCIPLES OF COMPOSITION

I compose pictures as I shoot, in the camera viewfinder, not in the computer afterward (you can do it on the LCD screen on a camera or phone, too). I don't think about composition in formal terms; it's all instinct, feeling and repetition, rhythm and flow, finding what pleases me and seems true in the moment. There are, of course, basic ideas in composition that tend to yield pleasing pictures instead of awkward ones (just Google "the rule of thirds" for more on this). Generally you want to:

- be aware that placing a subject in the dead center of a picture produces a very formal-feeling portrait, and is generally the least dynamic composition;

- be aware of, and take advantage of, things that naturally frame your subject (such as the lines of the table in the shot above, which frame the child on three sides);

- avoid odd intersections of lines and objects with the subject (like a tree behind a person that seems, in a picture, to grow out of the person's head);

- always push past rules about focus, posing, and composition to find your own sweet spot.

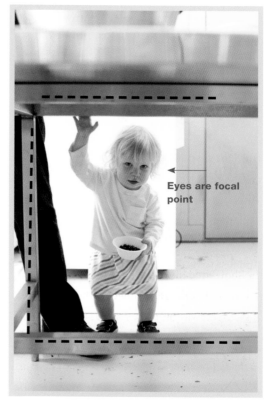

Eyes are focal point

▲ 1/125 · f/4 · ISO 640 · 50mm

Most of the shots in this book are of people, and in those shots the viewer's eyes will naturally seek out the eyes of the subject: The eyes usually become the focal point and, as I noted, should usually be off-center. The shot of the child above illustrates that, as well as the idea of framing: Her body is centered left to right, but her eyes are above center, and lots is going on at the edges of the picture because of the shape of the table and the grown-up's leg, which cuts in at an angle.

Of course, composition involves much more than placing the subject off-center. What's happening on the edges of the picture? Is something leaving or entering the shot? Do things in one part balance things in another? Does a strong line run through a picture at an interesting angle, cutting through the perpendiculars? In the simple shot below, taken at a community swimming pool, a line of trees moves down through the picture from right to left; the running boy, who is a fantastic jigsaw puzzle of angles all on his own, is leaving the shot—and his head is cut off, which helps reinforce that the real subject is the boy in the lower right, way off-center, who is staring into the camera. Eventually, the viewer's eyes fall on that boy's face.

I don't think about any of these things when I shoot a picture like this. However, I did get down on my belly to shoot it, which put me at eye level with the subject and naturally brought the composition into place. Moving the camera to the level of the subject, or to some other interesting vantage point that shakes the picture out of the obvious, is one of the subjects of Chapter 4: "Move Your Eye."

Here and there, you'll find composition examples showing the basic way a shot was set up.

Also look for these two symbols:

◉ ABOUT THE LIGHT

I've scattered a few tips about light throughout the book. Generally, I shoot without flash, using natural light, but I usually have my camera on manual, to override the natural inclination of automatic settings to reduce some of the drama of low-light or backlit situations. Most point-and-shoots now allow some sort of manual override, or at least the bracketing of exposures, and you'll want to play around to get the effects you'll find in many of my shots.

TIP Look also for tips here and there; they'll give you a little more insight into how a picture was taken, or tell you how to avoid common mistakes.

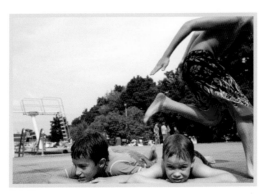

▲ 1/1000 · f/8 · ISO 500 · 38mm

PART ONE
WAYS OF SEEING

SHOOT THE MOMENT, NOT THE SUBJECT

L ife is a string of moments, like notes in a song. So is a photo shoot, at home or in a studio. Which moment will provide the unforgettable picture isn't much in your control. You can't even really see what your camera is capturing in the hundredth of a second the shutter is open. Often, you have no clue what your best picture is until you look at the series of moments playing back on your camera. Often, because that little screen on the camera doesn't tell you much, the surprises may happen on the computer, hours or days later.

If you can't see the moments, you can *feel* their flow, like feeling the flow of music. That feeling is essential to taking good pictures; it's as important as having a good eye. Ask yourself, "What makes these moments and these people extraordinary?" Ask that, rather than, "What's the pose? How am I cropping this?"

Don't get impatient: Fight the impulse to take a picture that will memorialize something that you're already projecting into the future with nostalgia.

As I mentioned in the Introduction, I often compare taking a picture to a kiss. Do you use your eyes when you kiss? Sometimes, but generally your eyes are closed and it is all about the feeling. I try to shoot from that same place. Sometimes I even close my eyes as I shoot pictures. I shoot using my heart more than my eyes.

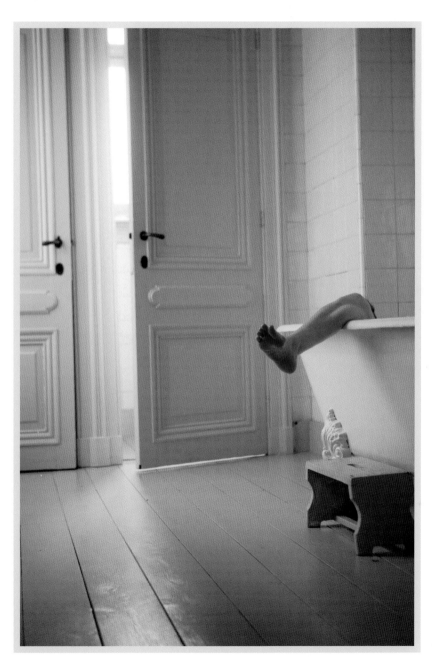

1. A Moment of Mystery

This picture is of my wife, Stephie, and a wonderful antique claw-foot tub, and the time we spent together on a vacation in Europe before the birth of our second child. At the same time, our experience is not what it is entirely about. As a picture, it's a half-told, beautifully lit little story: a moment that can be nothing but a mystery for anyone who wasn't there. Is the person in the tub relaxing? Naked? Alive? Stories like this happen all the time in our lives. It depends on feeling and seeing the moment as it happens—and, in this case, loving the creamy light that is pouring through an old doorway.

◀ 1/80 · f/2.8 · ISO 800 · 54mm

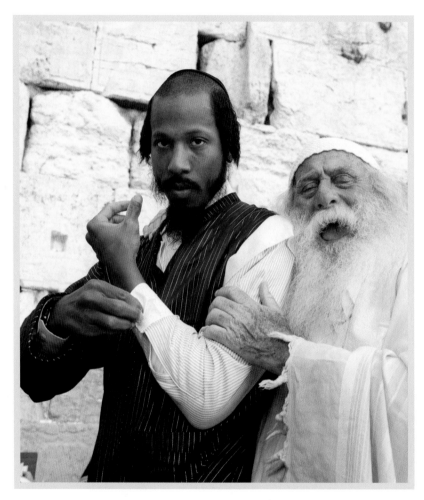

▲ 1/125 · f/2.8 · ISO 800 · 40mm

2. See the Moments You Cannot Make Up

This is a picture of the rapper Shyne, a Belize native who spent years in prison after being involved in a club shooting in New York. While in jail, he became a Hasidic Jew. I met him at the Western Wall in Jerusalem one morning at dawn. Here he is with one of the praying old men, who happened to be lecturing me on my own Jewishness. This picture came from a planned shoot but records one of those in-between, spontaneous moments that you have to keep shooting in order to get.

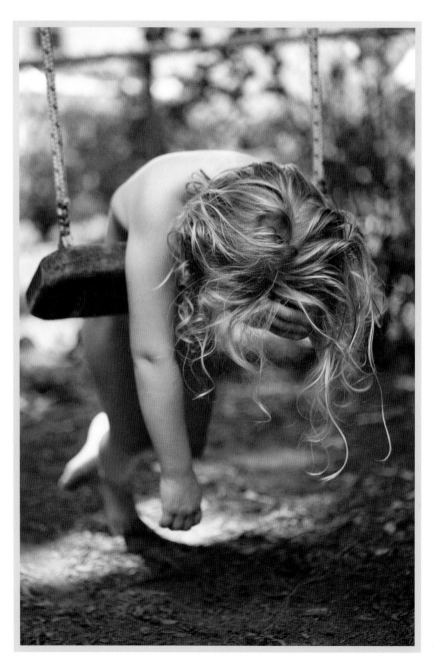

3. Moments You Stumble Upon

The more you shoot, the more often you'll happen upon a perfect picture in the middle of an ordinary day. This picture seems full of emotion yet holds its cards close, and it's one of my favorites. The girl is the daughter of my friend Elizabeth Fleming (a great photographer), who shoots incredible pictures of her own children.

For both of us, our backyards count among our most important canvases, where we know the nooks and the light intimately. This is where our kids live, and moments like this are always happening, whether we see them or not.

Your backyard—or your street corner, or your front porch—will reveal the same moments if you look.

◀ 1/400 · f/2.8 · ISO 400 · 64mm

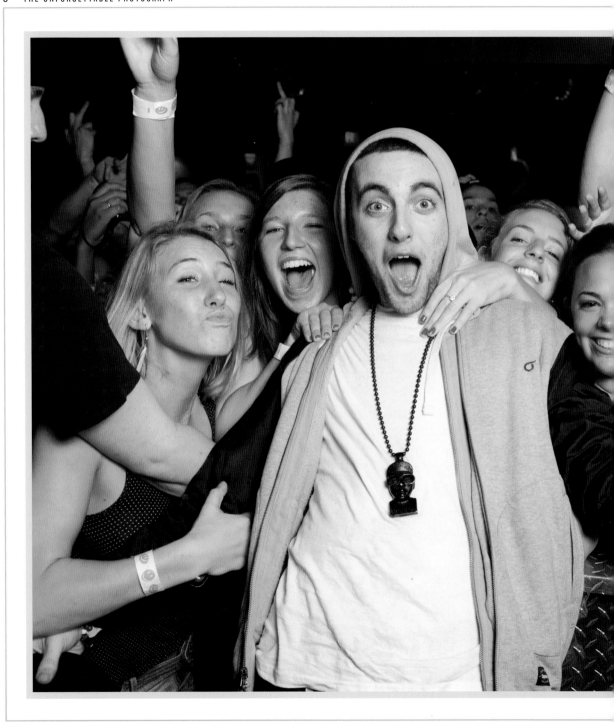

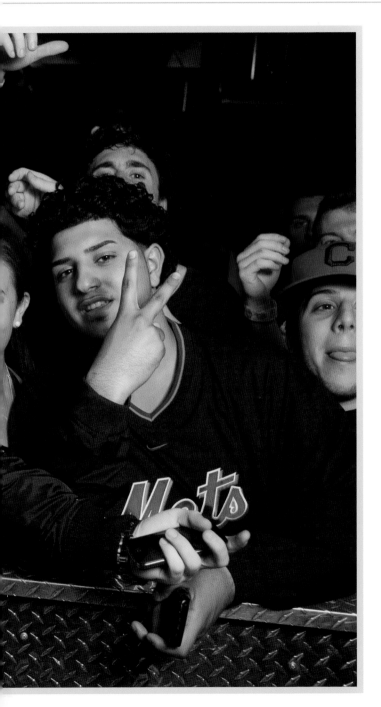

4. Lucky Moments

My friend Karen Meyers's son is the rapper Mac Miller. Maybe it's the fact that he and I graduated from the same high school in Pittsburgh, many years apart, or maybe it's because he's so funny, musically brilliant, ridiculously generous, and talented, but I was desperate to take some pictures of him performing.

This is a lucky moment at an after-party. It was so dark in the club, I could hardly see. My assistant was holding a strobe filtered through a "soft box" to make the light soft and reasonably natural. The flash was synced to my camera so that when I pressed the shutter, it went off. Until I did that, I really had no idea what the photo would capture.

You can rig a flash off your camera without too much trouble to produce a result not too different. The real subject is the miracle of Mac's charisma and a bunch of fans in love with the moment, and the real lesson is that good luck comes from being where you want to be.

◀ 1/50 · f/5.6 · ISO 640 · 35mm

5. Create Funny Moments

Every summer my oldest friend, Muzz, and I play a game by posing for one picture that is totally, 100 percent wrong. Here he is in his sister's bathing suit. The picture is more funny because the light is quite beautiful and delicate.

 ABOUT THE LIGHT

This is backlight extraordinaire—the background is blown out, but in a very nice way. You have to open the lens way up—at least several stops—to get this. You're shooting the person, but the camera, on auto, sees the bright light and will compensate by darkening the shot too much. Think about exposure in a backlit moment, and correct for it.

▶ 1/100 · f/4.5 · ISO 640 · 35 mm

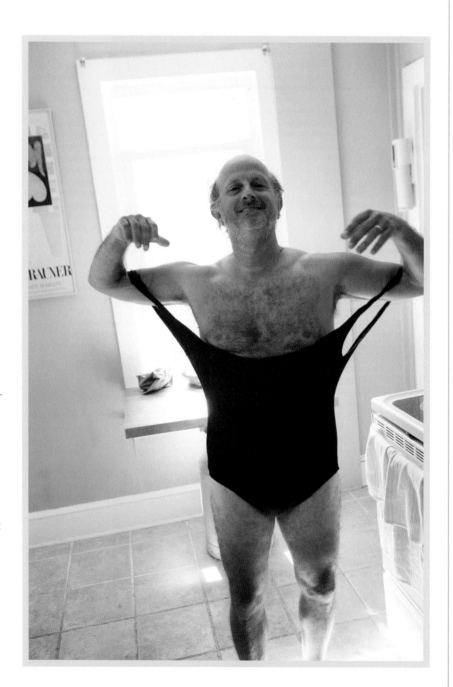

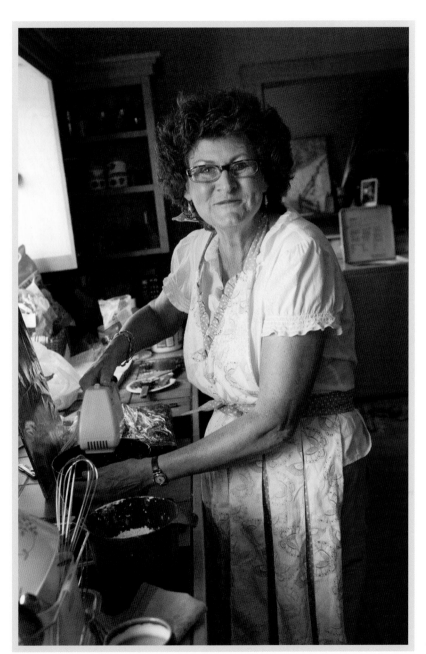

1/80 · f/5.6 · ISO 800 · 45mm

6. Everyday Moments

I almost never use flashes in everyday shooting, and if I had here it would have produced one of those frozen, badly lit snapshots, with weird shadows and red eye: totally unflattering. Instead, this picture is warm and soft, bathed in light from the kitchen window.

TIP My mother-in-law knows my camera is always out, which she tolerates, yet she is generally uncomfortable having her picture taken. I am sure I was saying something totally inappropriate; she always laughs. My technique for getting to pictures like this reminds me of the name of that old Talking Heads movie *Stop Making Sense*. I stop making sense, just talk and shoot.

7. Love the Moment

A photographer needs to be in love with the world, awake to everything that goes on. When I'm shooting people, I really am, for that moment, in love with them. That sounds corny, but it's what I feel and what I try to capture in my pictures. When I shoot, I am totally into being there, into appreciating who these people around me are, into celebrating who they are, into really enjoying myself and expressing that.

TIP Eye contact makes the viewer feel present, somehow, at the moment the picture was taken, at the moment the funny thing happened. As in life, eye contact in pictures is intimate, consensual.

➤ 1/250 · f/4 · ISO 400 · 62mm

8. Seize the Moment

Every summer I watch the parade of jumpers off the high platform at my community pool and promise to bring my camera to photograph it. Weeks go by. Then comes Labor Day, the last day the pool is open, and finally I find myself, with a roll of towel under my head, lying under the board, at the edge of the pool, looking up. (See photos from that series on page 80.) One time I'm there, and I see this kid going up the ladder wearing a pink cape. I have to scramble to get to the side of the pool, where I know the shot will be.

The 1/1000 shutter speed completely freezes Superboy in midair. But I don't zoom in on him: The lens takes in the whole community-pool scene, which makes the picture much more fun than if I had gotten in tight. And with the camera pointed straight ahead, the boy simply falls into the picture: a public display of his superpowers.

COMPOSITION

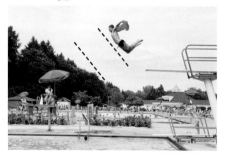

It's nice that the trees are angling down to the center of the picture and that his body is roughly parallel to that angle. But don't think I planned it! Pure luck.

▲ 1/1000 · f/9 · ISO 500 · 57mm

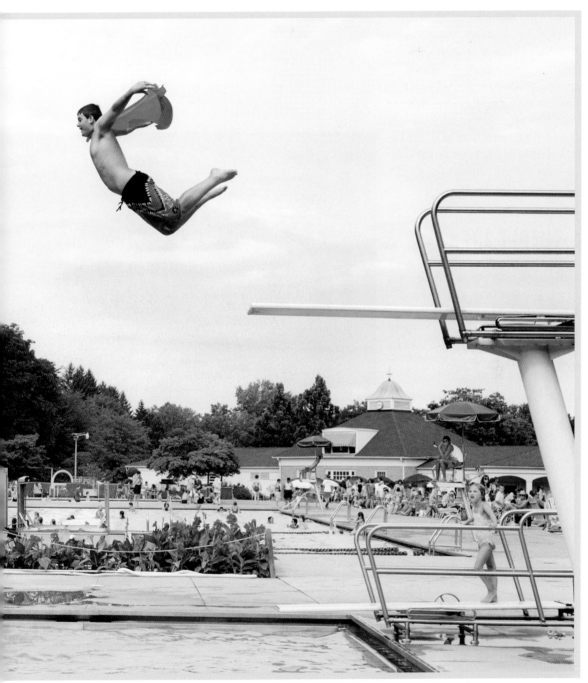

▲ 1/1000 · f/9 · ISO 500 · 57mm

9.

A SIMPLE IDEA

Find the funny moment

▲ 1/80 · f/5.6 · ISO 100 · 100mm

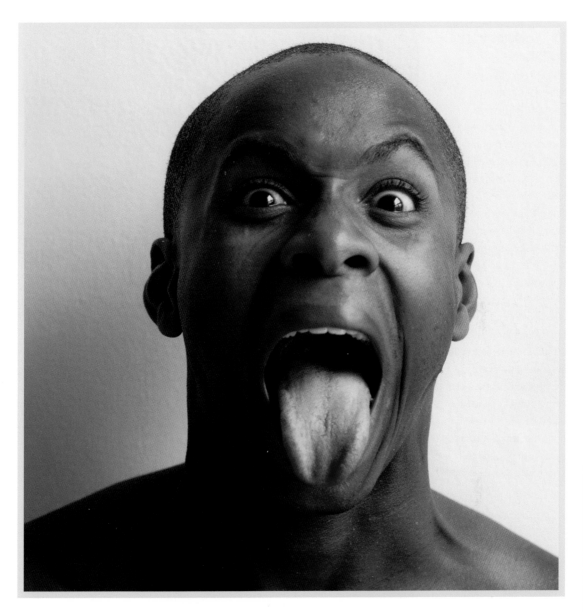

▲ 1/60 · f/5.6 · ISO 320 · 100mm

10. The Moment Is in the Details

Taken on vacation in a famous glove shop in Antwerp, the perfect shot came down to the particular way that the owner tried on gloves and then presented them to us to see if they were to our liking. This was a beautiful moment in the narrative of our visit. Little things like this are essential to storytelling.

Travel tends to make all of us hyper-aware of details like this; when we are away from the distractions of our lives, we come awake to the small moments. That's why we travel, and why we take pictures. The trick is to bring that hyper-awareness home with you, and to keep it alive.

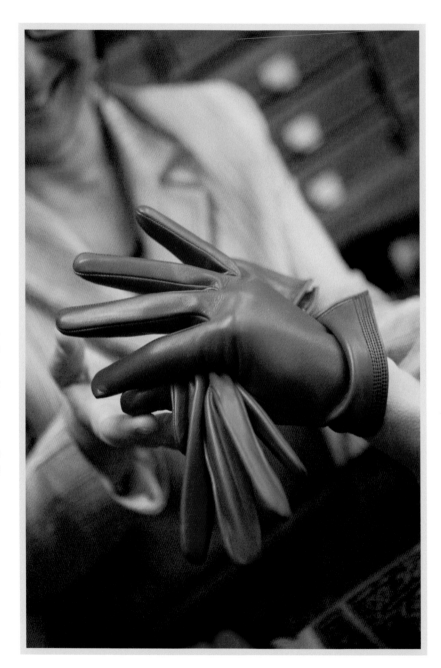

▶ 1/100 · f/2.8 · ISO 640 · 51mm

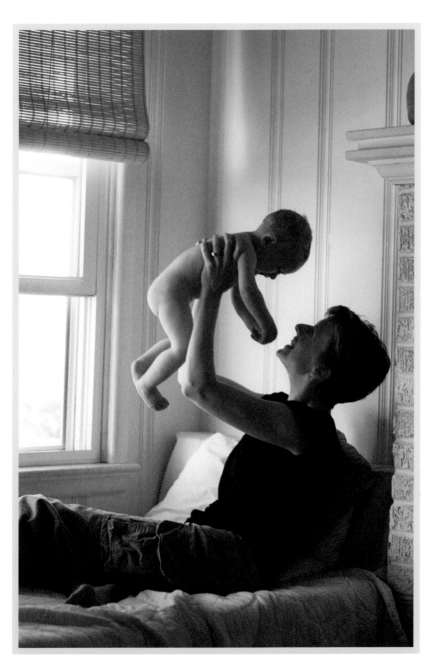

11. A Mother-and-Child Moment

I have long treasured the spot where this shot happened; it's in a beach house I have been going to since I was little. Now my wife and son were in that place.

Here the afternoon light was so beautiful that I chose to underexpose the picture: The light on the wall is perfectly exposed, while the subjects almost become silhouettes. Underexposing risks making a picture about the light, which I don't like to do. In the end, though, this is still about the moment between a mother and her baby, in a place I love.

☀ ABOUT THE LIGHT

A camera set on auto will not get this backlit exposure right. Manual settings or bracketing will. See page 317.

◀ 1/80 • f/3.5 • ISO 640 • 85 mm

12. Wait for Those Fleeting Moments of Baby Attitude

People often say I make babies look like old people, but I think that's just because I'm trying to capture who they really are rather than take the "perfect" baby picture. Furrowed brows, old-man stares, looks of profound outrage: You have to be open to moments like this; you can't capture the full range of babies' expressions by willing them to happen.

Doing his best Burt Young impression.
→

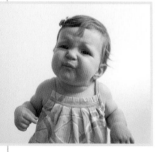

Sampling one of her first ice creams.

▲ 1/100 · f/9 · ISO 640 · 45mm

▶ 1/100 · f/2.8 · ISO 200 · 100mm

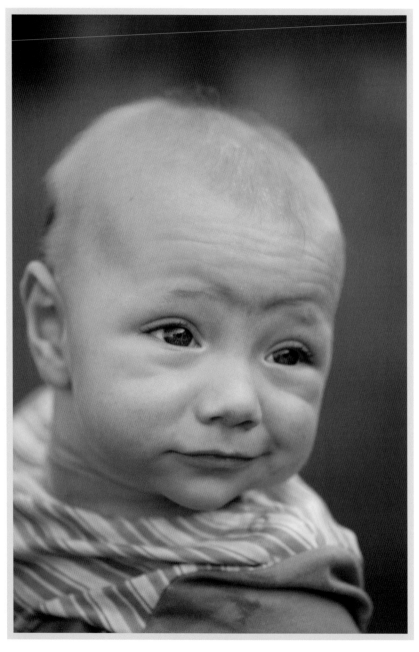

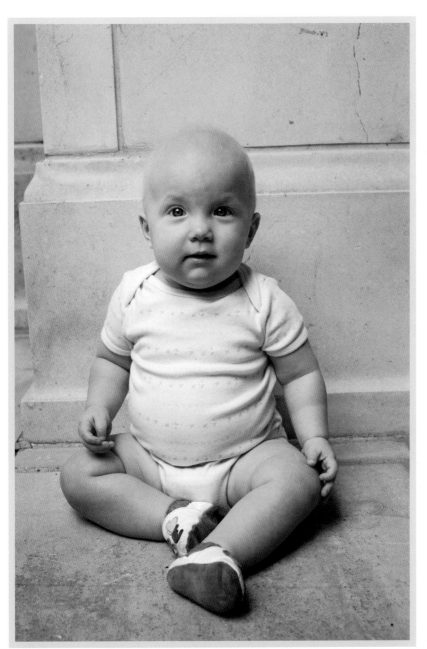

13. Create a Baby Moment

Babies will react the first time you put them somewhere they have never been before: a swing, a chair, on the concrete floor in a grand space like this public library. You have about one second to get the right expression and pose. It's very difficult to re-create a shot like this, but easy to set up the next moment of surprise—just move the baby to another novel situation.

TIP So many shots depend on getting down to the eye level of your subject, whether it's a baby, a dog, or a wild animal.

◀ 1/125 • f/7.1 • ISO 500 • 50mm

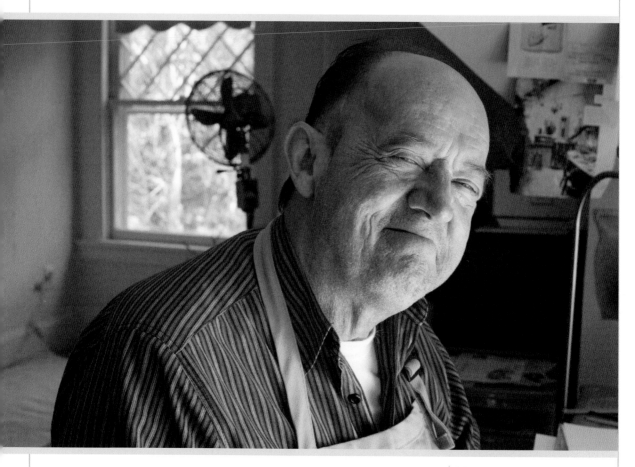

▲ 1/60 · f/11 · ISO 800 · 50mm

14. The Sweetest Moment

There are a lot of things that are less than perfect in this picture. Had there been time to put it together, I would have moved the fan in the back so that it was not coming out of my father-in-law's neck. I might have moved other distractions out of the frame, too. No matter: This is just the sweetest shot, a perfect Steve moment. He was working in my wife's art studio, doing what he loved—creating art—and giving me his "Go ahead, take that picture" look. He loved being photographed, and a subject who loves having his picture taken is a gift: When you find one, shoot lots. When we miss Steve, it is these pictures that help—and make us miss him all the more.

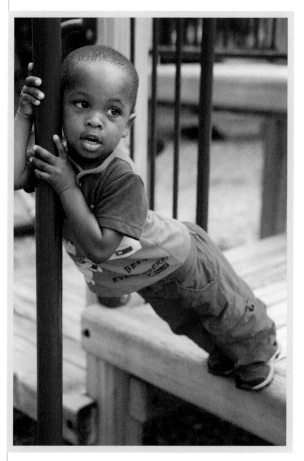

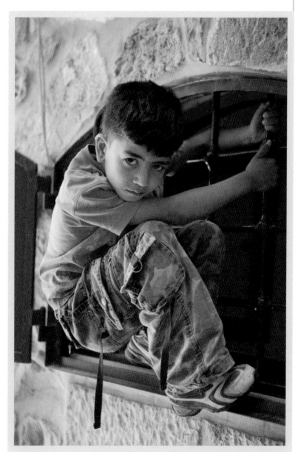

▲ 1/250 · f/3.5 · ISO 160 · 66mm

▲ 1/125 · f/2.8 · ISO 200 · 57mm

15. Moments of Great Gravity

Whenever people fight gravity, there's struggle, a moment of suspension. Children love testing their bodies against the pull of the world, and I love to shoot them hanging like bats or monkeys, to see them flexing their bodies in ways that only athletes or dancers can match. The shot on the left was taken at a park in New Jersey; the one on the right, in an alley in Jerusalem.

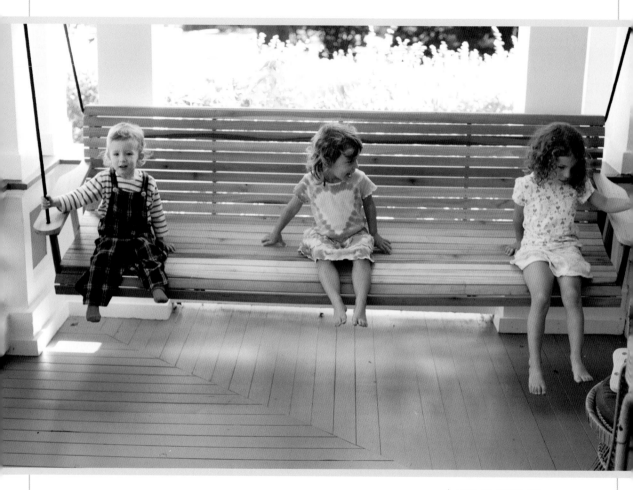

▲ 1/100 · f/4 · ISO 500 · 500mm

16. The In-Between Moments, #1

The first inclination is to scoot these kids together and have them look at the camera. This is much more interesting, one of those in-between moments in the rhythm of a Saturday when each kid is in his or her own world.

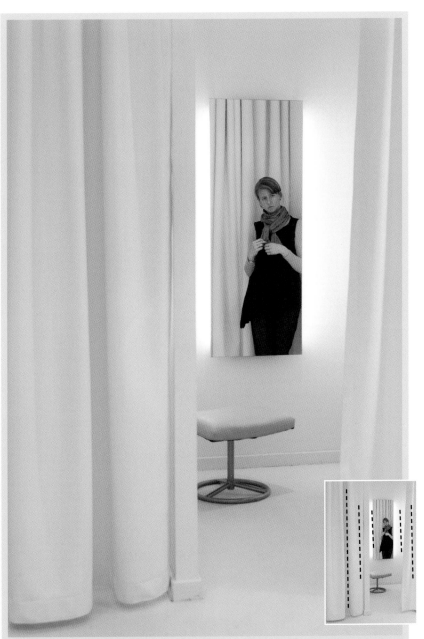

17. The In-Between Moments, #2

The little things that happen between the most-often-shot moments of our lives (when everyone expects to be photographed in exactly the same way) are just as emotionally important as the big reveals. If you're not looking for those little moments, you miss 99 percent of what is going on.

In this picture, my wife is in a dressing room in a classic in-between moment. In one sense, nothing is happening: She is checking herself out in the mirror, considering a new dress. Meanwhile, I am sitting in the "husband" seat outside. This picture is a little non-moment of permitted voyeurism.

COMPOSITION

The parted curtains, and the light-bracketed mirror beyond, are framing devices—you really feel like you're getting a peek inside.

◀ 1/60 • f/5.6 • ISO 640 • 51mm

18. Collaborate with a Moment

The third floor of our old house was perfect for napping—and for taking pictures. It had the most exquisite light, and I was always certain to have my camera with me when we climbed the stairs. So I was ready when my son began looking for something in the tub.

Some photographers are creators. I am better at collaborating with a moment.

☀ ABOUT THE LIGHT

The best light for beautiful effect is almost always filtered. Here, it comes through a cheap white curtain, gently bouncing off the subject, gorgeous against dark walls. Be sure you know where the best light in your house is.

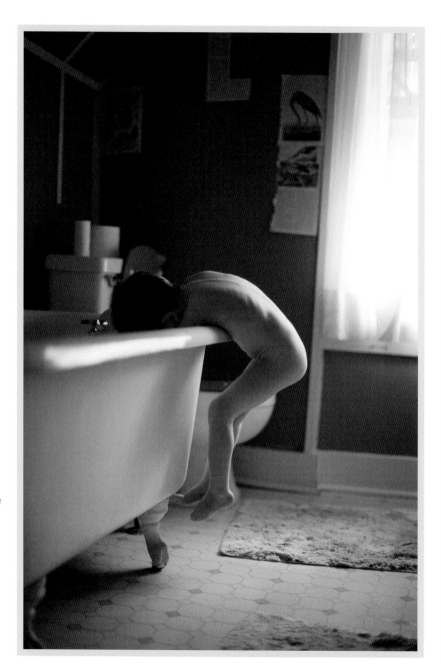

▶ 1/60 · f/1.4 · ISO 640 · 50mm

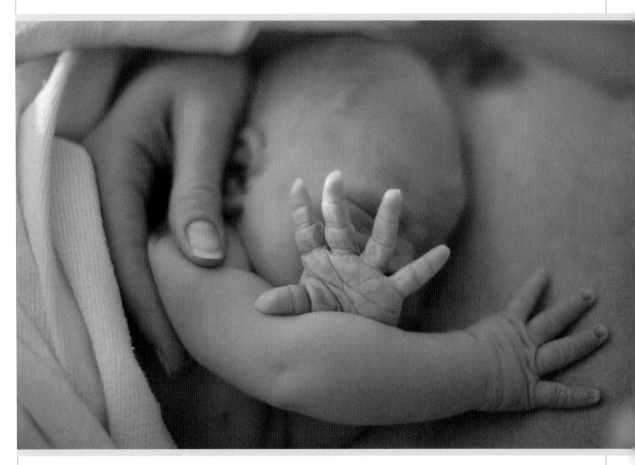

▲ 1/160 · f/1.2 · ISO 800 · 50mm

19. Decide How Much to Intrude on a Moment

My first son, just born. With a shot like this you come to terms with how much you want to use your Total Access Pass as the photographer of your own life. It's a balancing act between just being there, in a very fresh moment, and pulling out your camera to take a picture.

When I first saw Jackson, I was somehow shocked that there he was, fully assembled, arriving with a complete body and personality. Tiny hands and fingers and, amazingly, fingernails. I needed to move in really close to show how mind-boggling this child was to me.

When I look at this picture now, I remember the feelings but not the fingers; I remember crying, but not that skin on skin. The picture captures something specific and particular that I would not have remembered otherwise.

KEEP IT REAL

We are all storytellers, photojournalists of lives that are rich with tears, bruises, tenderness, strangeness, and humor. There's nothing wrong with shooting smiles and holiday rituals, but life isn't a marketing campaign. More interesting stuff is going on.

That's your job as a photographer—to shoot the world as it is. Remember that you have a story to tell and that the camera, honestly used, has a way of staring without being rude. That's not to say that it doesn't sometimes feel awkward (or, yes, rude) to pull out a camera, and there are times when it is just heartless to do so, but the real challenge is getting up the nerve to shoot when most people simply don't. This is what photojournalists are paid to do. It's what I do in my own life. And it's what you can do in yours.

You will need to figure out what your personal rules are, but for me, it starts with allowing myself—encouraging myself—to shoot feelings I may want to avoid, even when it's uncomfortable. I try to do that without inhibitions. I get that camera in my hands, and I feel freed to be as honest with myself—and the world—as I can be. That doesn't mean I have permission to be a creep, but I push the shutter knowing that honest photos, even ones that aren't obviously tough, can push buttons. As you give up your safety net, as you make that smartphone photo about a *feeling*, you'll have to deal with that. Photos take on a life of their own and may tell stories you didn't intend to tell. Subjects may feel revealed in ways they don't like. It comes down to trust. Do they trust your motives? Do you?

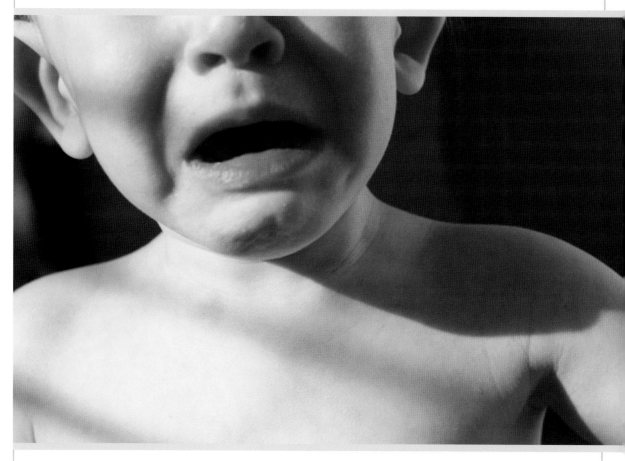

▲ 1/250 · f/9 · ISO 500 · 63mm

20. Shoot Their Tears

Could a picture be more in the moment than this one? I suppose it seems cruel, taking pictures when your child wants consolation, but kids cry all the time, I am a fast shooter, and today this picture has a lot more resonance for my son than another shot of him jumping into a pool.

TIP I didn't crop this: It is exactly as shot. Not seeing his eyes focuses your gaze on his so, so expressive mouth.

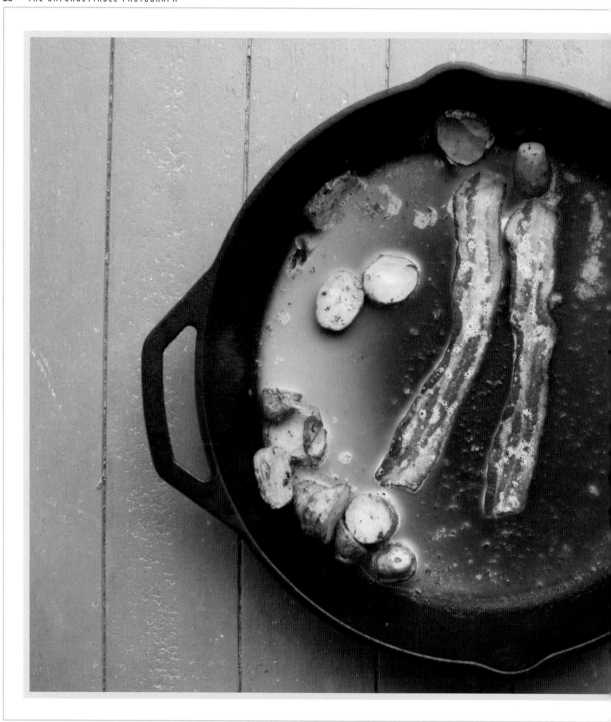

21. Shoot Your Grief

My father-in-law was not well, and yet he made this food that he knew was not good for him. Then he slammed the pan down and said it didn't mean anything, because there was nothing he could eat that would be healthy enough to keep him alive. He was a master at making great Southern breakfast feasts, and at that moment it felt like he was throwing in the towel.

I took the pan outside, where it was cold. The grease hardened and seemed to turn into something else, something important. I took this photograph for myself; it was not meant to be shared. It's about my frustration and sadness on that difficult morning.

◀ 1/100 · f/5 · ISO 640 · 50mm

22. Embrace the Awkward

Seeing something like this funny moment at a friend's wedding, your inner voice may say, "Don't take out a camera; don't photograph this." But I think of all pictures—funny, sad, messy—as acts of love, whether they are pictures of friends or strangers or my own children. People ask me what I say to my subjects when I am taking pictures. Basically, I always try to have my mind in its freest, most unfiltered, improvisational state. My father used to say about me, "Whatever is on his mind is on his lips." I don't care if what I am saying makes sense. I just care that I am as vulnerable and open as I hope my subjects will be with me.

▶ 1/200 · f/6.3 · ISO 400 · 60mm

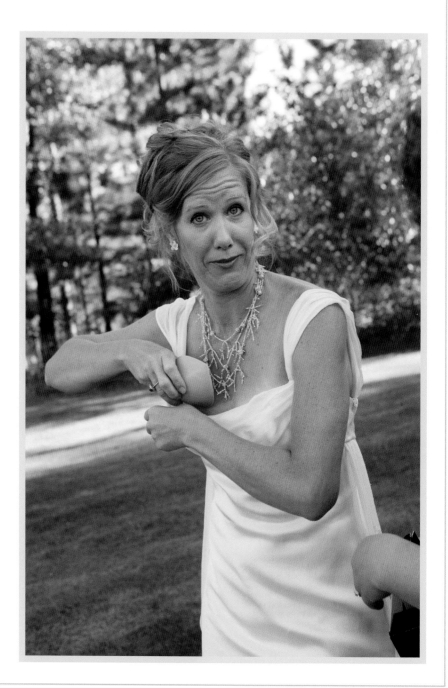

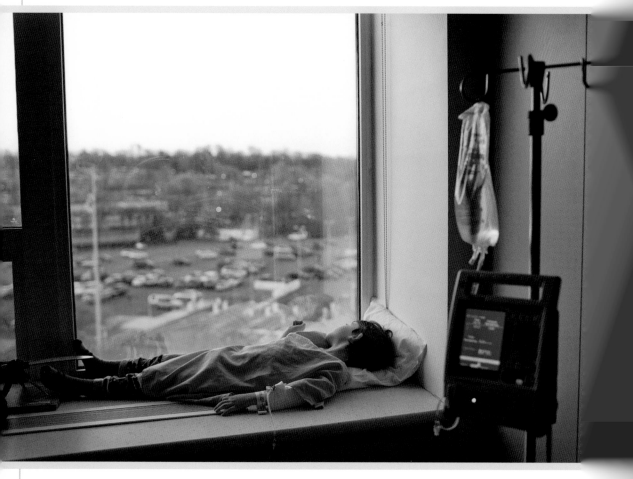

▲ 1/125 • f/2.2 • ISO 800 • 35mm

23. Beauty in a Place of Fear

Some people use the camera to remove themselves from the scene and be the cool observer, but for me it's a tool to get further in. I have taken a lot of professional pictures in hospitals, usually of models, sometimes of real patients, but in this case I was with my son, who had been admitted with a worrisome stomach ailment. Jackson is used to having the camera in the mix, so he was comfortable with me taking pictures, even here.

One morning, after a night when I had stayed over with him, we woke up and cleared the windowsill so he could watch the sun rise over the parking lot. "Daddy, that is the most beautiful sunrise I have ever seen!" he said. Backlit, the IV bag all aglow: This is not where we wanted to be, yet, when you look, beauty is everywhere.

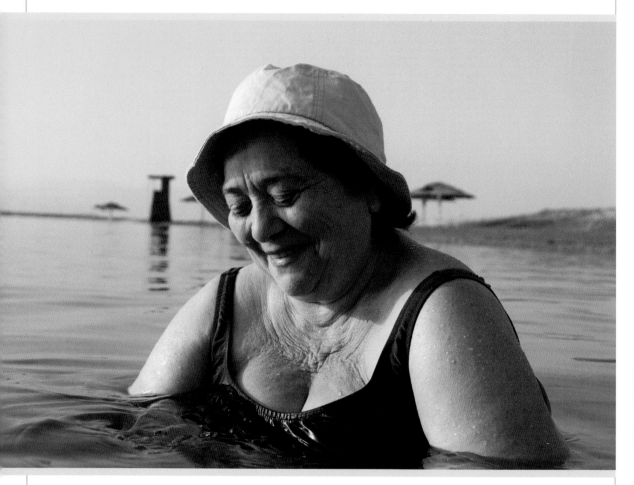

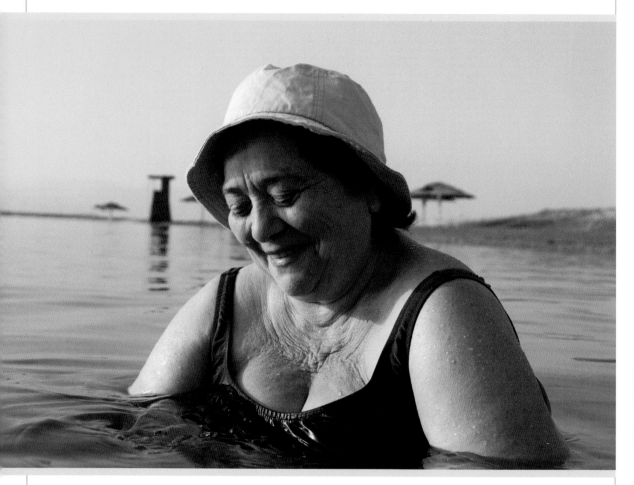 1/125 · f/11 · ISO 100 · 70mm

24. Real Age

I got in big trouble with my family when I used a picture of my 85-year-old great aunt in a bathing suit for the cover of my college newspaper at design school. The taboo of age: I just don't see it. I love the woman in this picture, who I found swimming in the Dead Sea. We didn't speak a word of the same language. No problem. She had the craziest pointy-breast bathing suit and was totally game.

TIP The Dead Sea is the nastiest place to take a camera. The sea floor is sharp and slippery, and you can just breathe in the salt. But at sunrise, when all the Russians take to the waters, I snuck in with my camera. Light from Jordan was making everything beautiful. Don't be afraid to take your camera where others don't. Just don't slip!

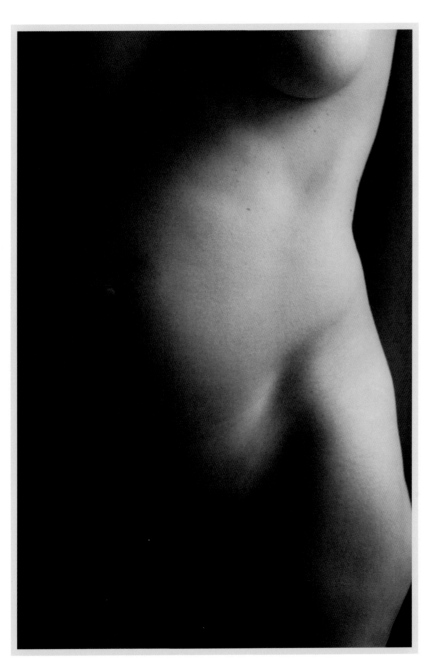

25. Real Nakedness

I hate pictures of women holding their breasts with false modesty. I want to see everything. That isn't the same as showing everything. This shot uses light and shadow not only for discretion, but also to show the contours and bumps of a body during pregnancy: not perfectly glamorous, but beautiful.

The Internet has screwed everything up about taking naked pictures. There is no control, no privacy, no decorum, it's just everywhere. So we don't shoot our kids naked, we don't put pictures of our wives or husbands out there in the world. Yet I love naked pictures.

◀ 1/80 · f/5.6 · ISO 800 · 50mm

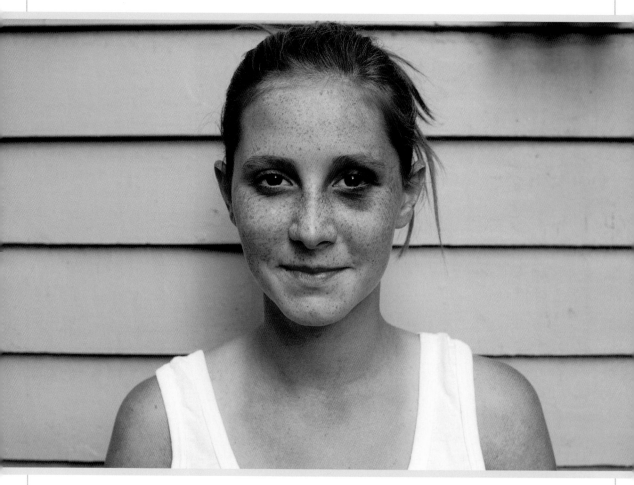

▲ 1/125 · f/6.3 · ISO 400 · 50mm

26. The Simple Mug Shot

A deadpan, funny shot provides evidence of the everyday life of kids: in this case, a lacrosse injury. For a mug-shot effect, find a neutral background, out of the sun. I used a patio wall.

TIP If there are strong lines like this in a background, keep them fairly level when you shoot. There's a Straighten tool in many computer photo programs, but it works by cropping out significant parts of the picture—a problem if your portrait is very close. Also, make sure lines don't run into the subject at a distracting point, such as the eyes.

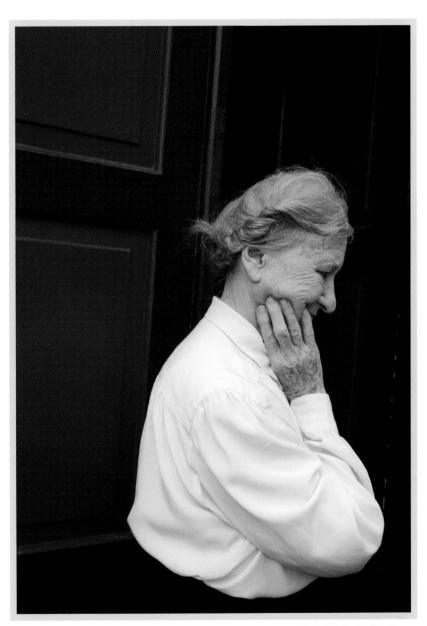

▲ 1/320 · f/7.1 · ISO 500 · 43mm

27. Negotiate with Shyness

I took this shot of a most amazing woman in Kraków. Paulina Kisielewska, then 87, is one of the "righteous gentiles" who saved Jews during World War II. She was terribly uncomfortable being photographed. Finally, she agreed to let me take a few frames if she did not have to look at the camera. So I had to engage her and not engage her at the same time—all while not speaking her language. I wanted to respect her wishes while capturing her strength and power. This shot manages to do that.

I often play a sound track in my head while I'm shooting. This time I let my imagination take over. I swear I could hear the sounds of people running on the cobblestones of the old ghetto outside her house, on those streets where 60,000 Jews once lived.

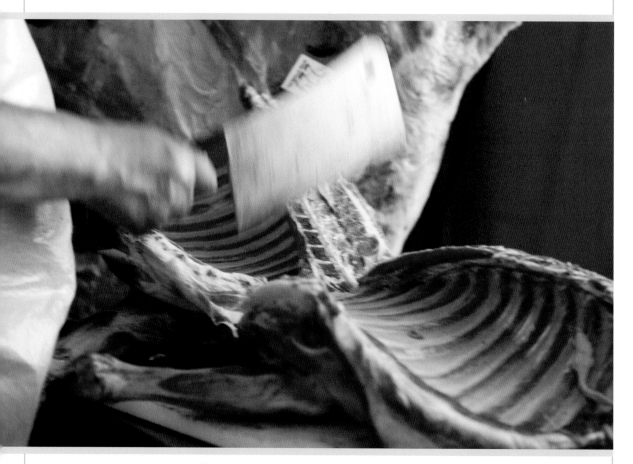

▲ 1/100 · f/4 · ISO 400 · 100mm

28. Get Close to the Grotesque

I was walking through a food market in Tel Aviv. It was hot, there were lots of people, I wasn't thinking, just looking and shooting with a lens that got me close to the action. This is a good habit when you're traveling, to just walk and shoot, walk and shoot.

 Butchery is strange and bloody, but the light was beautiful and the movement of the knife acknowledges the violence of the work.

TIP A shutter speed of 1/100th of a second yields the blur on the butcher's downswing.

△ 1/30 · f/7.1 · ISO 400 · 40mm

29. Don't Force a Smile

There is nothing more joyful than a genuine smile or moment of happiness, but there's a whole bucketful of emotions that get lost in the forced smile. Lately I have found myself asking people to simply look into the camera with their lips closed. It yields a better, more natural shot. This picture of a friend's grandmother would look strange if she had a big grin. Instead, it's a gorgeous, honest shot: not sad, just rich and interesting.

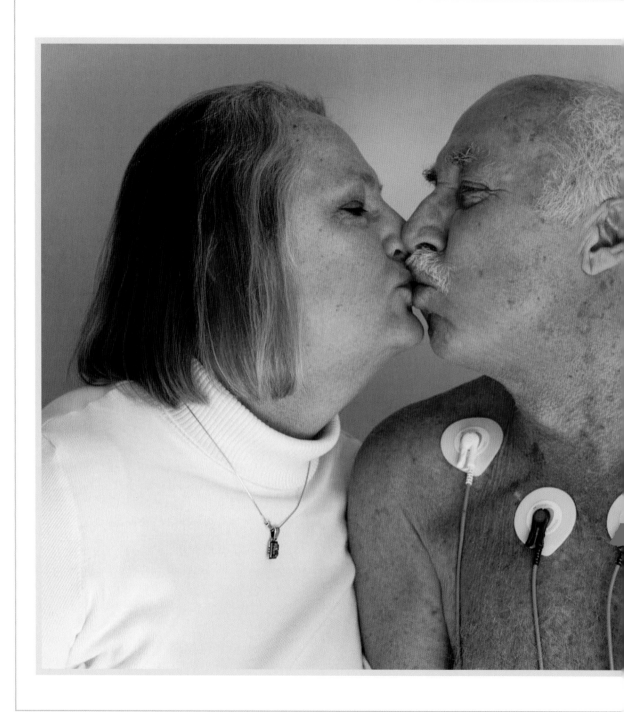

30. The Reality of Love

In this case, I was doing a health-care story near Providence, Rhode Island. I saw this sweet couple; we got to talking. It's a powerful picture because you are wondering about the state of his heart—yet you understand the state of their hearts.

TIP If you're a wallflower, you may have enough trouble just starting a conversation with people you don't know, let alone starting a conversation about taking their picture. I'm definitely *not* a wallflower; I can't really explain where I get my nerve. I can tell you that it's a good tactic to go up to a person who inspires you and tell him or her exactly how you feel; 99 percent of the time that person will agree to be photographed. Go up to almost any stranger, showing genuine interest in who he is or what she is doing, and the door flies open.

It comes down to trust. I don't take advantage of people. I'm not going to make fun of them or do anything to embarrass them. I made that deal with myself a long time ago. I may miss some good shots, but I never have to make excuses for my work. Final advice, which goes a long way: Don't be a creep.

◀ 1/100 • f/6.3 • ISO 400 • 100mm

EMBRACE INTIMACY

When I arrived at art school to study photography, I hadn't had much exposure to people who were full-time artists. Suddenly I was surrounded by students who wore their emotions on their sleeves and made art each day to the full depths of all they were feeling. It was new, unnerving, and inspiring. I came to believe—and I still believe—that this sort of creativity is inside everyone, and if you can find the connection between feeling and seeing, you can take a great photograph.

Intimacy itself is a rich part of life to explore. So many things happen daily that are emotional and loving, and they are among the things I am most interested in as a person—and therefore as a photographer. I am shooting the most intimate feelings I can find, and connecting those feelings with the world.

Two things are in play here: the intimacy between the subjects of the picture, and the intimacy between you and the subjects that comes with *taking* the picture. Photographing the intimate moments of your life, and those of others, may take you to the edge of your comfort zone, but that's where emotional creativity lives. In this chapter are a few examples of the enormous variety of human intimacy, and some tips for capturing it authentically.

1/80 · f/2.8 · ISO 320 · 57mm

31. Find the Right Distance for Intimacy

A girl can't get much closer to her sister than when she's plucking her eyebrows.
I've known these girls since they were born, and they're comfortable with my
camera, but I knew that if I were right beside them they would have turned away
and laughed. So, even though I usually like to get very close to my subjects, I stayed
inside the house; they knew I was there, but they didn't care. That's part of the
disappearing act that happens when trust is established. Yes, shooting through a
window suggests you're seeing something you weren't supposed to see, but this is
a measure of voyeurism I am comfortable with.

ABOUT THE LIGHT

This is a tricky exposure. In a quick shot like
this, you have to pay attention to the details—
the arms, hands, shoulders, faces—to make
sure that the parts of the girls in shadow are
not totally black. It's a backlighting challenge
(see page 170), requiring you to open up the
lens a bit.

32.

A SIMPLE IDEA

Get close to a big, wet kiss

1/100 · f/5.6 · ISO 800 · 100mm

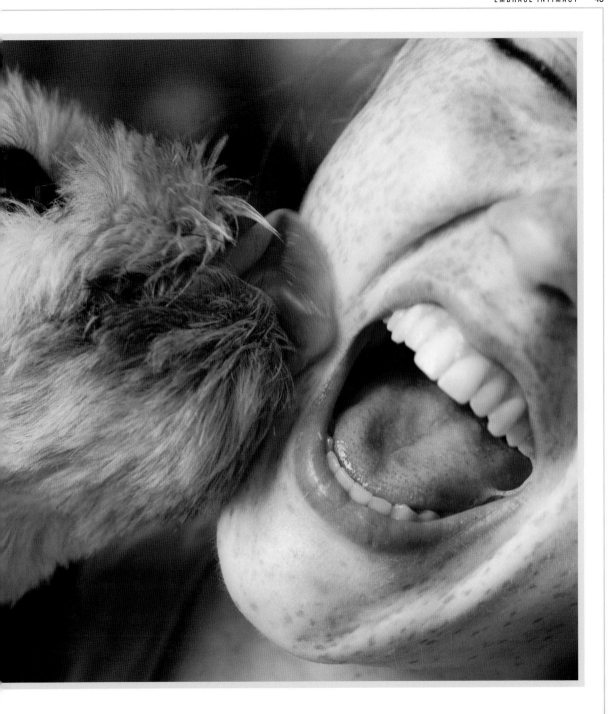

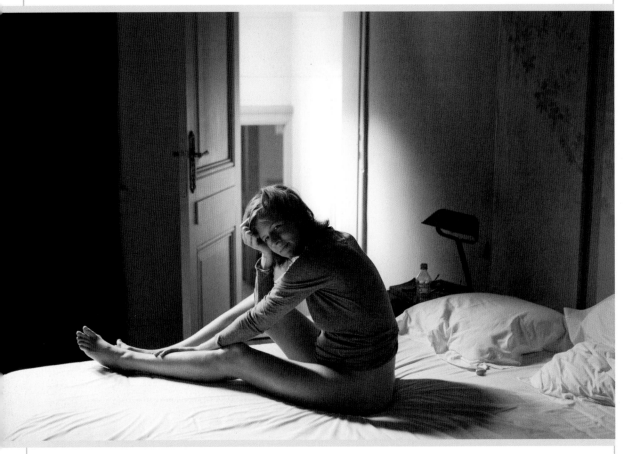

▲ 1/80 · f/2.8 · ISO 800 · 51mm

33. Intimate Secrets

Pictures like these are part of the play that fuels my personal photography. This is a completely different image for the two people in that room than for anyone else seeing it. There are a hundred whispers inside the frame and just outside of it. Nothing is said out loud. What you don't know: where it was taken, what just happened or is about to happen, and the nature of the relationship between the woman and the photographer. The one thing you do know is that she trusts him.

First, don't spring the camera on your partner. You have already agreed that pictures will not be shared or put out in the public sphere without mutual agreement. Be clear with each other about what you are allowed to shoot, knowing that sometimes rules can be broken. Adding a camera can change the dynamic in a relationship in a wonderful way. Just be careful.

◉ ABOUT THE LIGHT

The light in this shot preserves the mystery. Big windows create a beautiful glow when the light bounces off the wall and through the door. The trick is letting the subject stay sufficiently in the shadow without being hidden in it.

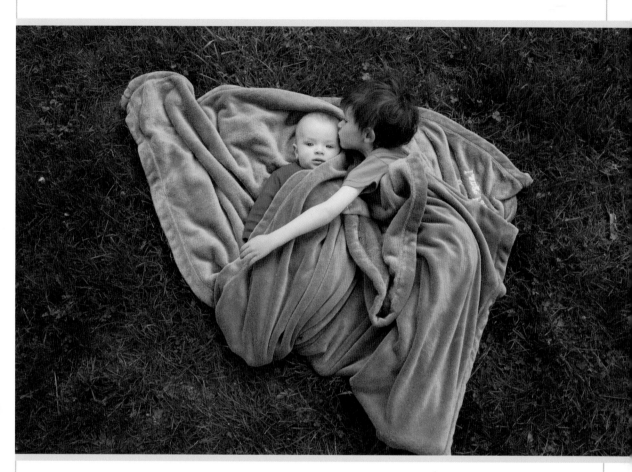

▲ 1/100 · f/9 · ISO 640 · 35mm

34. A Lucky Bit of Intimacy

I was having a really hard time getting my boys to even stay together in one shot. Finally I took a blanket out onto the front lawn and simply gathered them up.

This moment of love and protection is what I was trying to find. But it was the briefest moment. I shot it quickly from above because, for just a few seconds, I had them immobile.

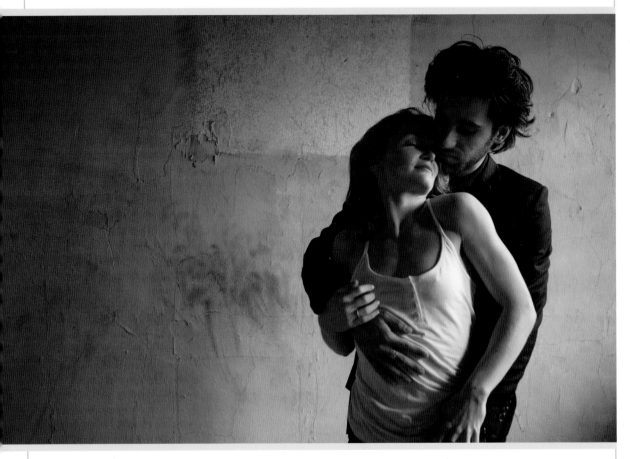

▲ 1/160 • f/2.8 • ISO 800 • 50mm

35. Ease into Intimacy

I had an incredible location for these two pictures: a room above a theater on New York's Lower East Side. Window light was bouncing off the building across the street, coming in lovely and low and soft. And I had this couple—a dancer and a French singer who were game to play. I began by shooting them from outside the room, which helped them get comfortable. I had them start at opposite sides of the room with their eyes closed, hands out, moving slowly, trying to find each other. That was my only direction; the rest was up to them. When they finally touched, they started to dance. By the time I took the picture on the opposite page, I was very close.

This sort of photo is a negotiation with the subjects, even though I usually don't know where I'm trying to take the negotiation. When I pick up my camera, I believe that I will discover something once I set things in motion, and then I will build from there.

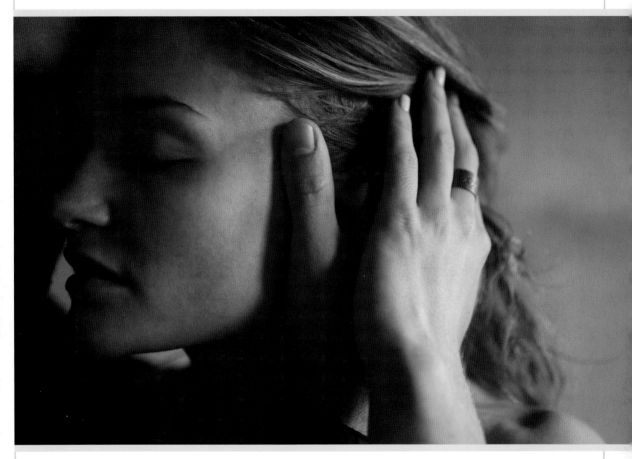

▲ 1/160 · f/2.8 · ISO 800 · 35mm

TIP Find a raw space to shoot in. It may be an attic, where there's unfinished old wood or layers of wallpaper. It might be a warehouse, or an abandoned building. Any room where there are layers of texture, evidence of history, will make a good shot. Often the light will be dusty, adding mystery and beauty to a picture.

Finding a space like this is not hard. Imagine shooting someone you love in such a beautiful environment.

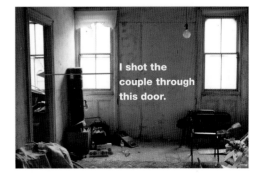

I shot the couple through this door.

36.
A SIMPLE IDEA

Intimate
details
speak
volumes

▶ 1/60 · f/4 · ISO 800 · 50mm

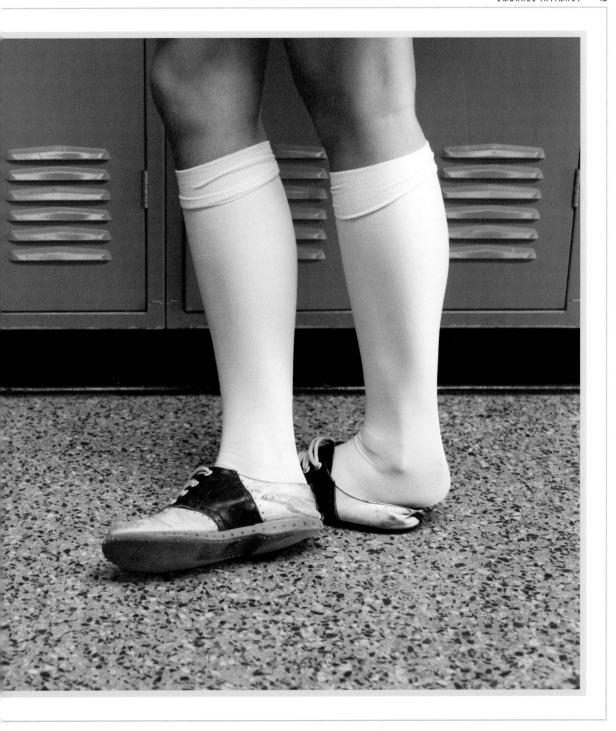

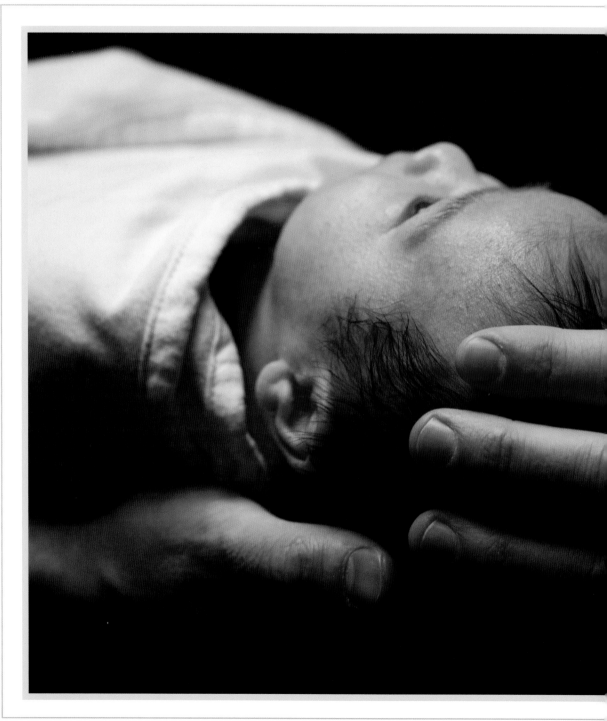

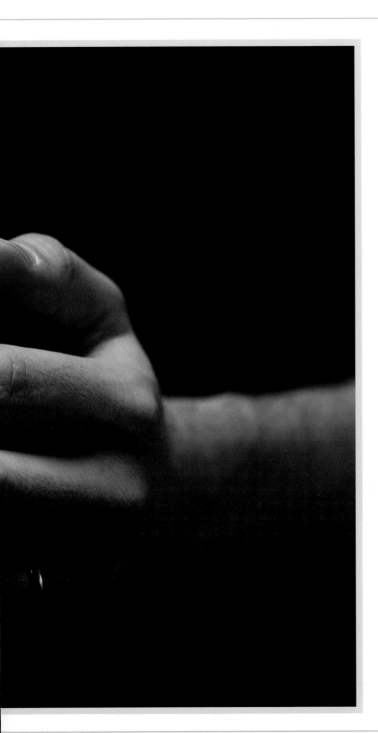

37. Find Intimate Light

This was shot in a rather dark apartment, with the only light coming from a skylight, which gives the picture its beautiful lit-from-above look.

I focused on my cousin's hands and let the rest of the picture fall away. For this I used a macro lens, which lets you get incredibly close (many cameras have macro settings). Sometimes I joke with my subjects that I am not shooting surfaces but capturing their souls. I want to get in that close.

☀ ABOUT THE LIGHT

The thing to remember about a patch of light is that you can move things in and out of it until you get an interesting effect. The instinct is to be directly under the light, but try moving just out of it, so that it hits at an angle—more gentle, more luminous, more appropriate for a moment like this.

◀ 1/60 · f/4 · ISO 500 · 100mm

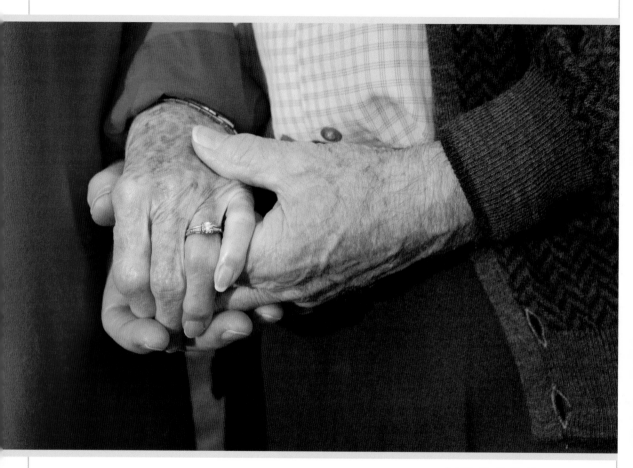

▲ 1/125 • f/8 • ISO 200 • 70mm

38. Just Hands

Our Aunt Kay was 93 when this was taken. She did not like having her picture taken at all. "I'm too wrinkly," she would tell me. Uncle John, on the other hand, loved having his picture taken, so that helped. I posed them, took some shots, and then just went in on their hands.

This is a bit of a nod to my teacher at art school, Wendy MacNeil, who often shot only the hands of her subjects. Her pictures were haunting.

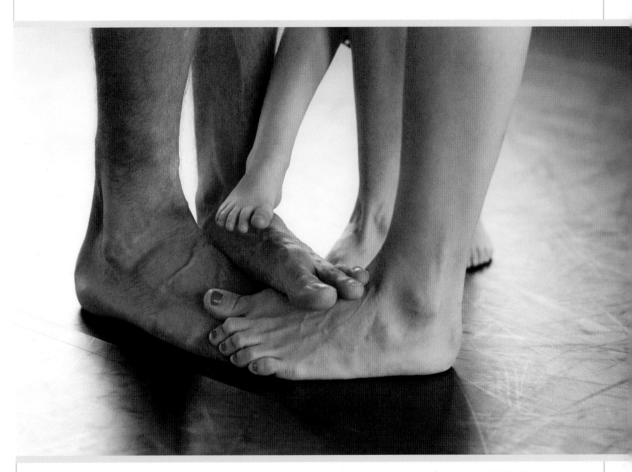

▲ 1/320 · f/3.2 · ISO 800 · 85mm

39. Just Feet

I took my son to a dance rehearsal that I was photographing. Soon he was trying to get in on the action, dancing all around the room, but I love this tight shot most of all. A picture like this, a small slice of a much bigger scene, is an act of visual editing, something you need to figure out how to do with your eyes while you're shooting. Here in this big, brightly lit rehearsal space at the Baryshnikov Arts Center in New York, there was a small, sweet moment happening. And then it was gone, save for this picture.

40.
A SIMPLE IDEA

Get intimate with food

1/60 · f/6.3 · ISO 800 · 50mm

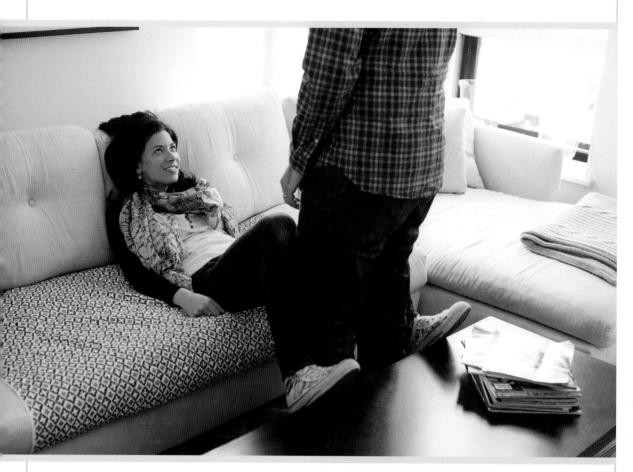

▲ 1/100 · f/3.2 · ISO 500 · 50mm

41. Vanishing from the Shot

I love when I completely disappear: Even though I'm in the room taking this picture, it feels like we're witnessing two people who are completely alone. To achieve that effect, I needed to have the complete, relaxed trust of the subjects, who let me observe the moment. Later, when I showed the picture to the couple, they said, "This is exactly who we are. This is exactly how we touch each other and talk to each other." If I had directed Sam and Erika, it never would have looked like this.

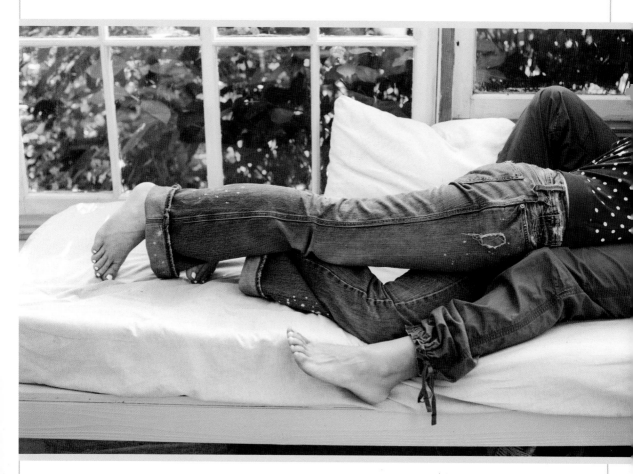

▲ 1/80 · f/3.5 · ISO 250 · 50mm

42. Half-Hidden Intimacy

Often, showing only a part of what is going on allows you to tell more: This was shot on assignment for a marketing piece about LGBT lifestyle. I wanted to show the couple being intimate with each other, but the mainstream company wanted a discreet picture. With this photo, which was shot in a backyard guestroom at a summer home that was all windows, we each got what we wanted.

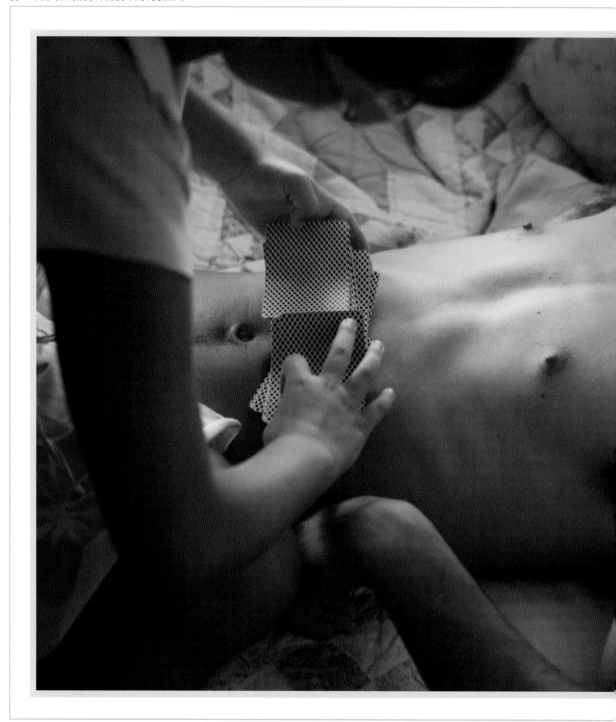

43. Intimacy and Unintended Meanings

Some people see this shot of a young girl playing cards on her cousin's stomach just as it is: entirely innocent. Others detect echoes of less-innocent fashion advertising. You can't control the reading, but you have to be aware of the varieties of interpretation.

Pictures are not truth, and when you put them out into the world, they find a life of their own. The social media world is an instant publishing machine with no foolproof delete button, so I take this responsibility very seriously. I'm trying to get people to reveal themselves, but it is my job to let them know if they're revealing themselves in a way that is not obvious to them when they're posing—or, as here, not posing, just playing.

COMPOSITION

How you frame a picture changes its meaning. The shot that I took closer in accentuates the intimacy. Neither of these shots was cropped afterward.

▲ 1/60 · f/2.8 · ISO 400 · 35mm

◀ 1/60 · f/2.8 · ISO 400 · 60mm

MOVE YOUR EYE

I n a world saturated by images, we are powerfully influenced, almost pro-grammed, to take predictable pictures—to slot subjects into conventional poses and places. Instead, you want your pictures to show what makes you you. Keep moving until you find the place where, suddenly, you're seeing things differently. Forget about what is right and be open to being seduced by what you might have thought was wrong. Always be hunting for a new angle.

You never want to feel like your feet are planted in one place, that you are locked at eye level, standing up. If that happens, you risk falling into the trap of believing you have found the right picture much too early, and then you just take a lot of shots from that single point of view, over and over. Move your feet, bend your knees, get your pants dirty. Get low. Climb above. Don't zoom the lens unless you have to: Move your body to move your eye. Push your camera right into things.

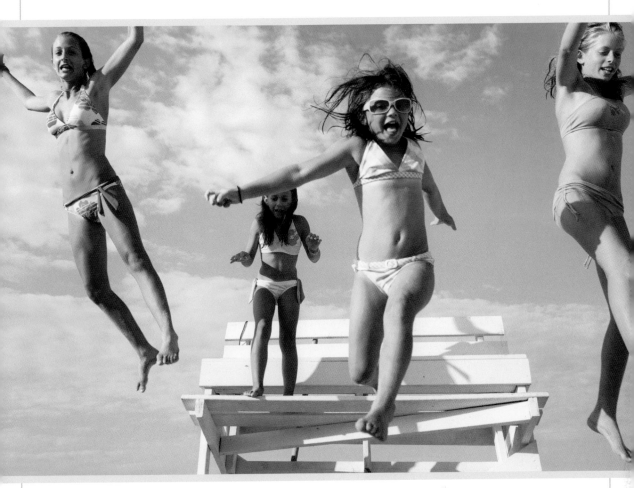

▲ 1/640 · f/6.3 · ISO 160 · 38mm

44. Move into the Action

This shot was something I couldn't have cooked up—it seems too dangerous. These girls (mostly my friends' kids) were already jumping off a lifeguard stand down the beach. It was ten feet above the sand. They kept jumping, and I started shooting. The key was to get in real close, with a slightly wide-angle lens, and just fill the picture with jumping girls—at a fast shutter speed to freeze the action. One of the things I love most is the girl, Emma, who is hanging back, having her own moment, afraid to make the leap. She gives the fearlessness of the others more impact. I made no attempt to have them look at the camera—it's not about that.

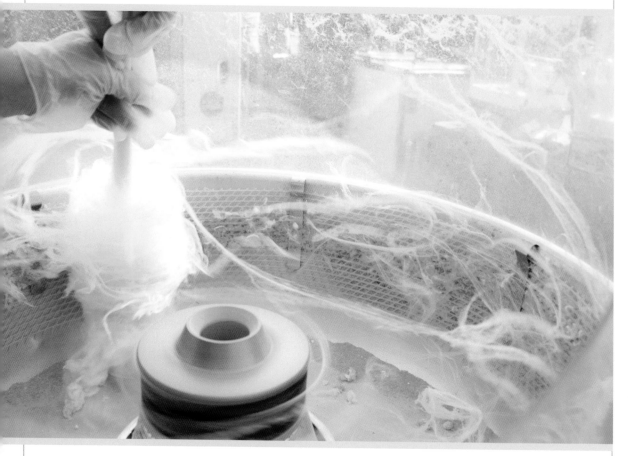

▲ 1/160 · f/9 · ISO 640 · 35mm

45. Move Right Inside the Machine

We were at a spring cherry blossom festival in New Jersey, and everyone was shooting the pink trees, but I found the pink of this cotton candy more interesting. I asked the vendor if he minded, then put my camera inside the machine. The air was full of sticky sugar.

☀ ABOUT THE LIGHT

This shot is lit from all sides, so judging the exposure from outside the machine wasn't a good bet. I stuck the camera in, pulled it out, checked the exposure, and stuck it back in again.

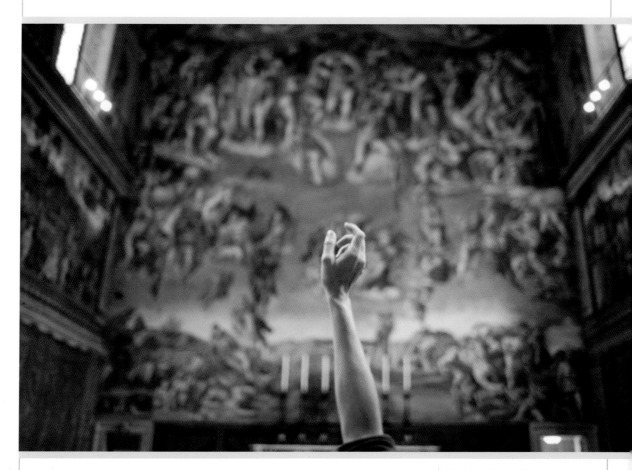

1/100 • f/1.6 • ISO 800 • 35mm

46. Move Past the "I Was Here" Postcard

You can buy a thousand postcards outside famous landmarks that do the job of identifying the place you've visited—why duplicate them? How can you personalize an experience in a well-known place? Of course, I was privileged even to shoot in the Sistine Chapel—it's usually banned. But a client got a private tour, and I tagged along. Believe it or not, I asked if they could turn on the lights! With the flip of a switch, the normally dark chapel lit up like a football stadium. The personal part is the angle: I photographed the hand of the guide gesturing toward the image of God reaching out to Adam just above where we were standing. The personalization principle applies everywhere: Move your eye until you find an angle, a subject, that makes the experience yours.

TIP With an SLR wide-angle lens that's wide open, you can achieve shallow depth of field against a big frame. With a point-and-shoot it tends to be more difficult. Read more about depth of field on page 315.

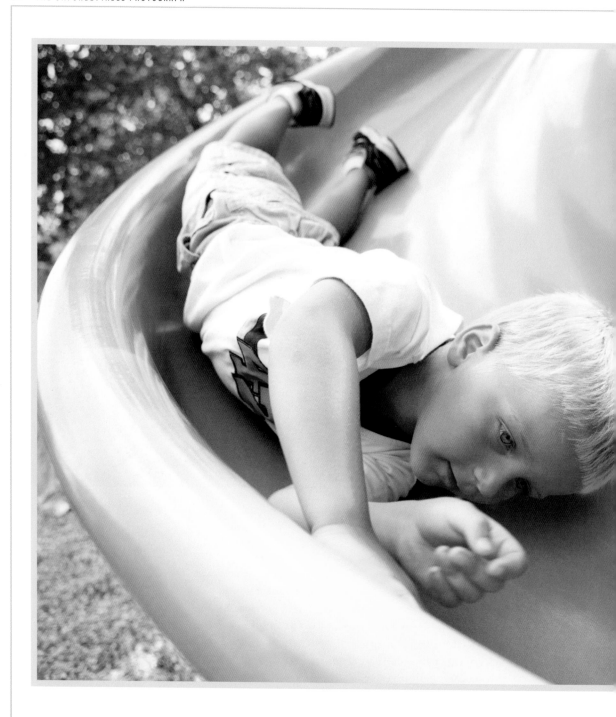

47. Move to a Tight, Simple Angle

Getting tight on the creamy, curving slide as the boy slips by eliminates a lot of background noise. It's like he's moving down the inside of a seashell.

This is one of those pictures where I found the angle and focus, then just pointed the camera at one place and waited for the kids to pass through.

1/250 · f/4.5 · ISO 250 · 24mm

48. Move to a Fresh Angle on the Action

Framing this shot low, without the ball, focuses the eye on the beauty and rhythm of the girl's movement in a funny way—and keeps the photo from being just another beach picture. It's good to get in the habit of moving your camera from where you think it *ought* to be.

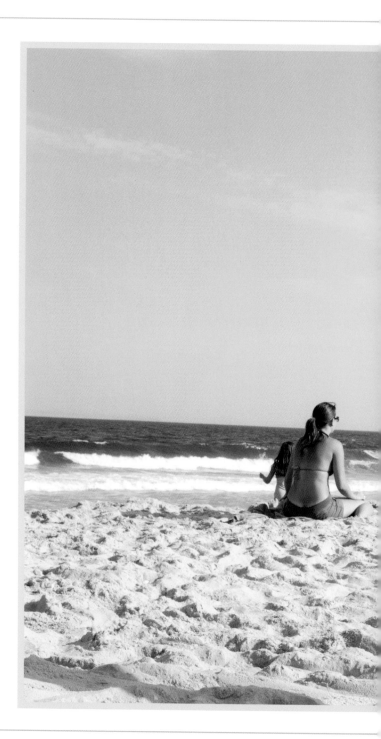

▶ 1/500 · f/13 · ISO 250 · 46mm

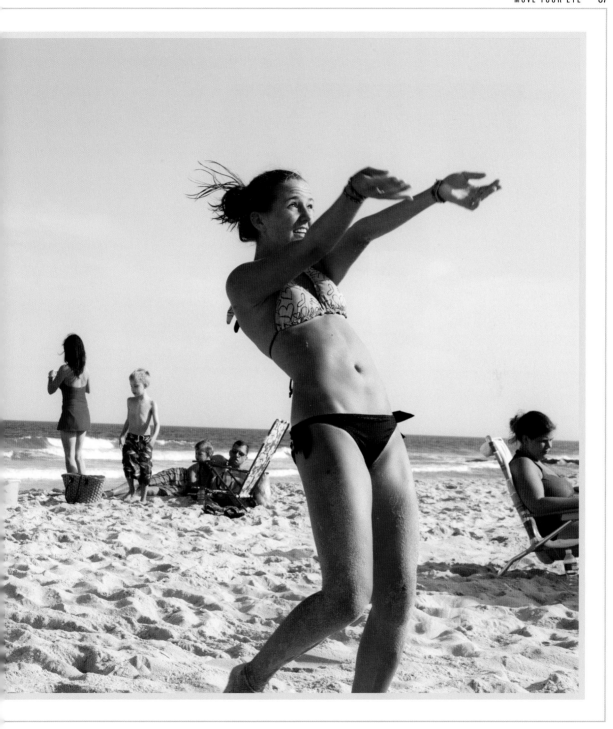

▲ 1/160 · f/7.1 · ISO 800· 50mm

49. Move in Close, #1

Many people love telephoto lenses. I use them occasionally, but not for technical reasons: for emotional proximity. Getting close requires confidence, but it's essential, and you have to work at it until it's natural. The more you do it, the more you'll find that your camera disappears—and, with it, your self-consciousness. I am also pretty good at moving in and getting out before people even know what I'm up to.

One tip I learned from my father: He looked up over the camera to make eye contact with the subject, so that the subject was looking directly at him rather than the camera.

▲ 1/160 · f/4.5 · ISO 800 · 100mm

50. Move in Close, #2

I often hold the subject's hand in one of mine when I'm shooting, and shoot with the other.

51.
Move back

If you can get a small child to pose, you can pull back and get a picture like this. The distance produces a poignancy, all the more so if the setting is a little unexpected, like this unused Tennessee porch.

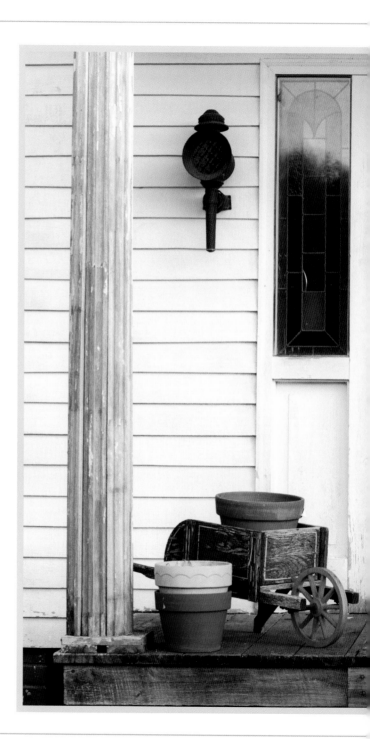

▶ 1/100 · f/7.1 · ISO 800 · 85mm

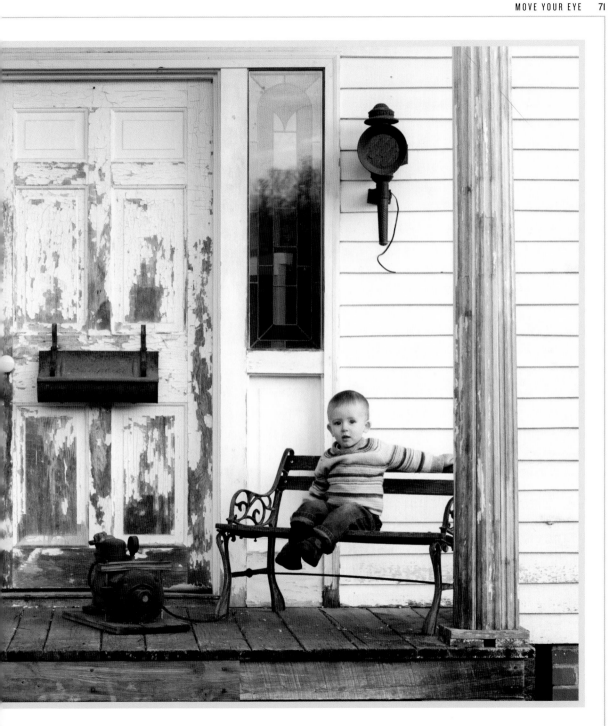

52. Move Around, 90 Degrees

I took a friend to get a shave at Aidan Gill, the great old-fashioned barbershop on Magazine Street in New Orleans. This is a good way to get interesting pictures— treat friends to a special experience, in exchange for the sound of your camera clicking. I took a lot of shots, but this is my favorite. The predictable angle might be from his side, but here I walked around to get the long, foreshortened view, with a lot of him out of focus.

☀ ABOUT THE LIGHT

This was shot with ambient light only. A wide-angle lens, with the aperture almost wide open, at f/1.8, produces the shallow depth of field that focuses the eye on the bliss of the warm towel.

▶ 1/125 · f/1.8 · ISO 800 · 35mm

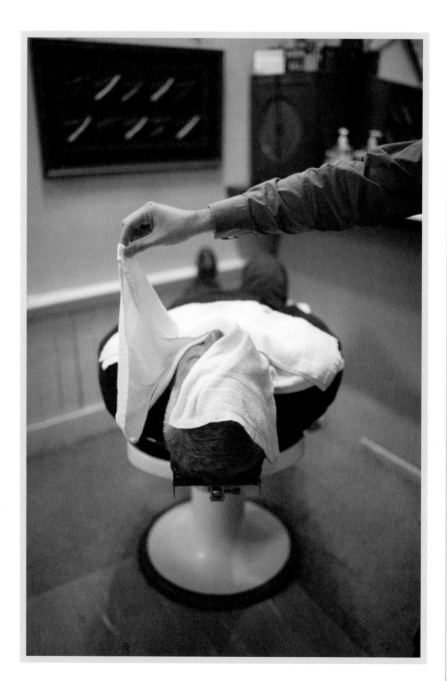

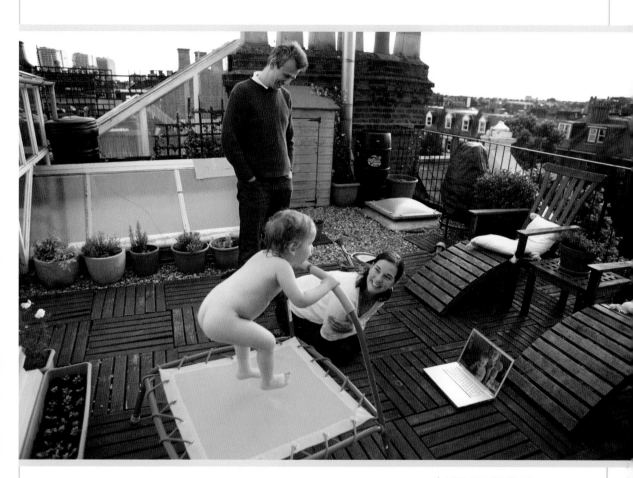

▲ 1/500 · f/3.5 · ISO 400 · 24mm

53. Move Up and Back

It's a small story: A family on a London rooftop talks to faraway friends in New Jersey on a laptop using Skype. The usual shot would be tighter: computer and family, with extraneous details removed. This photo pulls back and up to take in the complicated rooftop scene and the city beyond. Often a picture like this will fall apart into its details, unreadable, but that doesn't happen here because of the slightly elevated composition, shot with a wide-angle lens—somehow it takes in the whole sweeping scene but still seems close to the action.

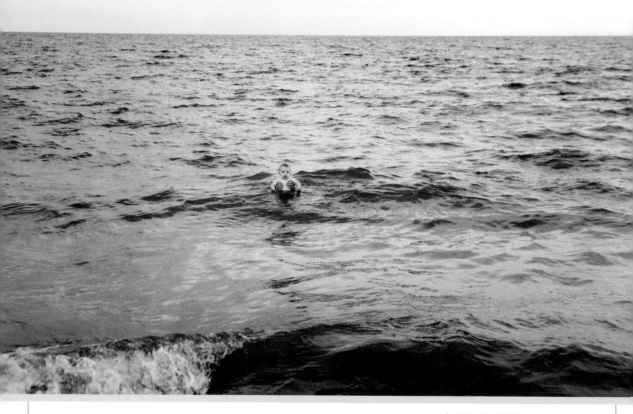

▲ 1/200 • f/8 • ISO 800 • 70mm

54. Move Very Far Away

My first rule of thumb for shooting people is to get close. My second rule is to break the rules. Pull back, sometimes *way* back. This produces a feeling of separation and isolation—not only in the subject but in the viewer.

In this case, a father holding a child, who's bobbing in a gray, empty ocean—just an expanse of scenery, immense, with no frame to the picture—produces a paradoxical sense of being there. It's all about scale, and it's all about distance.

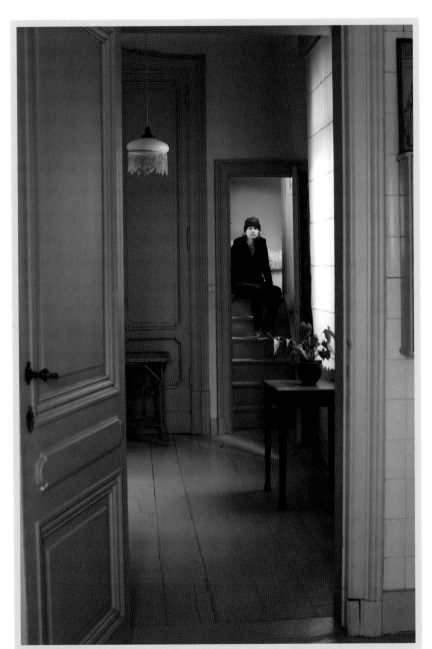

55. Move Way Back, into Another Room

By pulling back, I'm shooting through two doors, a room, and a stairway before the eye comes to the subject, and it's an entirely different sort of portrait, but gorgeous in a setting like this, with light like this—evoking a powerful sense of place.

☀ ABOUT THE LIGHT

This is a long, ⅓-second exposure using a tripod. That allowed me to get the aperture to 7.1, so that most of the photo is in focus, using only natural light. By using a manual aperture mode on a point-and-shoot, you could duplicate this shot—with a tripod.

◀ .3 seconds • f/7.1 • ISO 320 • 50mm

56. Move Outside and Shoot In

The cappuccinos at Stumptown Coffee in New York are hard to tear yourself away from, but I stepped outside and ended up taking one of my favorite pictures ever—the sort of shot that street photographers often capture of strangers but few people take of their own family members.

I love it because of how much is going on: my son looking one way, my brother checking something else out, a person walking on a street, a cab in the road, the people inside, and the reflection of the building. The reflective and transparent qualities of glass make this possible; it's like a multiple exposure, with everything flattened.

☀ ABOUT THE LIGHT

There's a lot of information coming at your light meter with a shot like this, so it's a good idea to use a spot meter (pinpoint) setting and expose for the critical detail, in this case the faces of my son and brother.

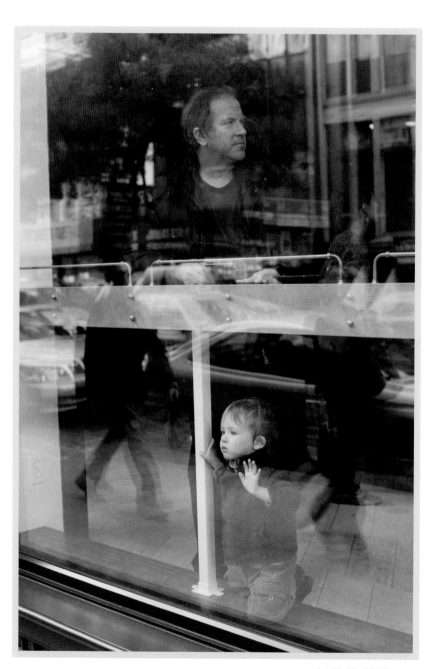

▲ 1/80 · f/5 · ISO 640 · 50mm

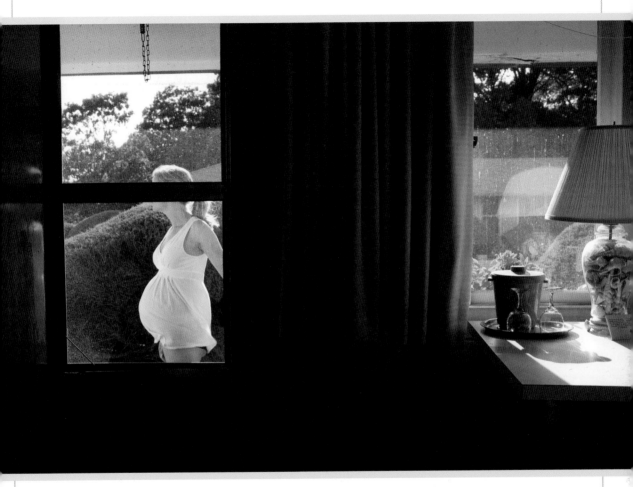

▲ 1/125 · f/8 · ISO 250 · 35mm

57. Move Inside and Shoot Out

We were staying at a great '50s-style motel on the North Fork of Long Island. I wanted to show the interior while using the light that was outdoors, too. I love how graphic this shot is, how mysterious, somehow voyeuristic—probably not "right" for a shot of my very pregnant wife, but that's where you end up when you play. Having Stephie's eyes X'd out by the window; having the large expanse of curtain between her and the banal interior of the lamp and ice bucket: An everyday moment, suffused with mystery.

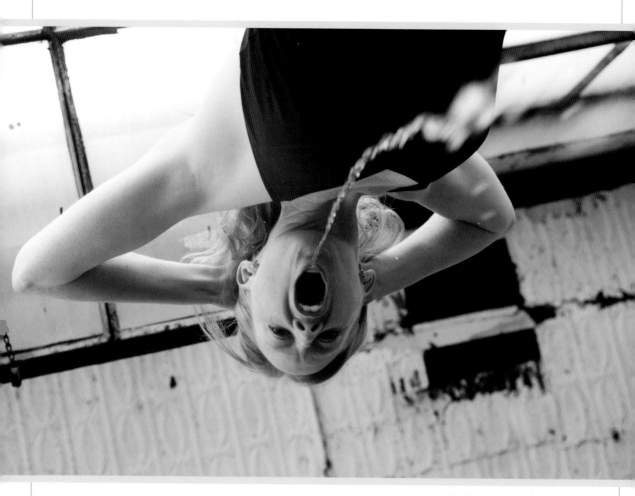

▲ 1/100 · f/5.6 · ISO 400 · 70mm

58. Move Down, Look Up, #1

Now this is an angle that really throws off the viewer's eye: It seems upside down. I'm lying on the floor, shooting up.

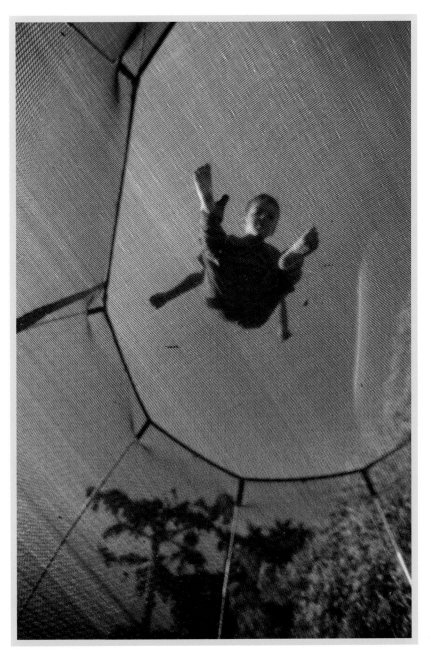

59. Move Down, Look Up, #2

Although a trampoline looks opaque from the top, I discovered a whole different view from below. I'm lying on my back here while the kids jump, and it's scary: At the bottom of each bounce, their feet are about an inch from my lens.

Shoot lots in a situation like this, especially with a point-and-shoot, which has shutter delay—it's hard to capture a particular moment.

TIP With a shot like this, you have to move to manual and pick your point of focus—or the camera will just focus on the thing immediately in front of you, the mesh. Pick your focal point, and wait for the subject to move into it.

◀ 1/640 • f/2.8 • ISO 800 • 21mm

TRY THIS

60.
Move under- neath

The inspiration for these pictures, taken at a community pool, was Aaron Siskind's "Pleasures and Terrors of Levitation"— photos from the '50s showing athletes on a trampoline isolated in midair, bodies twisting. The effect, removing the subject from context, placing it against an enormous sky, is about falling, even horror. I look at these pictures and can't help thinking of 9/11.

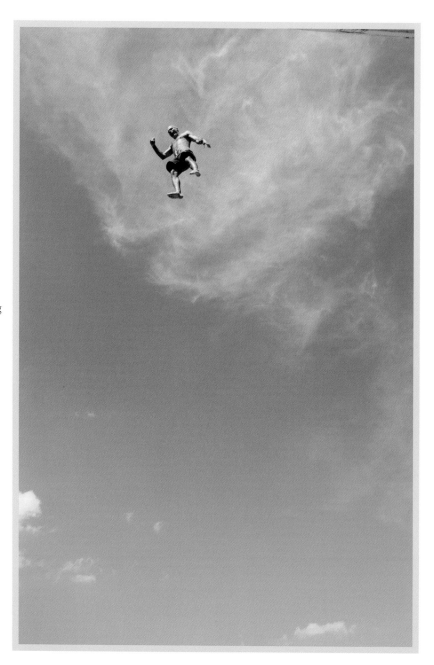

▶ 1/1000 • f/10 • ISO 500 • 35mm

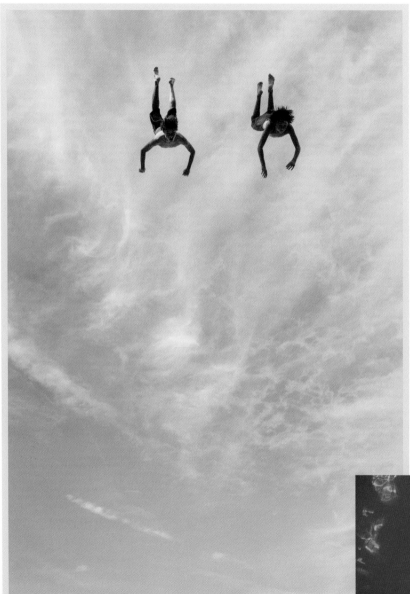

There were challenges. The divers did the same thing over and over, but I had no control over the timing. I couldn't see when they were jumping; I had to lie there under the platform, focused, waiting until a person plunged through my viewfinder. There were long gaps between each jump.

These two shots, from hundreds I took, were photographed a week apart.

TIP Me, lying right below the diving board. The shutter speed is very fast to completely freeze the divers against the sky. The wide-angle lens produces the vast sky.

◀ 1/800 · f/8 · ISO 500 · 32mm

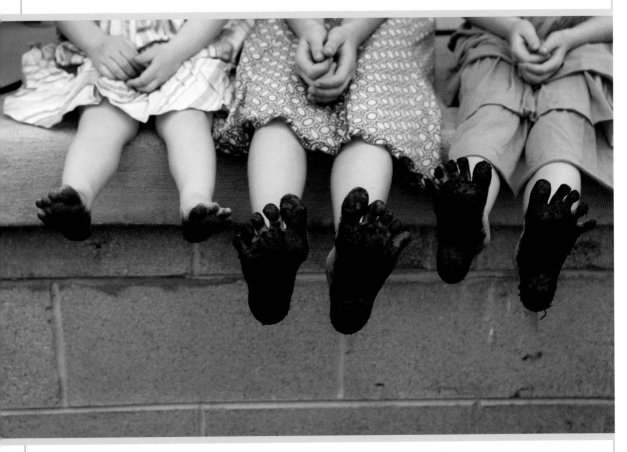

▲ 1/400 · f/6.3 · ISO 200 · 70mm

61. Move the Subjects Up

Here kids are elevated, their heads cut off, for a happy picture of mucky feet that run right
through the middle of the shot.

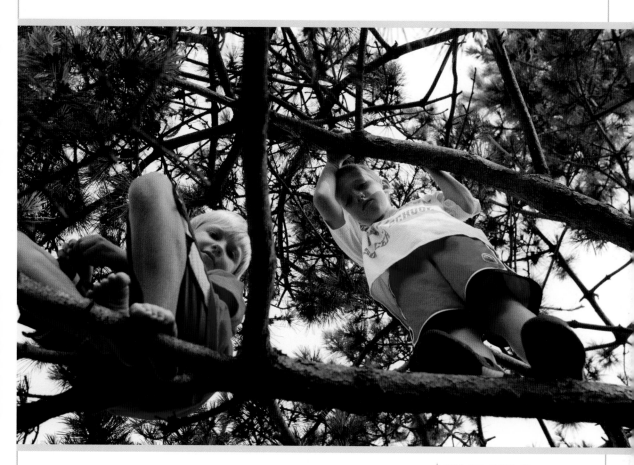

▲ 1/160 · f/5.6 · ISO 250 · 52mm

62. Move Below Your Subjects

Children are busy creating worlds that we are not invited into. Negotiating your way in with a camera requires that they not feel manipulated, but part of the process. They need to feel either equal to or more powerful than you. Being below them accomplishes that. They're feeling a little superior up there.

☀ ABOUT THE LIGHT

In the middle of the day, the light usually isn't interesting. But in a tree, filtered through branches and needles, it can be.

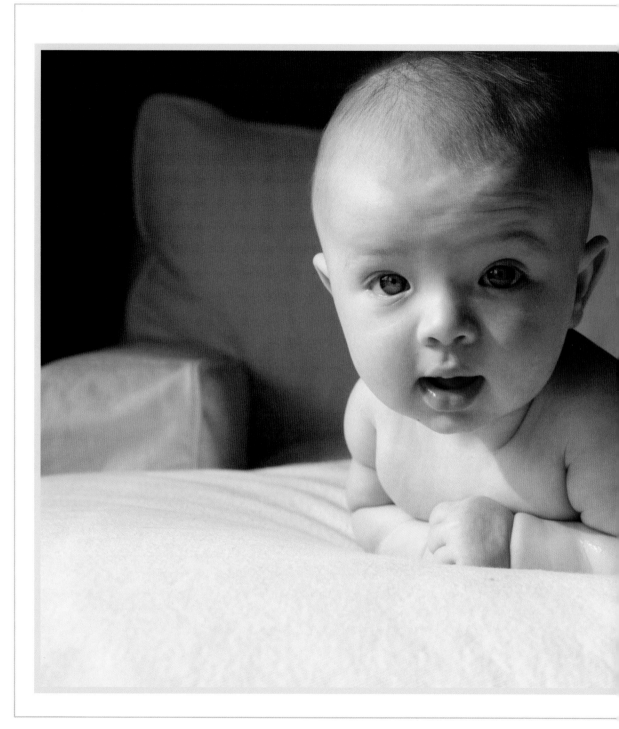

63.
A SIMPLE IDEA

Move to baby's eye level

1/250 · f/9 · ISO 500 · 50mm

64. Drop to the Floor

Shots of kids from an adult's eye level are rarely interesting. Get your pants dirty and bring the camera down to their altitude. The effect is to enter their world on their terms.

Toddler's-eye view

⟶

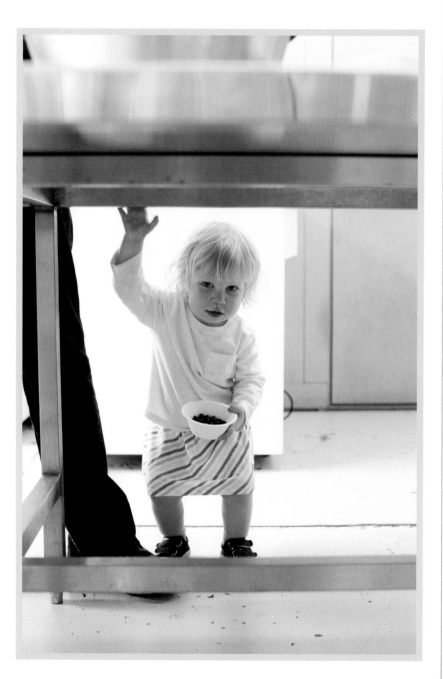

▶ 1/125 · f/4 · ISO 640 · 50mm

Dog's-eye view

→

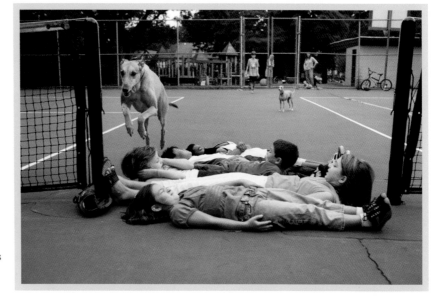

▲ 1/640 · f/4.5 · ISO 200 · 42mm

65. Move to the Main Subject's Eye Level

With shots like these, you don't know what you have until you review the images afterward. Shoot lots, trying to keep your focus on the thing, the person, or the animal that *is* the focus.

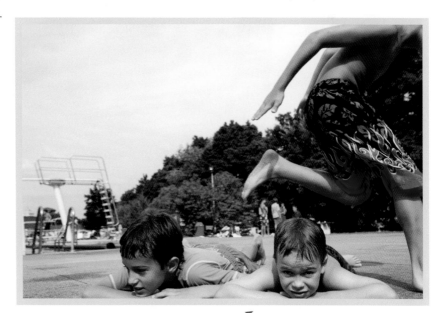

Kid's-eye view ↗ ▲ 1/1000 · f/8 · ISO 500 · 38mm

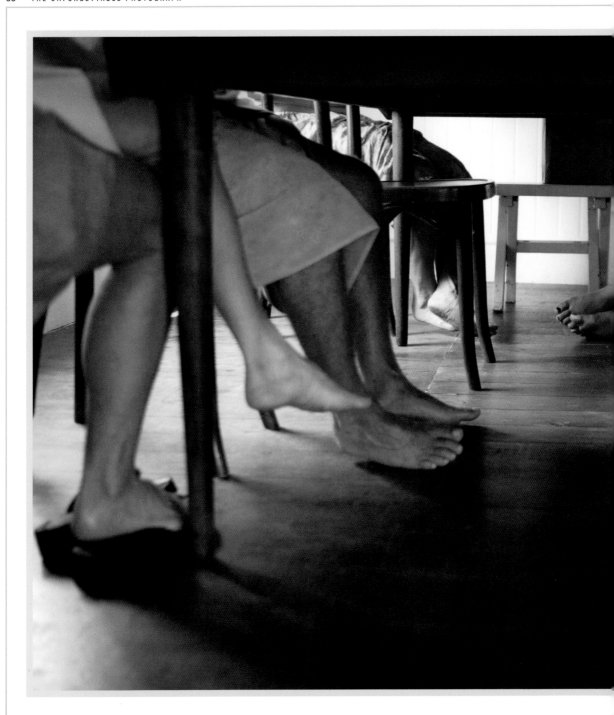

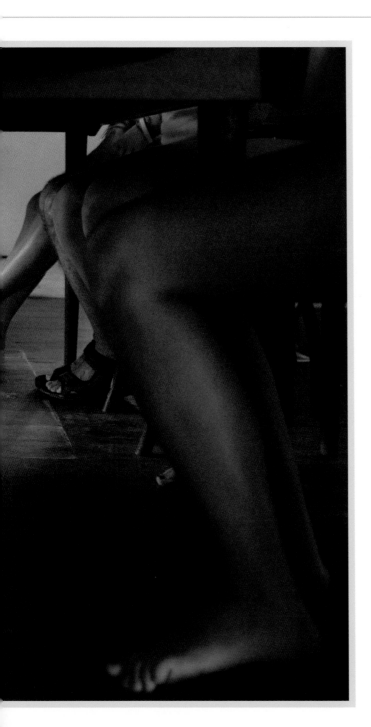

66. Move to an Unexpected Place

I just got under the table and started shooting in a place that most people, except babies, never see. Summer, beach house—not a big day for shoes.

1/50 · f/2.8 · ISO 800 · 38mm

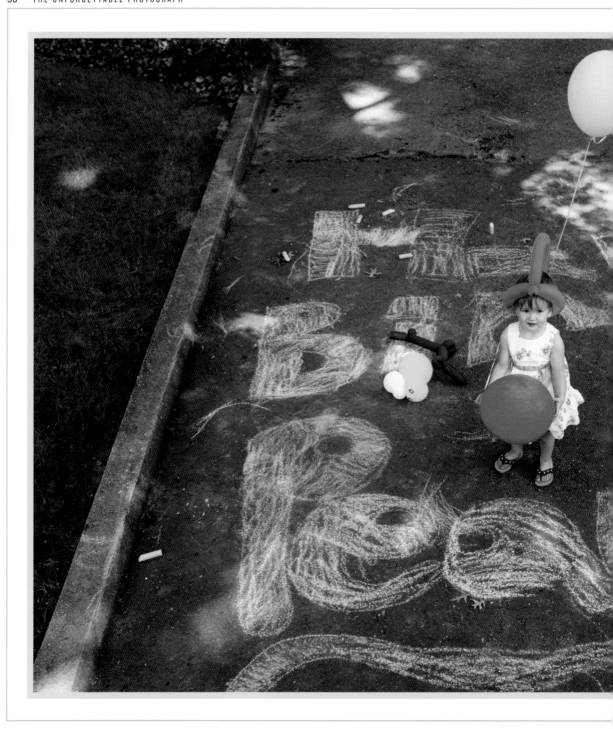

67.
Move to a bird's-eye view

Climb a ladder, step onto a chair, go to a second floor—shooting down provides an interesting view. Here a wide-angle lens exaggerates the effect.

◀ 1/125 · f/7.1 · ISO 500 · 35mm

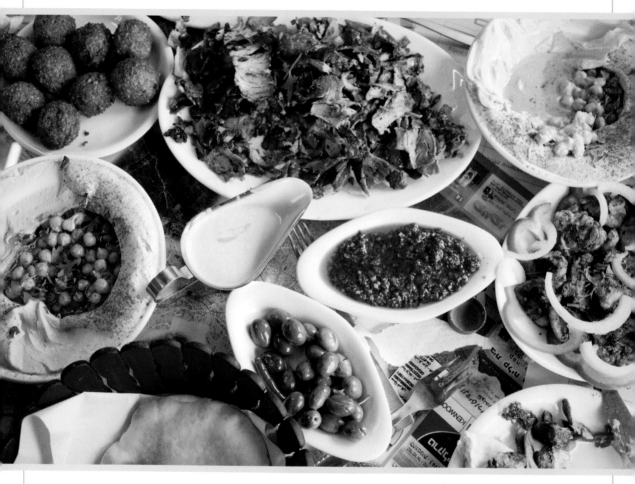

▲ 1/125 · f/5.6 · ISO 800 · 35mm

68. Move Your Body Over Your Subject, #1

Shooting from above is a simple way to eliminate the background and get an interesting picture: We don't usually look at the world this way. But it's easy when shooting from above to not lean over *quite far enough*—and then the perspective gets weird. Put your whole body into it and compose the picture with your eye.

Everyone who looks at this picture wants to eat this meal, wants to be the people who sit down to it—even though the food itself doesn't look particularly unusual. It's a typical lunchtime feast in a small Israeli town.

TIP I wanted the frame bursting with food, and some of the food to be hidden from view. And yes, I did move the dishes together a bit to get that overflowing-table effect. It's okay to intervene now and then like this. Just be sure you're actually improving the picture and not compromising the integrity of the moment.

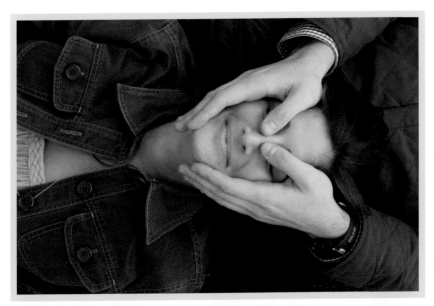

▲ 1/60 · f/6.3 · ISO 800 · 50mm

69. Move Your Body Over Your Subject, #2

With people, as with food, if you shoot from above but hang back a bit it can make the shot feel slightly off, a near miss, not quite "true" in the sense that a plumb line is true.

TIP Watch the angle of your subject's head. If it tilts back too much, it looks odd. (I've done this type of shot a lot with celebrities, and I put something underneath their heads to prop them up a bit. You don't want to be looking up their noses.) Most of the time I have people close their lips, too.

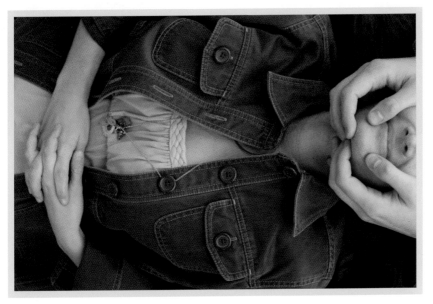

▲ 1/60 · f/6.3 · ISO 800 · 50mm

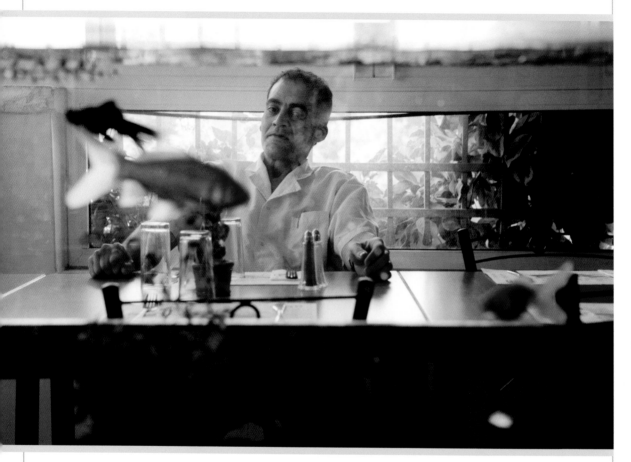

▲ 1/60 · f/5.0 · ISO 800 · 70mm

70. Move Around the Room

In most rooms there's a way to fall back and shoot from a new angle, often by shooting through things. I was at a restaurant in an Arab town in Israel, just shooting around the restaurant after a great lunch. This man was the owner and I followed him all around the room as he counted money, talked on the phone. Then I went behind the fish tank, where things got a lot more interesting. The light comes from both the side and the back, and the fish swim by.

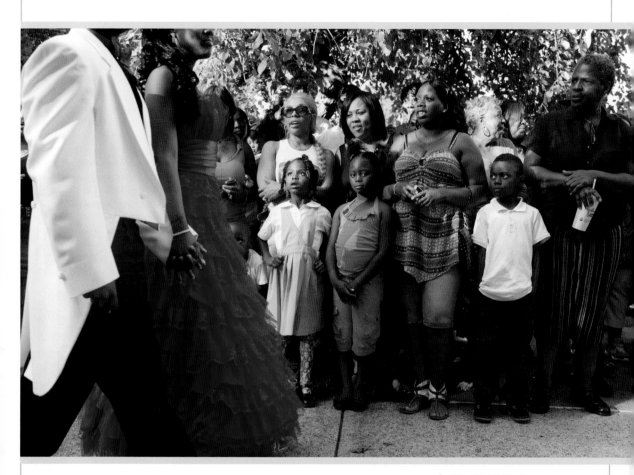

▲ 1/250 · f/5 · ISO 640 · 35mm

71. Move Your Eye Away from the Main Subject

I was invited by a friend, Jon Fisher, who teaches high school photography, to a park where students going to the prom paraded by. I got down low and shot the people watching the people, which was more interesting to me, leaving just enough of what they were watching to let the viewer in on the story.

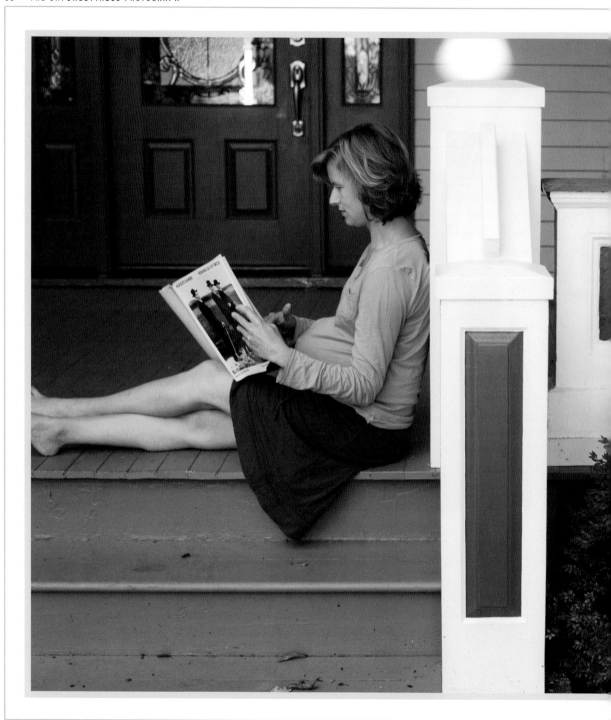

72.

Move your eye off-center

Here's an example of the good that can happen when you shift the subject to the left or right of center and use other elements in the shot—lines, rectangles, colors—to create a lot more visual interest than a simple shot straight up the stairs would have produced.

◄ 1/125 • f/5 • ISO 640 • 50mm

SEE THE LIGHT

f someone looks at one of my pictures and says, "Wow, the light is beautiful," I feel like I have failed: I don't want my pictures to be about light or composition or technical tricks. I want my pictures to be about stories, people, ideas, feelings—anything but their formal qualities.

Still: Light is the photographer's palette and toolbox, a kind of visual thesaurus that offers a thousand ways to portray the same scene or subject. It has predictable habits and favorite hangouts—which you should get to know, especially in your home. Yet it constantly surprises. It's restless, always changing, moving on. It skims, dances, passes through, bounces off, often all at once.

Light for me is joy, and a well-taken photograph holds that joy. So learn to play with it. Use light in the "wrong" ways. Underexpose pictures—there's almost never too little light for a picture, and each year brings new cameras that are even better at capturing the smallest amounts of light. When you're done with that experiment, blow pictures out with "too much" light.

In the end, there are two important things to know about light, and they're connected. First, you do have to pay attention to it, or you'll miss its subtleties and moods. And second, as you experiment, take your camera off its automatic settings and get it in sync with what you're actually seeing and feeling. Even with a phone camera, by the way, it's possible to manipulate light and shadow; by touching (in the case of the iPhone) different parts of the photo on the screen, the exposure will radically change.

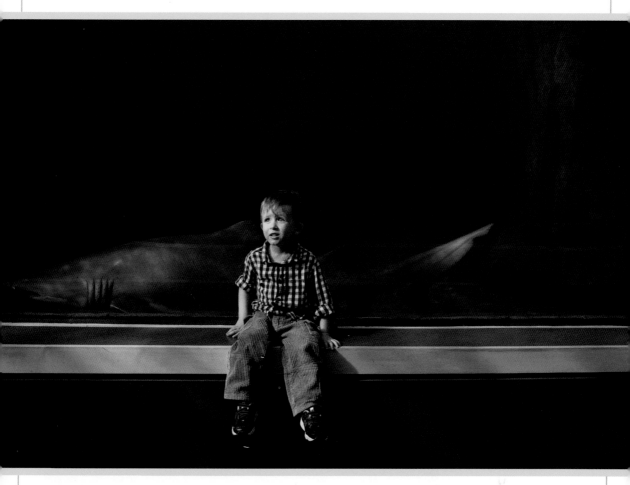

△ 1/100 · f/11 · ISO 640 · 35mm

73. Glass without Reflection

This was shot at the Pittsburgh Aquarium. I set Jackson on the ledge and waited for the shark to come around. What I love about this is the terrible look of the shark and the innocent look of the boy, contrasted by the hard light on Jackson, with the shark softly lit behind.

You often have to negotiate with glass to keep your reflection out of a picture. As long as the subject is brighter than you are, it generally works out fine. It helps to be wearing black, or to shoot from the shadows, or at an angle that avoids showing your reflection. In this case, the light was pouring down from a fairly steep angle and then heading down at the same angle—not coming back at me.

74. Remember, There's Almost Always Enough Light

There is no perfect amount of light, and rarely too little light for a picture. I keep my eye out for little sources. Just the glow of an iPhone or the candlelight in a dark bar can be enough. I love the three-dimensionality of this shot: my son tucked inside a big velvet chair, the champagne in the bucket, and the restaurant in the background. Try layering your shots with detail, while still staying focused on what the shot is about.

TIP Just 1/8th of a second exposure with my point-and-shoot camera, ISO at 800: Yes, it's "noisy," but it's beautiful.

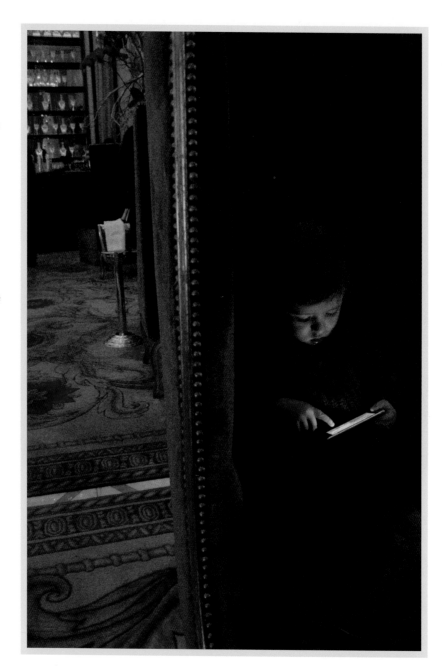

▶ 1/8 · f/2.8 · ISO 800 · 7.4mm

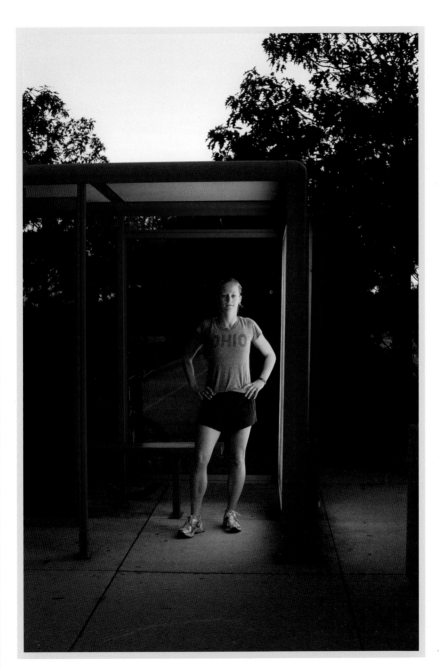

75. Never Stop Looking for the Right Light

I wanted to photograph my friend Annie, who is a runner in Columbus, Ohio. We began by shooting her running around the field—expected shots, though not to be avoided for that reason. Then, as we were walking to the car at dusk, I saw the glowing light from an illuminated ad in this bus shelter.

Many times, when I think I am finished taking pictures, the best picture is yet to be taken. Although it's always good to shoot people doing what they do best, that may turn out to be only your jumping-off point. Never stop looking until your eyes close at night.

◀ 1/125 • f/6.3 • ISO 640 • 50mm

76. Catch the Last Bit of Sunlight

We had built a complete studio set, down to handmade wallpaper, for a shoot with Jonah Hill. There was the usual strobe lighting in place. Then I saw a streak of sunlight from West L.A. fighting its way through a crack in the curtains. I turned off the strobes and every other light in the studio, put my camera on a tripod, and shot at a slow 1/30 shutter speed.

TIP Tripods are a great tool for steadying long exposures, but anything can work to steady the camera: a wall, a couple of books on a table, a suitcase. And there are a lot of great portable tripods available that clamp to anything.

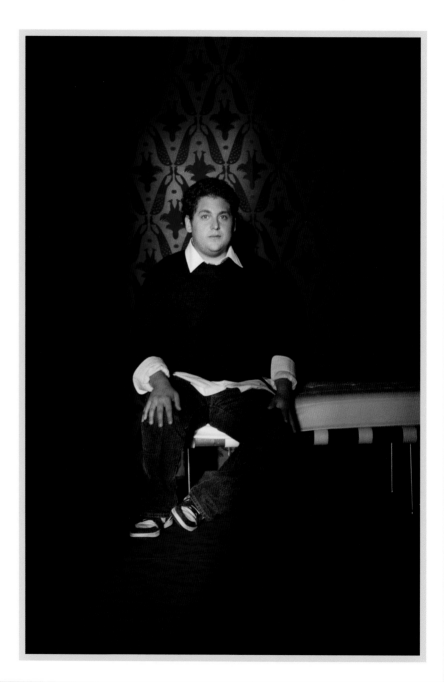

▶ 1/30 · f/2.8 · ISO 400 · 70mm

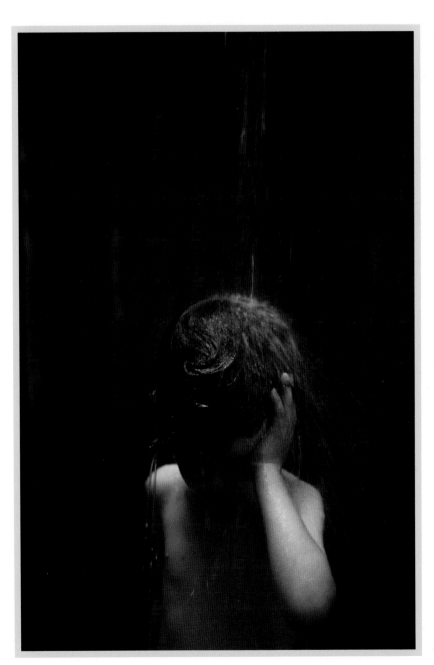

77. Capture Low Light from Above

Outdoor showers are a favorite of mine. I could do a whole chapter of pictures from these wonderful wet studios. The first problem, of course, is keeping the camera from getting fogged or wet, but I care more about pictures than cameras.

What makes this so beautiful is the late-afternoon light filtering in from above, falling so dramatically on my son, while the 1/60th shutter speed captures the motion blur of the water.

TIP Most cameras can stand a little dampness if you wipe them off quickly, so have a dry towel on hand. Don't wipe the lens that way, though: Use a non-scratching lens cleaner. If you're using a camera with a removable lens, always have a protective filter on it.

◀ 1/60 · f/2.8 · ISO 800 · 55mm

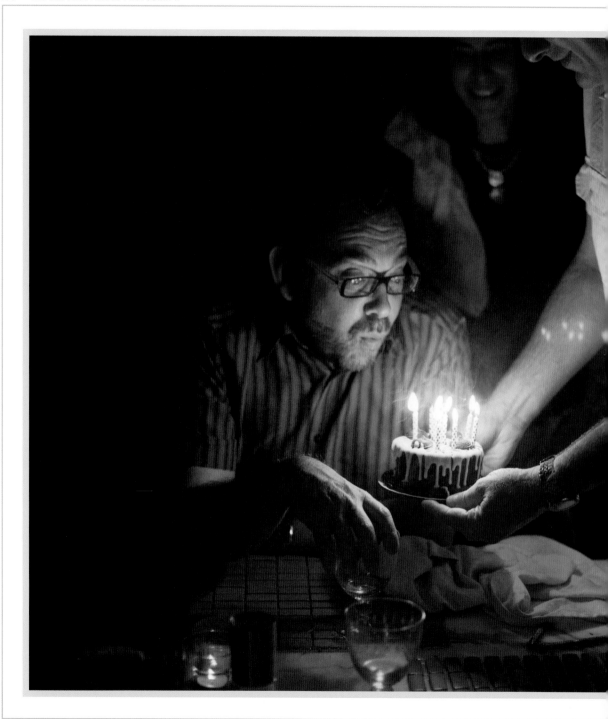

78. Avoid the Flash

I rarely use flash at home; I don't like a
blast of light taking over the shot. When
you push the ISO over 800, it may become
pixelated and the colors may be off (you
can correct the latter on the computer),
but the low-light effect is so dramatic. The
trick is to set the camera beforehand. The
lens will be opened up to take in as much
light as possible. Take a test shot, look at
the exposure, and adjust. If the shutter
speed is low, prop the camera against
something or use a tripod. Know that
the feeling of a picture like this is more
important than a perfect exposure.

1/60 · f/1.6 · ISO 800 · 50mm

79. Play in the Headlights

Driveway, spring night, Pittsburgh, 8 p.m. . . . and we're playing in the headlights of the car! It's fun and slightly sinister, in a *Cops* sort of way. You can create a similar effect in a large, dark room with a flashlight, or even with LED headlights that strap onto your head. Anything can be a light source. Try brake lights, too.

▲ 1/100 · f/2.0 · ISO 800 · 35mm

☀ ABOUT THE LIGHT

A headlight makes an unusual light source—brilliant, focused, producing so much contrast. On automatic, a camera will struggle to get the right exposure. You have to change the exposure (opening and closing the aperture manually) and watch the results as they happen. Don't trust the LCD screen on the camera for subtlety, though, so take lots of pictures along the way.

▲ 1/100 · f/3.2 · ISO 800 · 35mm

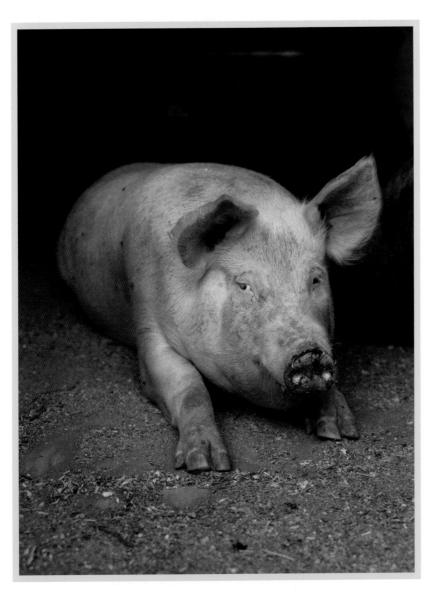

80. Don't Be Afraid of the Dark

There is a natural tendency to want to fill pictures with as much light as possible—and automatic camera settings try to do this for you—but setting your subject against darkness often works. Dark backgrounds make the subject look more dramatic and elegant—like our friend here, shot in California. The dark barn wood and soft light add emotional richness to the shot. I also love the floor of the barn—and so I included lots in the shot.

◀ 1/100 · f/5 · ISO 100 · 95mm

81. Find a Patch of Light

Studio photographers often control the light with cards and flags that produce a rectangle or square of light to frame the subject. At home, a window or a doorway naturally creates the same effect. Use that light to isolate or highlight a subject in a space.

TIP Move the subject around in the patch of light for different effects.

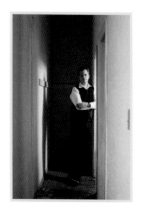

▲ 1/80 · f/5 · ISO 640 · 50mm

▶ 1/80 · f/5 · ISO 640 · 50mm

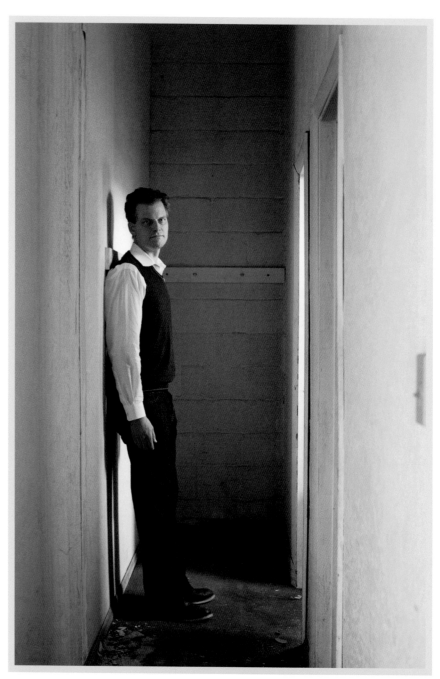

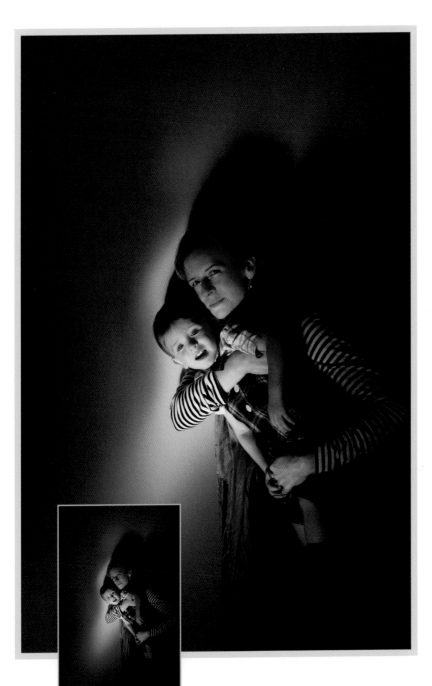

82. Dramatic Light

This could be a portrait done with studio lights, but it was actually shot in an old building on Governor's Island off New York City. Light bounced off the floor in the hallways of an old officers' quarters, and I grabbed it.

There is no simple line between studio photography, with its artificial light, and natural-light photography like this. By setting an exposure, you manipulate natural light to produce the effect you want—just as a studio shooter does.

☀ ABOUT THE LIGHT

This room would not appear this dark to the naked eye. Putting the faces in the bright light and exposing for them darkens the background—a noirish effect, made even more so when the picture is converted to black and white.

◀ 1/125 • f/6.3 • ISO 800 • 50mm

◀ 1/125 • f/6.3 • ISO 800 • 50mm

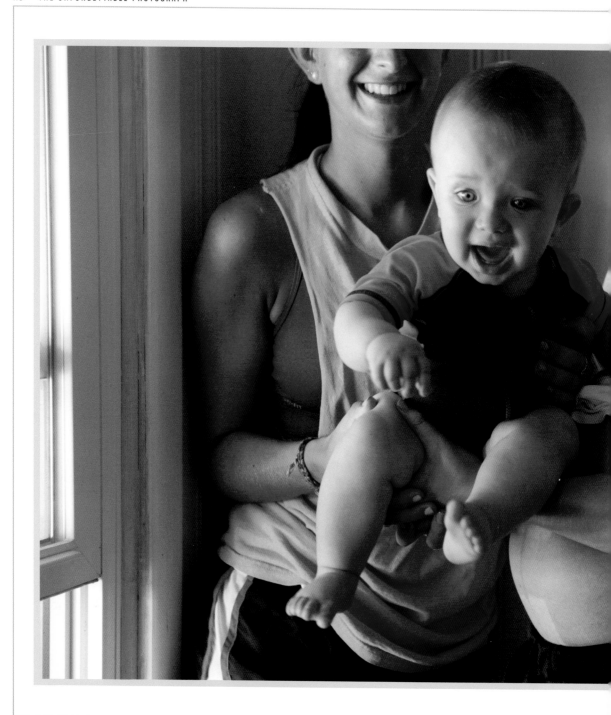

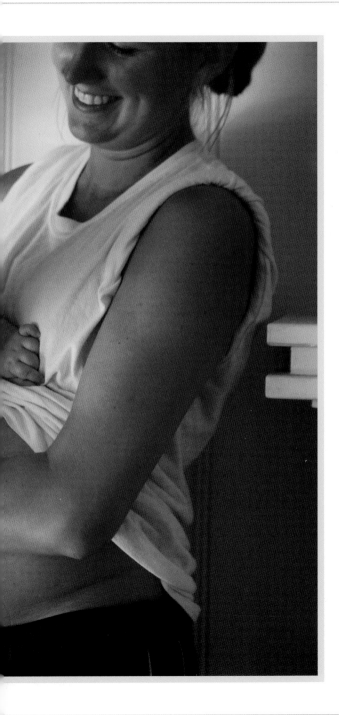

83.
A SIMPLE IDEA

Move a group into gorgeous light

◀ 1/100 · f/4 · ISO 800 · 55mm

84. Know Where the Best Light in Your House Is

There was one small south-facing window in the attic guest room of our old house, and the light from it made my son look like he was being launched from a cream puff. In the morning, when the light came in and bounced off a low-angled white ceiling, we played in its glow.

It's a low-light situation. I shot this at ISO 800 with the big, fast lens of my SLR wide open (f/1.2), which produced the shallow depth of field. Newer cameras, with big sensors, can go to even higher ISO speeds without producing too much noise.

TIP The gorgeousness of the out-of-focus part of this picture has to do with the soft light but also the quality of the lens I'm using, which, when opened up wide, is known for this luscious effect.

▶ 1/400 • f/1.2 • ISO 800 • 50mm

▲ 1/125 · f/6.7 · ISO 100 · 55mm

85. Get to Know the Light in Your Yard

The corollary to the essential rule that you should get to know the light in your house is this: Do the same for your yard (if you're lucky enough to have one). I know that light spots, shaped by the neighborhood trees, play across our lawn every afternoon. So I told my friend Rachel to just lie down in one of the light spots—this one created by light bouncing off a second-floor window.

TIP It's tricky to capture detail in both the sunlit subject and in the shadowed grass in a shot like this: You have to expose for the person's skin while—and this is the technical part—making sure that the shadows and highlights are within usable exposure range.

There's a secret to making it work: Use the camera's histogram, a light-sensitivity map that almost all cameras can display. Trouble is, few photographers use it. In the simplest terms, it can tell you when the light or dark parts of a high-contrast shot are beyond the ability of the camera's chip to record. There are plenty of good sites online showing how histograms work. I recommend you check them out, and make a habit of summoning the histogram in high-contrast situations.

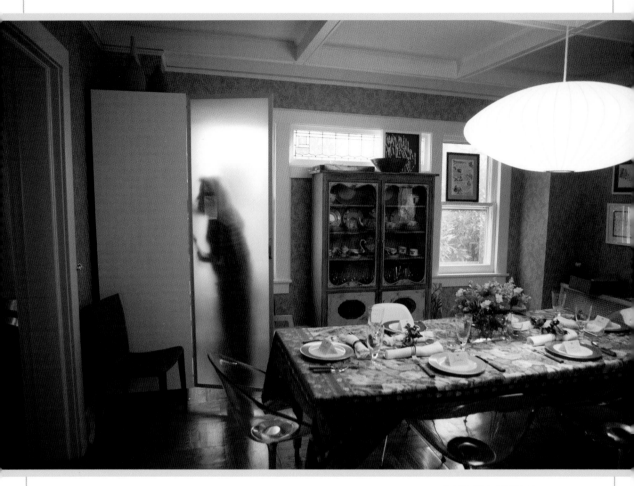

▲ 1/60 • f/2.8 • ISO 800 • 24mm

86. Through Glass, Lightly, #1

I have taken many pictures of my mother setting the table through the years; she is a master, sometimes setting it a day before the dinner. Photographing her at work is a loving act of remembrance for me. In this picture, she is hidden, with window light through a cabinet door producing a haunting silhouette. I used a wide-angle lens to take in a lot of the room. These kinds of light effects are all around you. Shoot the predictable shot and then keep photographing, always watching for something you don't expect.

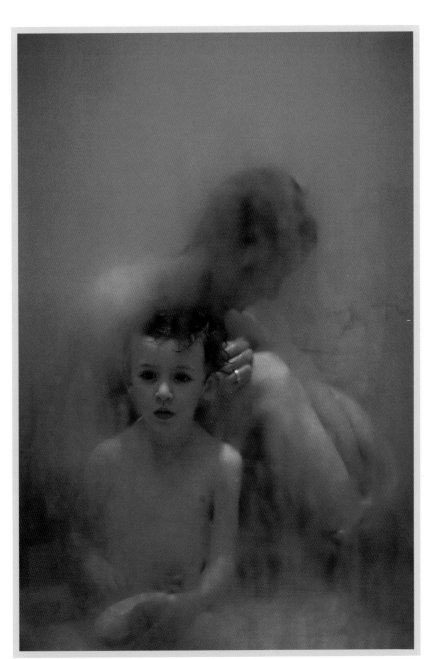

87. Through Glass, Lightly, #2

When I ran to get my camera to capture this mother-and-child moment, I was not imagining such a painterly shot. It happened because my son began playing with the fog on the shower door. I love this one—the moment is so quiet and intimate and beautiful.

☀ ABOUT THE LIGHT

The light in this room was not particularly romantic, and certainly not this warm ("warm" light has more yellow in it, while "cool" light tends toward the blue). All recent cameras have a feature called auto white balance (AWB), which automatically adjusts the color temperature in various light situations to approximate what your eye sees. Sometimes you need to take the camera off that setting to get what you want—or to adjust the color afterward in your camera.

⏏ 1/100 · f/1.6 · ISO 800 · 50mm

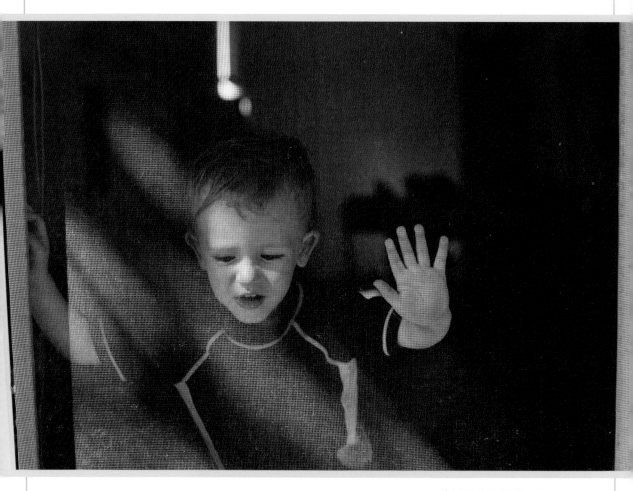

▲ 1/250 · f/3.5 · ISO 400 · 50mm

88. The Play of Light Across Surfaces

In this case, direct light, usually a difficult source for a portrait, is coming at such an extreme angle that it's catching the texture of the screen door and a bit of my son's face, while leaving much else in beautiful shadow. The play of the light elevates a shot from ordinary to interesting. I like seeing bodies pressing against screens and windows—they create a barrier that is transparent and often fun to play with. Screens soften the light, framing the subject and giving him a surface to press up against.

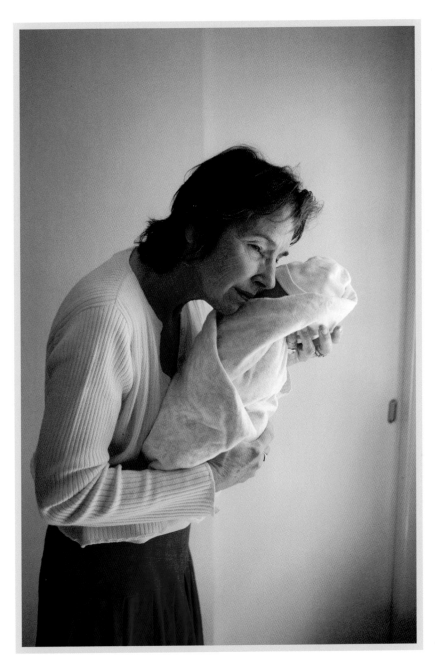

89. Face Them into Soft Light

This shot is totally posed. It's all about a new grandmother holding her new grandchild. I wanted the light to feel like soft cream bathing them both, so I took the shot by a white-curtained window. If I shot too close to the window, though, it would get too contrasty and the shadows would go dark. It's easy to move a subject back a step or two, so that the contrasts soften. Sometimes you may need to pull a curtain over the window, to soften the light.

1/100 · f/2.8 · ISO 640 · 35mm

My favorite detail is the foot poking into the edge of this shot.

→

90. Keep an Eye on the Shadows

Shadows follow us around like a parallel movie of our lives, painted on the surfaces of the world, stretched, elongated. They describe not only the shapes of bodies but also the relationships between them. Sometimes I do family portraits that consist only of shadows.

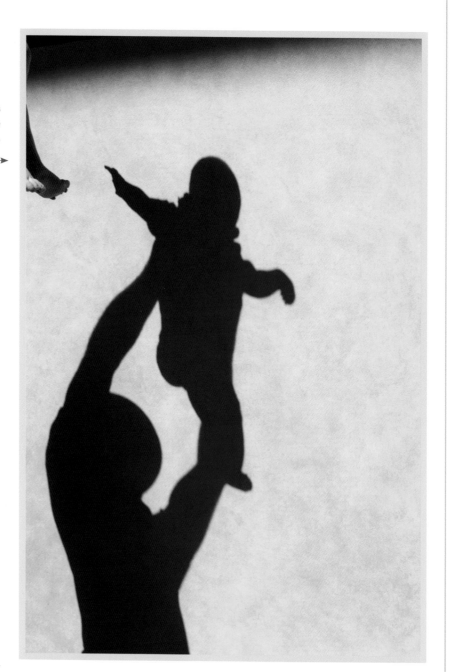

▶ 1/400 · f/16 · ISO 500 · 34mm

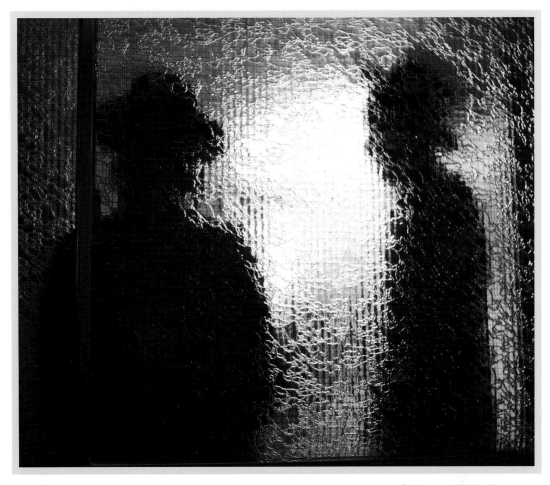

▲ 1/50 · f/1.2 · ISO 1000 · 50mm

91. Look for the Stories That Light Reveals

Glass serves up light in all kinds of ways; you just have to look for it. I love the hard sunlight that bounces off skyscrapers in Midtown Manhattan at lunchtime, for example. I also love the quality of light as it passes through things. This shot was taken at night in the town of Safed in Israel, as I looked through a window designed to hide the activities inside a house of worship. Cameras are not welcome, so I shot from the outside, and captured these shadows backlit against the textured glass. The exposure isn't a pure silhouette, though—you can see some detail.

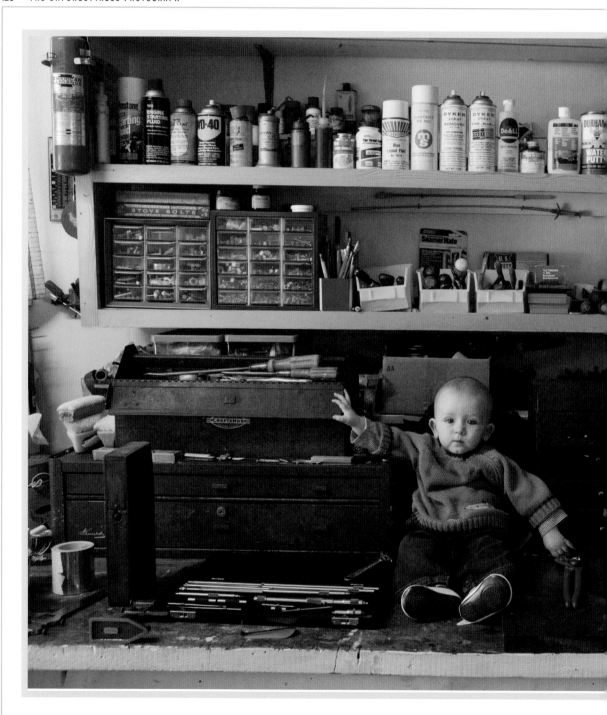

92. Let in a Little More Light

A flash would wreck this shot, which is all about the details and the deep shadows in a dark workshop. But it could easily be underexposed. I opened the window to let a little more light in, then pushed the ISO to 1,000 and used a slow shutter speed, holding the camera as steady as I could. As always, the exposure is for the skin tones of the subject's face.

TIP This was taken in Terra Haute, Indiana, in our 92-year-old uncle's ultra-neat garage workshop. Inserting a baby onto the workbench does two things: It's poignant, and it makes the eye dwell even more on the setting itself—a setting that might otherwise never have been photographed.

◄ 1/30 · f/5.6 · ISO 1000 · 34mm

93. Use the Drama of Hard Light

Hard light is not generally flattering for portraits, but it can be used to etch your subject with incredible, sculptural detail. The brighter the light, the more you can close down the lens (here, f/7.1, so there's lots of depth of field) to capture those deep, sharp details.

This was shot in the very early morning in the Dead Sea, with light coming in low, hitting one side of the man's face and his floating hair, while the sea beneath remains a black mystery.

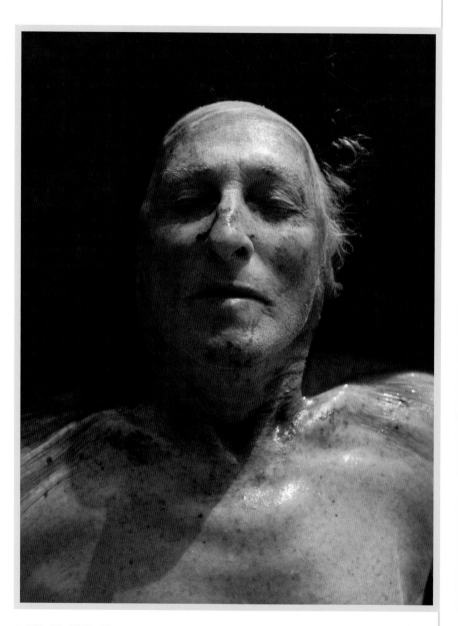

1/125 · f/7.1 · ISO 100 · 110mm

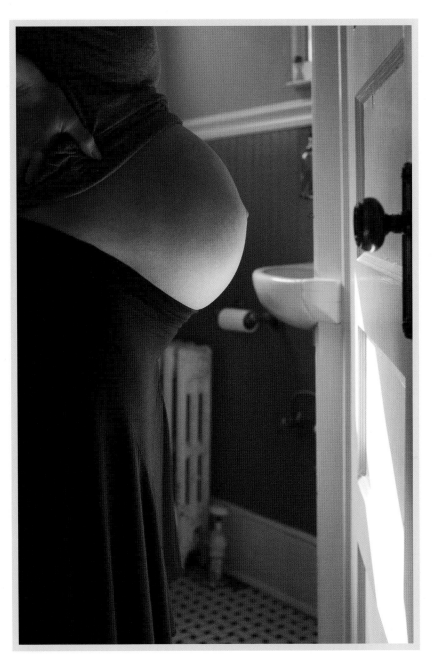

94. Bounce Bright Light

I wanted a picture that would show how my wife, Stephie, looked late in her ninth month of pregnancy, without that gauzy effect used so often. The key was to get light on the bottom of her belly. Bouncing light in the studio, usually off a white surface, foil, or other reflective surface, is the oldest trick in the book. This shot simply uses the white bathroom door to do the same thing. No studio gear, just a white surface.

If you don't have a surface, get someone to hold a big piece of white cardboard to bounce light from a bright source—a window or a lamp.

◀ 1/250 · f/4.5 · ISO 640 · 50mm

95. Be Patient

I was at the Dr. Shakshuka restaurant
in Tel Aviv, famous for a North African
dish it describes as "a cousin of huevos
rancheros." The cook was indoors; I was
in the outdoor eating area. The face of the
cook is almost entirely hidden; there's just
the morning light, direct sun, sweeping
in from the side, through the translucent
white of the egg, just at the moment it
falls into the pan—a moment I obviously
waited for.

TIP I don't speak Hebrew, but I elbowed my way
right into the middle of things. Here's the
secret to getting in tight in crowded situations: People
almost always like the attention. I am, with my camera,
smiling, saying, "This is so beautiful. So incredible."
There is no reason to be shy when you are entering
people's personal space with love and wonder.

1/200 · f/9 · ISO 200 · 43mm

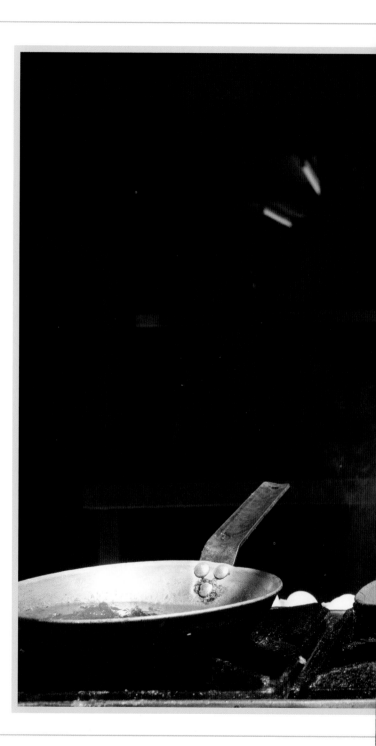

FEEL THE RHYTHM

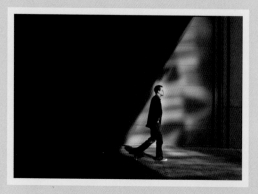

There's a natural rhythm to life, but when people pick up a camera, they often seem to lose their feel for it. They stiffen up, and shoot stiff pictures. It's not surprising: Taking photos is a thoroughly strange act at first. So is posing. Photographers and subjects resort to predictable angles and predictable poses as a defense against the strangeness. You have to get past that.

Start by letting go of the idea that you can set up the perfect moment and then press the shutter button at just the right instant. Unless you are shooting something inanimate, that rarely happens: By the time your brain processes and responds, your finger is reaching for a moment that's long gone. Milliseconds make the difference in human movement.

In a studio, or a home, one way to find a rhythm is to play music; the benefit is huge. It inspires the photographer, allows subjects to let go, and gets everyone

into sync with a rhythm that is outside the photography itself. Program play-lists on your phone or computer for different situations; that way, you can just press the button and create a feeling. I've included some of my favorite playlists throughout this chapter to show how music inspires me.

Likewise, I use language with my subjects more for rhythm than meaning. I don't want to direct; I want to get a rhythm going with the sound of my words. What I say to every single subject is, "Do you know what we are doing? We are only putting love out in the world." I'll add: "I don't care what you look like, I am only interested in photographing your soul." I might say something ridiculous like, "I need someplace to stay. Can I stay in your guest room?"

This may sound daunting, but when you try it you'll find that it's really all just about having fun: playing music that inspires, talking freely without think-ing, getting into that place where anything can happen, both with you and your subject. If you're in sync and just a little bit lucky, the shutter will open at just the right beat.

Outside the studio, every scene has its own rhythm, every place its beat. I listen for that, and I always have something playing in my head—a jazz song, a show tune, an internal metronome—trying to find that rhythm.

Often, I try to change the center of gravity in a picture when I am shooting. Getting people slightly off balance means they are a bit less comfortable. In the rhythm of things, as in music, there are beats and there are off-beats. The off-beats can be the most interesting.

Loosen up. Find your groove. Then shoot it.

96. Turn Up the Volume

Loud music was playing when I shot this picture of my wife jumping on a bed in a hotel room, where we went just to take pictures. This one is about the rhythm of our play, set to music you can't hear but you can almost feel in the energy of the shot. The first rule of shooting, almost always: Turn up the music! Second rule is to make it even louder. You can talk before and after the shoot. During the shoot: music.

TIP When you're shooting into the light, adjust the camera. See pages 170 and 171 for more information on getting the best results.

MY PLAYLIST

1. "Free Money," by Patti Smith
2. *Mingus Ah Um*, by Charles Mingus

▶ 1/640 · f/1.4 · ISO 800 · 35mm

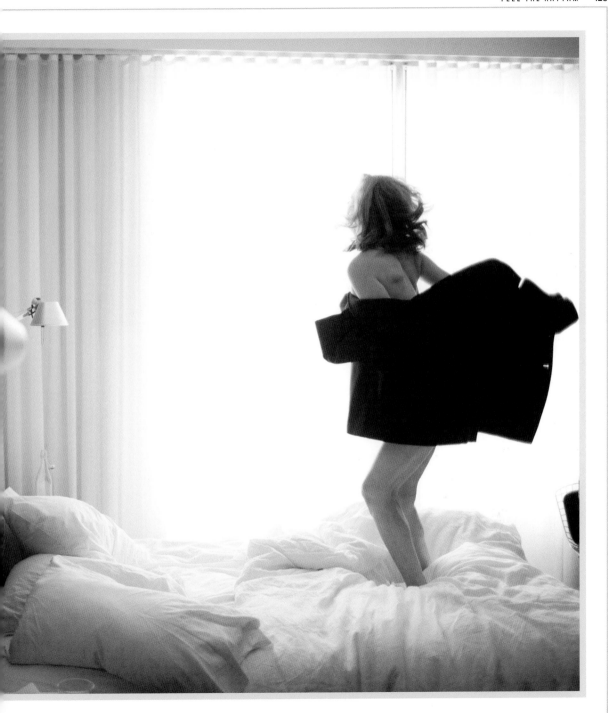

97. Break Rules, Find a Rhythm

No running. No splashing. Don't plunge in with your clothes on: There are all these absurd rules about water. So break them— good pictures happen that way.

This shot is of the great choreographer Aszure Barton in the swamps of Florida, during a break from an intense dance rehearsal. Aszure insists on breaking every rule, tearing away any pretense. We went out in the water and trees and played. She was fearless. She lay right down in swamp water for a mysterious beauty shot (see page 198). Then we tried this splashing picture. Look at her gaze, look at her foot. This shot captures the challenge and attitude that Aszure throws at me, her dancers, and her audience. Think how much fun a kid would have, given permission to splash the camera like this.

▶ 1/230 · f/4 · ISO 400 · 60mm

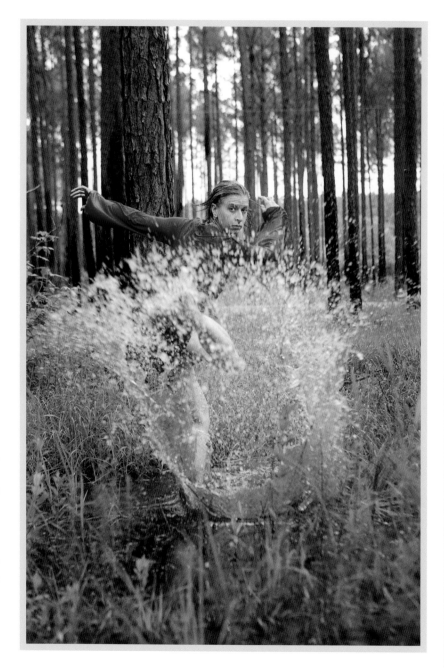

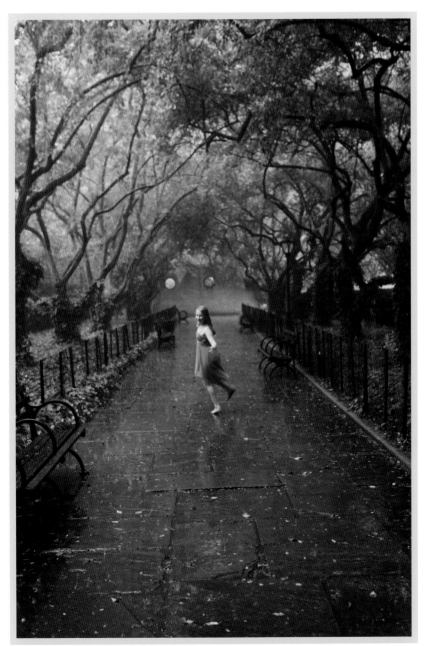

98. Comings and Goings

I was at a wedding in a park. It started to rain, and this girl was running. I shot her running out and back, but this perfect little moment of her turn, with her feet up, her arms up, her body tilted forward, and her dress swinging around, seems to capture so much of her joy.

It helps to have a camera that can shoot several frames a second, which the newer point-and-shoots do. Even so, you have to get a little lucky. That happens when you get into the groove and take plenty of pictures.

MY PLAYLIST

1. "I Wish It Would Rain," by Nanci Griffith
2. "I Hear the Rain," by Violent Femmes
3. Nina Simone singing "Feeling Good" or her version of Randy Newman's "I Think It's Going to Rain Today"

◄ 1/60 • f/3.5 • ISO 800 • 45mm

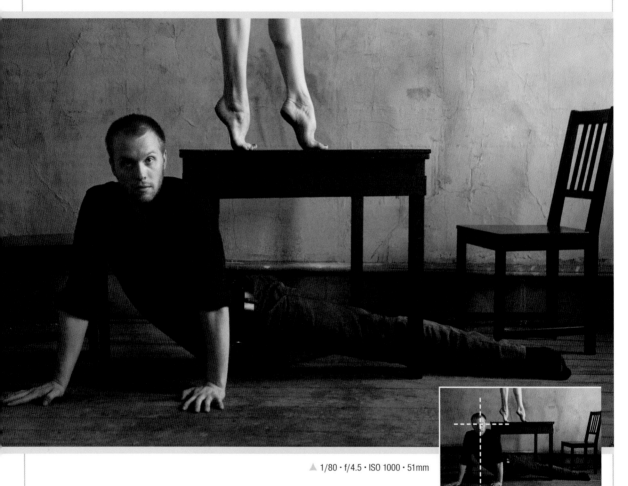

▲ 1/80 · f/4.5 · ISO 1000 · 51mm

99. The Rhythm of a Tight Composition

This picture, which seems to contain so much energy, almost like a compressed spring, looks rigidly composed and stage-lit, but it was taken entirely in natural light in a room above a theater in New York's East Village. For me, composition is a reaction to an idea set in motion—in this case, by two dancers. As soon as you cut someone's face off, or hide it, you introduce a mystery and a tension to the shot. Here, the photo captures movement and posed stillness all in one frame. I had a big advantage using professional dancers, but you can play in any attic light and get interesting compositions with friends. Light coming in from small windows helps, as do unfinished old walls, which seem to breathe.

COMPOSITION

MY PLAYLIST
I. "Nantes," by Beirut
2. "De Cara a la Pared,"
by Lhasa
3. "Kalimba Suite,"
by Bobby McFerrin

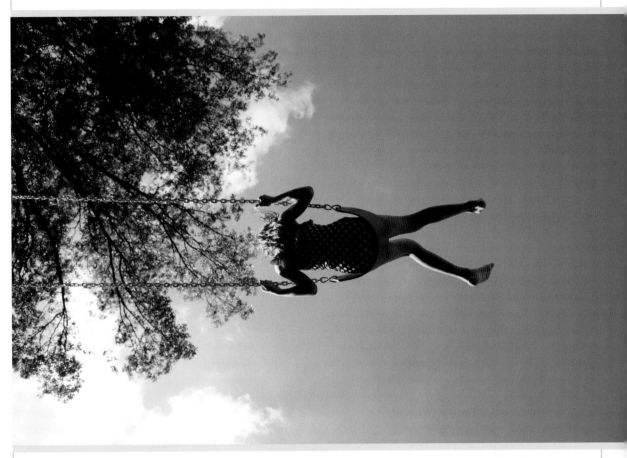

▲ 1/1000 · f/5.6 · ISO 400 · 25mm

100. Follow the Pendulum

When I'm shooting a picture like this, there is definitely music going through my head. It may be a song my father sang all the time, "I've Got the World on a String," or I may just be humming to myself, trying to get into the flow.

☀ ABOUT THE LIGHT

1/1,000th of a second stops the action dead, and a wide-angle lens takes in the sweep of the sky. But with bright sky and clouds above, it would be easy to turn this into a silhouette. I didn't want that; I wanted details in her hair, bathing suit, and legs. So I opened the aperture a bit to capture those details, then just shot away until I felt I had a nice composition.

101.
A SIMPLE IDEA

Shoot the quiet

▶ 1/160 · f/3.2 · ISO 800 · 50mm

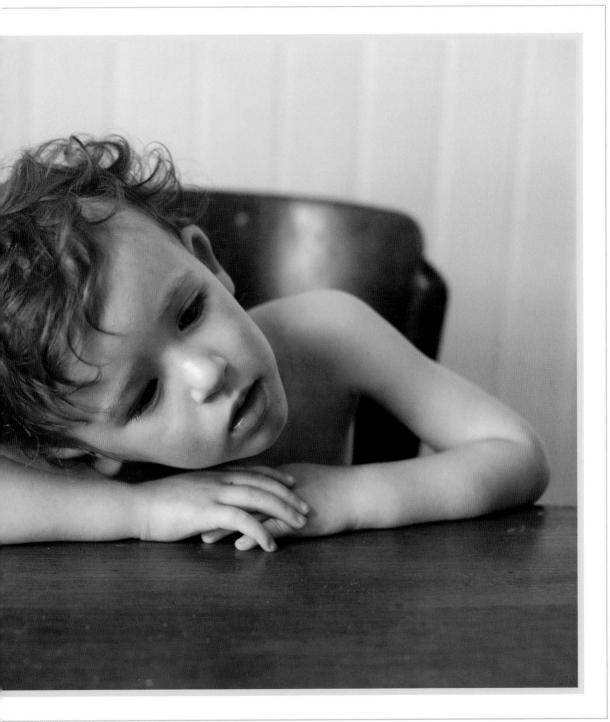

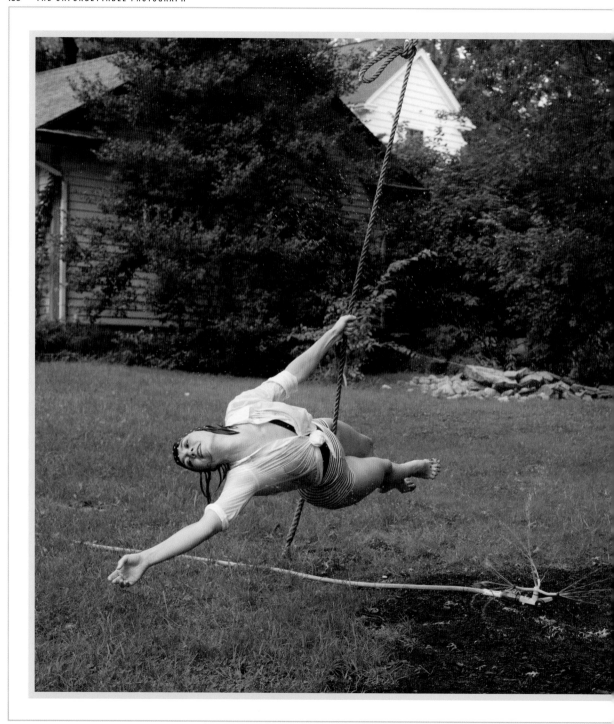

102. Get into the Swing

This picture, like several in this chapter, is about the rhythm of play. I made up a project to dress the actress Jessica Love in vintage bathing suits, then photograph her all over the yards in our neighborhood. These houses we leave empty when we go to work, these yards that sit quietly all day—they're perfect stages for play. Jessica is a free spirit, very fun, very inventive, and whatever we came up with, she would do.

This is a totally normal scene of suburban America interrupted by one surprising element of tension, motion, and beauty. It was play, but not easy play: There was a little knot on the rope, and it was hard for Jessica to stay on. She had to take a run at it, jump on, hang tight, and look relaxed—and I had to capture the moment of abandon.

MY PLAYLIST

1. "Woody and Dutch on the Slow Train to Peking," by Rickie Lee Jones
2. "Acontece Que Eu Sou Baiano," by João Gilberto
3. "Crickets Sing for Anamaria," by Marcos Valle

◀ 1/500 · f/5 · ISO 640 · 50mm

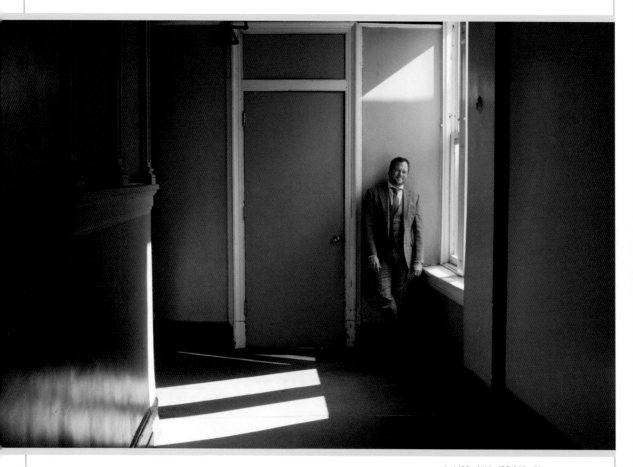

▲ 1/80 · f/14 · ISO 640 · 50mm

103. The Rhythm of Light and Lines

This is interior designer Malcolm James Kutner, who works in an amazing building in New York's SoHo. The moment I arrived, I loved this scene: the light coming in, all monochromatic except the light blue door—it's like a set for a Hopper painting. There's no movement, but it has the rhythm of a precise piece of music.

MY PLAYLIST

1. *Bobby Short Loves Cole Porter*— the entire album!

2. "Sweet Talk," from *Bobby Short & Mabel Mercer at Town Hall*

3. "This Must Be the Place," by Talking Heads

4. "Grey Gardens," by Rufus Wainwright

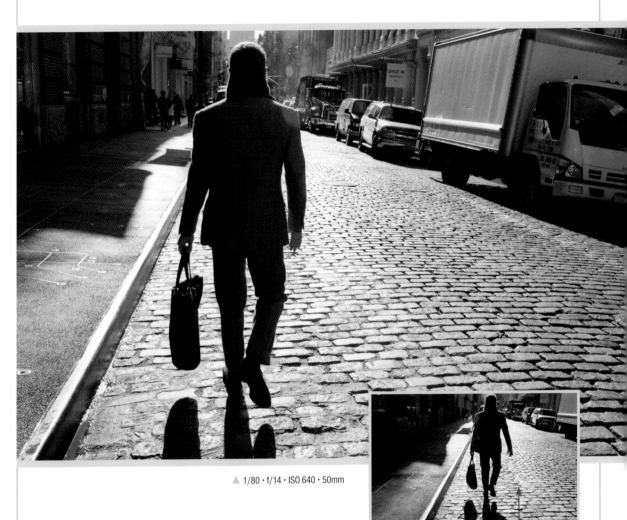

▲ 1/80 · f/14 · ISO 640 · 50mm

▲ 1/640 · f/9 · ISO 500 · 35mm

**The arm straight out makes
this shot a bit more awkward
than the one above.**

104. Fall into the Rhythm of Walking

When you shoot people walking, a foot or arm often gets frozen in an
awkward position, something out of place, and the picture just feels a
little wrong. One way to get into a groove is to just fall in step behind
your subject, move in the exact same rhythm, and shoot in step.

105. The Rhythm of Repetition

Often I see people spend more time examining the shots they've just taken on their camera screen than taking more pictures. Not productive! You can't predict when you'll get a good shot in a sequence like this, and you certainly can't see it on a tiny screen. Just keep shooting. No harm asking most subjects for a do-over—and another. For kids, it's a game.

TIP For this Chaplinesque shot, I got far away and down on my knees so that, shooting up a bit, I would have the sky as most of the background, rather than the road and the trees. Then I asked my supermodel to walk toward me. I started shooting while he was far away and kept shooting through the whole sequence.

MY PLAYLIST

I. "Viva la Vida,"
by Coldplay

2. "Wild Wild Life,"
by Talking Heads

3. "Jackson,"
by Johnny Cash

4. "Walking Spanish,"
by Tom Waits

▲ 1/400 · f/5 · ISO 640 · 63mm

▲ 1/200 · f/8 · ISO 320 · 50mm

106. Rhythms in Between

This is an outtake from a big shoot in London. The boy was the model, accompanied by his mother. During lunch, I kept shooting. I was teasing him with my camera. He tried to kick the lens. This single frame, from a weeklong shoot, was the best picture. And as for the music . . . the owner of the location we were using was a famous BBC disc jockey and had an insane collection of music that we had going the whole day.

MY PLAYLIST

I. "King of the World,"
by First Aid Kit

2. "Telephone Call from Istanbul,"
by Tom Waits

3. "Go Do," by Jónsi

4. "Give It Away," by Andrew Bird

107. The Rhythm of Light and Shadows

Think of light as having its own rhythm, like a sound track, played out all through the day. Light moves, and people move in and out of light. This was shot on a Chicago street one morning. I was walking around, scouting for locations, and thinking about Harry Callahan, one of the great street photographers who shot and taught in Chicago, and later at the Rhode Island School of Design when I was there. I saw this amazing stream of light and just waited as people walked through, as if it were a brush painting them.

MY PLAYLIST

1. Definitely Thelonius Monk
2. "A Little More Faith," by Rev. Gary Davis

▶ 1/125 · f/8 · ISO 400 · 50mm

108. Get into the Rhythm of Waiting

I followed my son into a dark barn on a farm. I set up this shot and waited. After a quick ride around he headed for the door, and I was ready. (Was there any chance that a little boy on a scooter *wouldn't* head out an open door? I don't think so.) All the rhythm of the moment is in that little foot, perfectly positioned, which gives the picture its wistful going-out-into-the-world quality. The key here was being ready.

TIP The exposure is a little tricky in this one. I wanted to see some detail on the inside and also capture the green outdoors. While I waited, I shot a frame or two at different exposures and checked them on the back of the camera. But camera screens don't reflect the actual shot very accurately—you need to learn how the two relate.

COMPOSITION

▶ 1/400 · f/4 · ISO 400 · 50mm

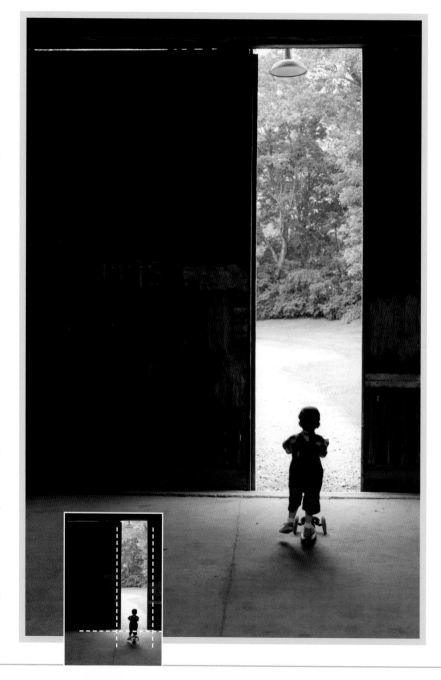

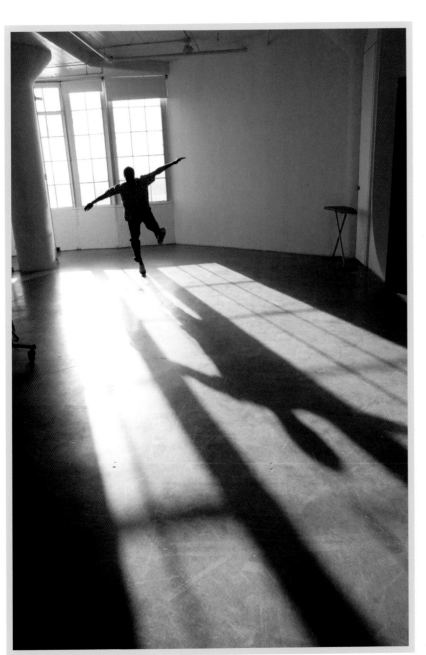

109. The Rhythm of Joy

I was testing the light in a studio with a group of tap dancers in New York. I love shadows, especially ones that are as alive as this one. I shot this with a wide-angle lens, camera turned on its side, and exposed to make the shadows as dramatic as possible.

MY PLAYLIST

1. "Doin' the New Low-Down," by Bill "Bojangles" Robinson

2. "Cotton Club Stomp," by Don Byron

3. "Is You Is or Is You Ain't My Baby," by Joe Jackson

◀ 1/400 • f/6.3 • ISO 320 • 28mm

110.

A SIMPLE IDEA

Catch the rhythm of the action

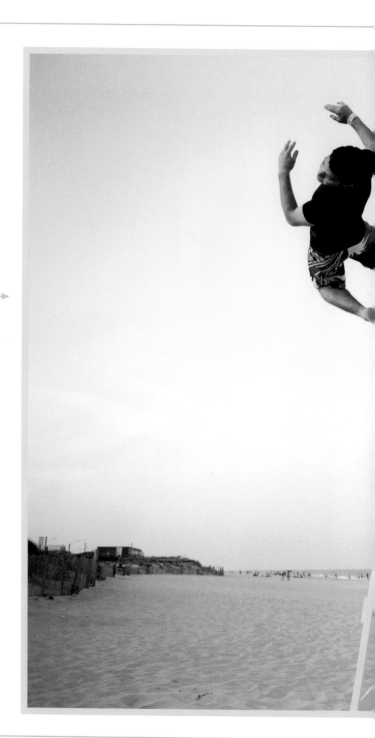

1/1000 · f/3.5 · ISO 640 · 28mm

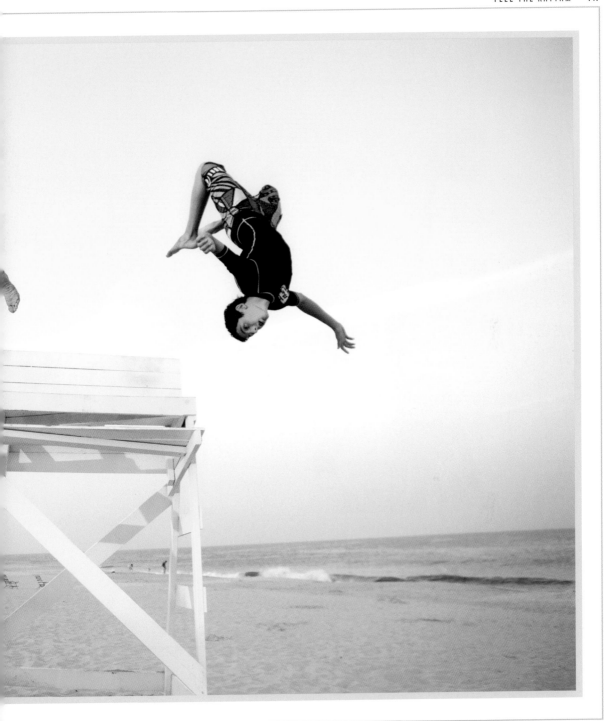

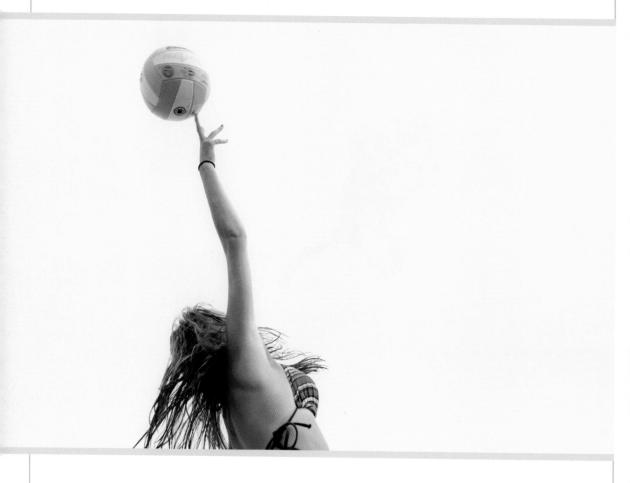

111. Isolate a Single Moment

On a crowded beach it can be tricky to isolate what you want to shoot amid all the surrounding hubbub. Here, photographing friends playing volleyball, I got down low and shot up. There were hundreds of people around, but this angle isolates the tipping point in the rhythm of a game.

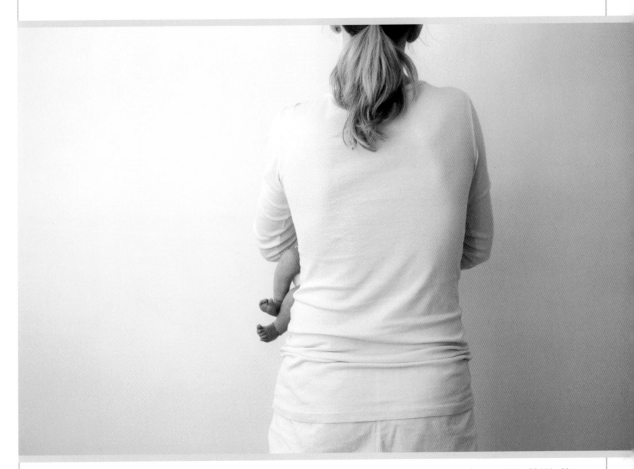

▲ 1/50 · f/3.5 · ISO 250 · 62mm

112. Let It Breathe

I don't go into something like this saying, "I want to get a sweet shot that just shows my baby's feet." Rather, I try to allow things to unfold in their own natural way, to breathe a bit. I don't pre-visualize. I create exercises to work through. In this case, I asked my wife to slowly turn round and round with the baby.

And then we all just breathed.

Another shot in the series.

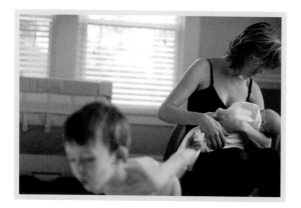

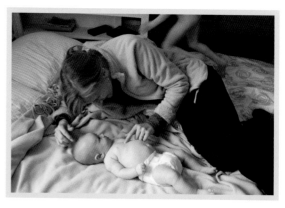

113. Finding the Rhythm of a Shoot

When I'm doing a professional shoot—say, a portrait of
a Hollywood actor—it has an arc. First come warm-up
exercises, in which I am getting the subject, and myself, to
loosen up, using almost any idea I can dream up. Then we
get into the place where things can unfold and pictures
can happen. It builds up, then winds down. For me, at the
peak, it feels like the room starts to spin and take off into
its own orbit. Somewhere along the arc the best pictures
lie. Maybe only one good picture.

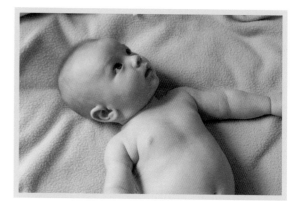

Sometimes the best shot happens during the warm-up
and it never gets any better than that. Sometimes I really
have to work my way up and let the picture breathe, like a
bottle of wine. I might feel I'm controlling it, but often I'm
just playing with ideas and paying attention.

Imagine this with your own pictures. If you decide, for
example, that you want pictures of your two little boys,
one of whom is an unpredictable baby—there will be an
arc there, too. Shoot the whole thing. The pictures on these
pages are a handful of more than 200 photos that I shot in
a very short period.

Don't be stingy about pressing the shutter button,
either because you think you already have the picture, or
because you are too busy checking what you have. Only
when you keep shooting can you find the wave and take it
for a ride.

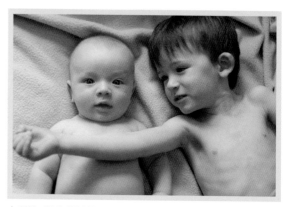

▲ 1/80 · f/6.3 · ISO 800 · 50mm

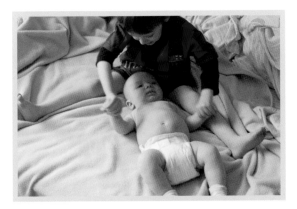

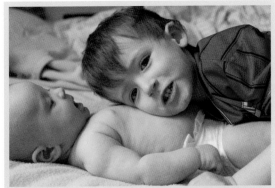

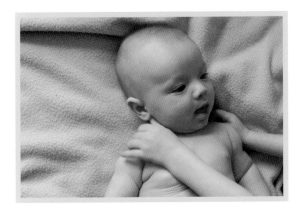

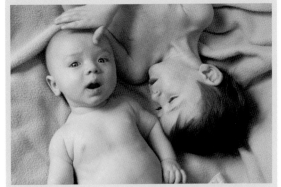

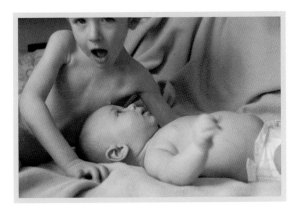

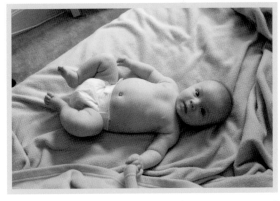

See the two best pictures on the next page. ⟶

▲ 1/80 · f/5.6 · ISO 800 · 50mm

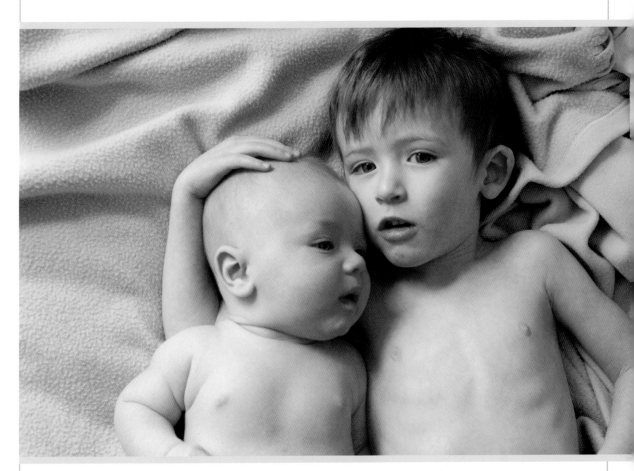

▲ 1/80 · f/5.6 · ISO 800 · 50mm

MAKING YOUR IDEAS REAL

GET A TINY BIT TECHNICAL

After a lifetime of taking pictures, the technical details of photography are second nature to me. My wife, describing her own experiences with a camera, complains that I can't understand her frustration because I "see a picture, set the camera without thinking, and attack the scene." She sees an image, but she can't always get her camera to capture it.

It's true that I have the advantage of decades of experience and millions of pictures taken. I'm not a technical photographer, though: I *feel* a picture as much as I see it. Today, every photographer has the advantage of astounding technology: New

cameras, loaded with automatic settings for exposures and preset effects, take care of technical details and leave you free to be creative.

You will find, however, that the seductive promise of all those auto settings begins to get frustrating. They tend to push pictures to a middle place, while the interesting photos lie out on the edge. Automatic cameras tend to brighten a room, when you may want it dark. They may cool the light, when you want it warm, or freeze the action, when you want it blurred.

To bend the camera to your vision, to really make it into an extension of your creativity, you need to take control of the autofocus, autoexposure, and the whole auto-mindset. The good news, again, lies in the technology: Almost all point-and-shoots now allow a lot of manual override, and even the iPhone allows you to adjust exposure with a touch of the screen.

The simple ideas in this chapter scratch only the surface of what you can do with a small amount of technical knowledge. The way to get better is to experiment creatively with shutter speeds, aperture, and all the rest. Digital photography provides infinite room for experimentation, because digital "film" costs almost nothing.

Technique on its own is a bore. The photographer Duane Michals, one of my great heroes, said he would rather see a horribly exposed photograph of a great idea than a perfectly exposed picture of something boring. A properly exposed photograph of a great idea, however: That's not a bad goal.

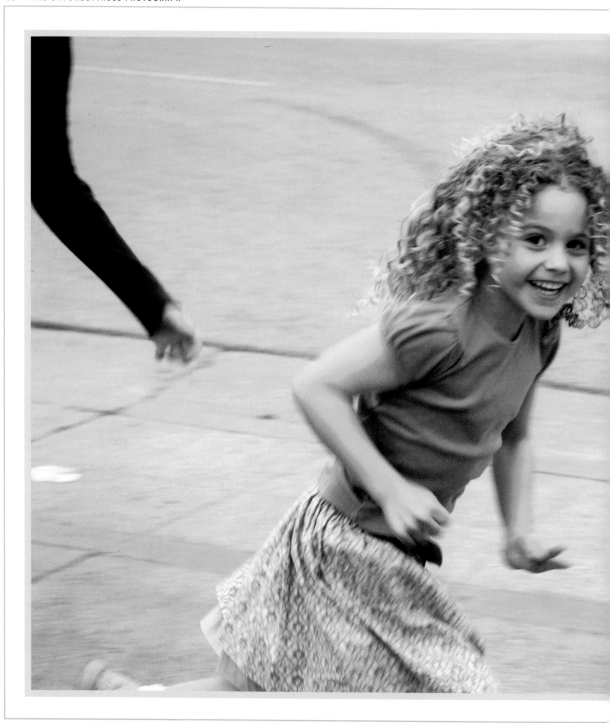

114. Pan the Camera

This is a simple effect involving motion blur—the blur that comes from using a slow shutter while something is in motion. You move the camera in the same direction that the subject is moving, while selecting a relatively low shutter speed on manual. That blurs the background more than it does the subject and produces an effect like this. You'll find that you need to take a lot of panned pictures to get one that works.

1/125 · f/13 · ISO 400 · 70mm

115. Embrace the Energy of Blur

Slow shutter speeds—here, 1/25th of a second—are underused. Blur captures energy in a way your naked eye doesn't register in real life, and allows you to strip motion down to its core energy.

This photo is from a series of pictures I took of my neighbor's kids, Lulu and Maisie, who were all dressed up. To make this interesting, I took them to a nearby nature reserve. I began by taking posed, still portraits. Their mother, the movie director Maggie Greenwald, was looking on, and I wanted to give the photos a bit of a cinematic feel. Although Lulu is unrecognizable, this ended up being one of my favorite shots—the energy of these young teenagers comes screaming through.

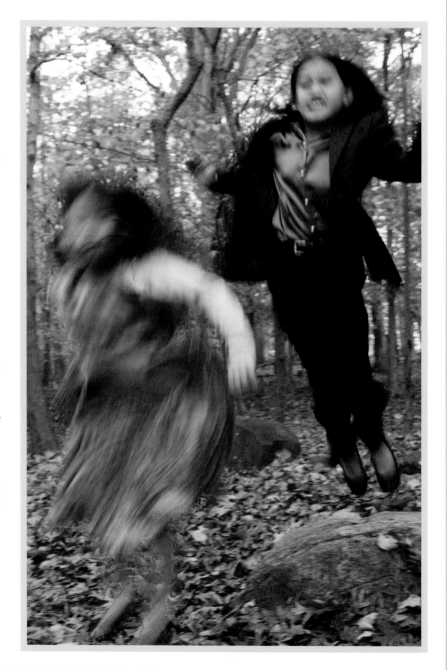

▶ 1/25 · f/9 · ISO 800 · 48mm

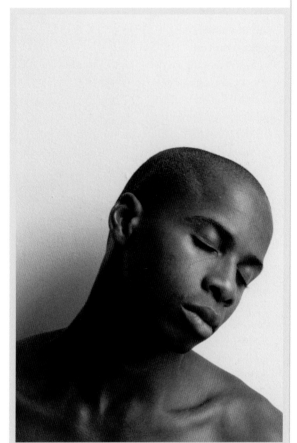

▲ 1/20 · f/10 · ISO 320 · 100mm

116. Try Portraits at Low Shutter Speeds

People are rarely as inert as a lot of photographs make them appear; I like the way the shot on the left captures the subject's energy, the one on the right his beauty. I used the same shutter speed—1/20th of a second—with both of these, and shot with a tripod. Most point-and-shoot cameras allow you to set the shutter speed using the "Tv" (shutter priority) or "M" (manual) mode. Don't be afraid of the manual mode, and don't be afraid of blur.

117. Push the Lens Out of Focus

A friend in art school painted everything out of focus. Her colors were beautiful and rich and her paintings were like dreams.

 This is the effect you get when you push the lens way out of focus, so that everything in the frame is as blurry as it is for a nearsighted person who has lost his glasses. Details blur, mood is heightened, and the colors can be gorgeous. If a scene gives you a dreamy feeling, try this (I do it a lot). Avoid the *slightly* out-of-focus shot, though, which looks like a mistake.

TIP While this effect is easy to achieve with a manual focus setting, you have to think a little more if you're using an autofocus point-and-shoot camera. Try focusing on something very close (you can even use the macro setting), then freeze the focus by holding the shutter halfway down, and then point the camera at the subject.

▶ 1/80 · f/5 · ISO 640 · 85mm

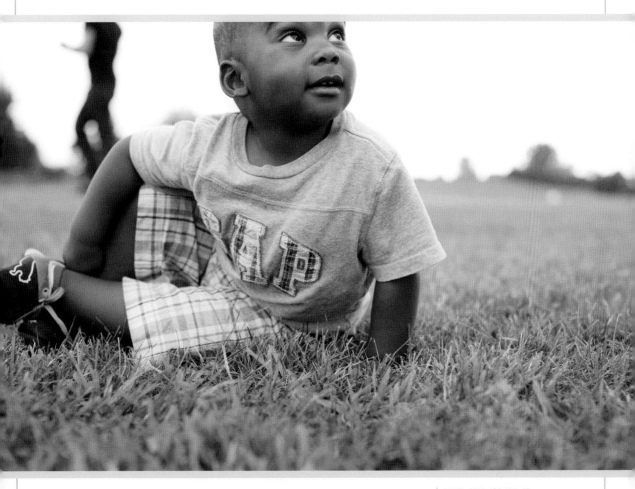

▲ 1/800 · f/3.2 · ISO 800 · 50mm

118. Crop While You Shoot

Getting down low, below the eye level of the subject, and cutting off part of the head and body: All of these add energy to this picture. It's possible you could do it in the computer, afterward, but it's much more likely that you'll capture the most dramatic picture if you crop in real time.

119. Try an Out-of-Focus Foreground

Having a person out of focus in the
foreground is a distancing effect, not unlike
shooting through a door or window. It
gives the photo a voyeuristic feeling. It's
a technique we all recognize from the
movies—the camera will change who's in
focus in the same scene, moving back and
forth.

Set your aperture wide open (the smaller
the number, the bigger the opening). That
will produce the shallow depth of field
needed to get a shot like this, which is easier
when it's a relatively low-light situation. And
then be sure to actually focus on the thing
you want to focus on.

TIP They say your first child gets all the attention and
most of the pictures. This photo is partly about me
trying to give my younger son some photo love. It's one of
my favorite images of the two of them. This is a peaceful
early-morning shot, just after 7 a.m. The first thing we do
every day is go out on our porch and look at the day. The
light is beautiful, indirect. The early bird gets the picture,
if he has the camera handy.

▶ 1/100 · f/1.6 · ISO 800 · 35mm

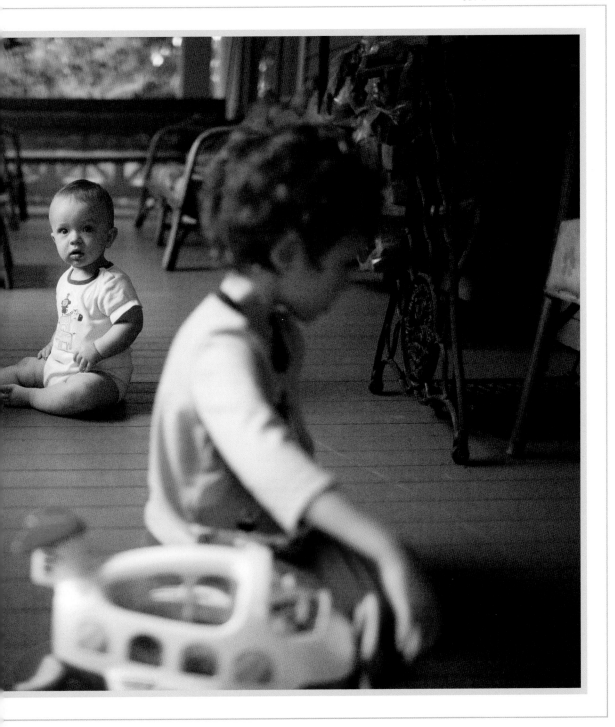

120.

A SIMPLE IDEA

Play with depth of field

1/500 · f/5 · ISO 640 · 68mm

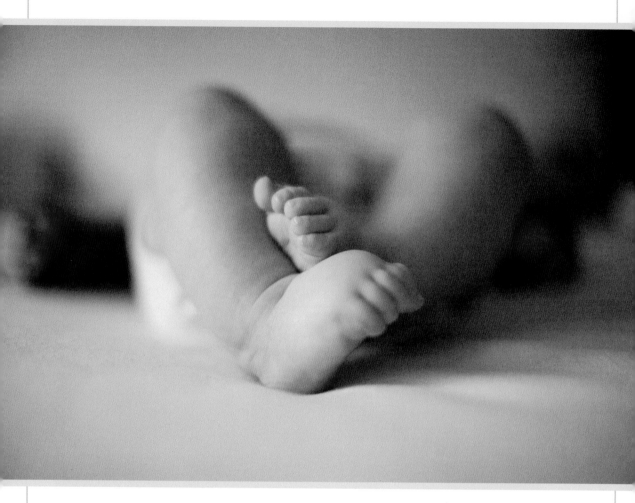

▲ 1/1250 · f/1.4 · ISO 800 · 50mm

121. Try a Very Shallow Depth of Field

When a lens focuses on a very close object with the aperture wide open, the rest of the picture can fall out of focus. I don't go for this too much because I don't want pictures to be so blatantly about technique. There are times when it works, though, as with this picture of a baby's feet.

The effect can be hard to achieve with a point-and-shoot lens in wide-angle mode, but you can narrow the depth of field by, first, selecting the widest possible aperture (the one with the lowest number) in the AV mode (aperture mode) and, second, zooming in. The longer your lens is extended, the less depth of field it has.

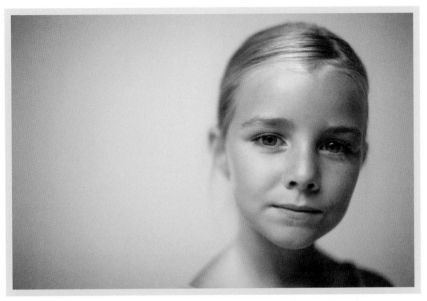

▲ 1/640 · f/1.4 · ISO 640 · 50mm

122. Play with the Serenity Effect

Very shallow depth of field can give a photo a serene look that a lot of portrait photographers go for: It flatters the subject. The viewer's eyes lock right into the small part of the face that is in focus (usually you're aiming for the eyes), and everything else falls away into a gorgeous gauzy blur. This technique allows you to micromanage the viewer's experience. It gets boring if you do it often, but it works when used sparingly.

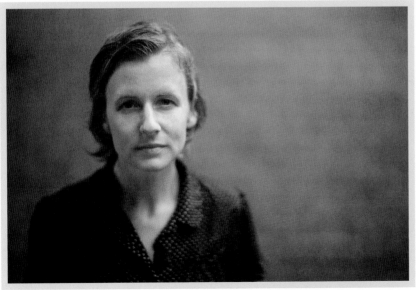

▲ 1/160 · f/1.4 · ISO 400 · 50mm

Expose for the face. The light is blown out here, but not so much that you can't see the boy's hair and the shape of his head. Backlight can be flattering light, so keep it in mind for portraits.

▲ 1/80 · f/2.8 · ISO 500 · 70mm

123. Shoot Against Backlight

When you point a camera set on auto toward a bright light, it will close down the lens—exposing for that bright light—with the result that things between you and the light will be silhouetted or underexposed. The problem is that usually you're trying to shoot those very things that are silhouetted. To compensate, you open up the lens. That in turn can cause the light at the back to blow out—you'll lose all or most of your detail. That's often okay, and shooting into backlight is something you'll often want to do, for beautiful effects.

TIP Both of the shots on this spread appear quite bright, but they really aren't—I had set the ISO rather high and shot at a fairly slow shutter speed to get the skin tones right.

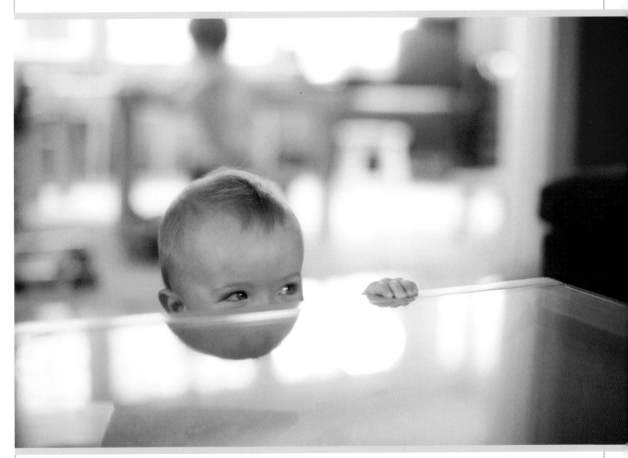

▲ 1/80 · f/1.8 · ISO 800 · 50mm

124. Bathe the Subject in a Pool of Light

This isn't just backlighting, it's all-around lighting. This baby isn't going to stay in a peeking position for more than a moment, so you have to do what I did—set the exposure ahead, then wait, and keep waiting for the shot to come to you. The lens is opened up for the baby's face.

☀ ABOUT THE LIGHT

Many cameras allow you to set the light meter so that it reads from a spot in the middle of the frame (rather than averaging the light from all over the frame). You can take a reading from the face, then keep that exposure by holding the shutter button halfway down. With an iPhone, you can just touch the screen at a place that has the exposure you want.

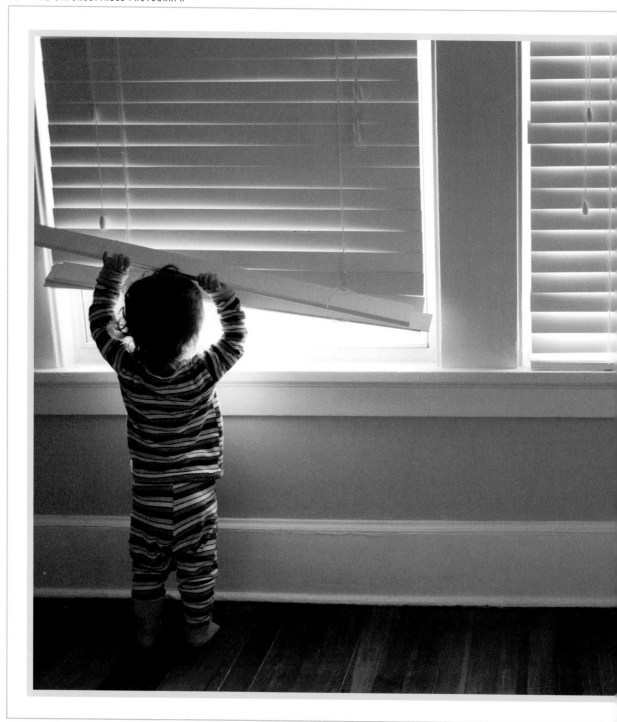

125.

A SIMPLE IDEA

Shoot into the light

◀ 1/80 · f/2.2 · ISO 2500 · 35mm

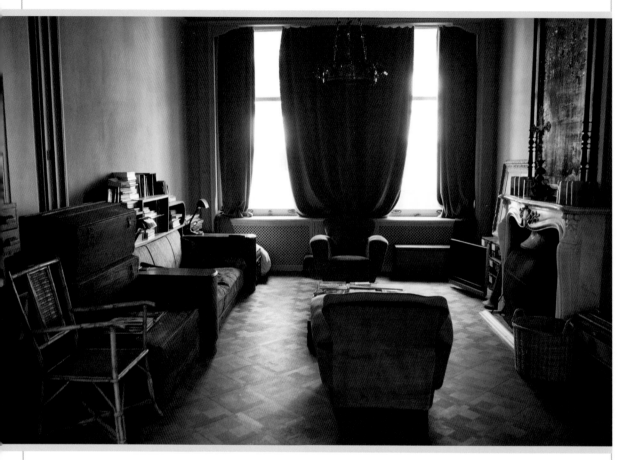

▲ 1/50 · f/3.2 · ISO 640 · 30mm

126. Balance Light and Dark

This beautiful apartment we rented in Antwerp was dark save for the bright morning light that streamed in. The furniture could easily have become silhouetted, or there could have been too much flare (flare is usually caused by very bright light bouncing around inside your lens). You're trying to find a nice balance, and sometimes you need to play with your exposure and move around so the flare is minimized. Take several exposures.

TIP With digital images, especially RAW images (see page 318), you have a little leeway for correcting dark shadows or blown-out light with computer software: There are settings in the software that specifically allow you to lighten dark areas. Don't rely on this to save a shot, though. If you brighten shadows too much at that stage, the picture can get noisy and ugly. If your camera will bracket exposures—take several exposures at once—use that feature in situations like this.

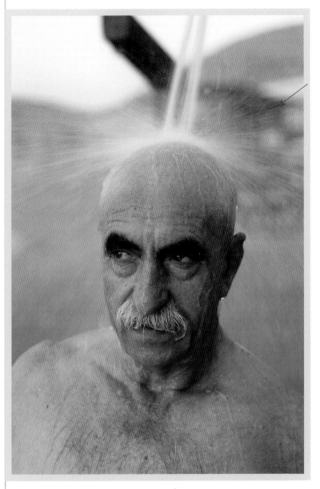

A powerful cataract of water is just a blur at 1/100th of a second.

Shot right at the start of the shower's downpour with a shutter speed of 1/320th of a second: It doesn't quite stop the blur.

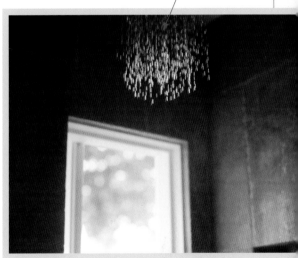

▲ 1/100 · f/4.5 · ISO 100 · 110mm

▲ 1/320 · f/2.5 · ISO 800 · 50mm

127. Capture Splash and Spray

When taking water shots, vary your shutter speed to create different effects—from a blurred gush to a necklace of droplets to diamonds absolutely frozen in air. For the shot on the left, the shutter was quick enough to keep the subject sharp but slow enough to blur out the rushing water. The shot on the right uses a faster shutter speed to suspend the water a bit more, while backlight gives it the quality of crystal.

128.

A SIMPLE IDEA

Use the macro setting on your camera

▶ 1/400 · f/4.5 · ISO 160 · 100mm

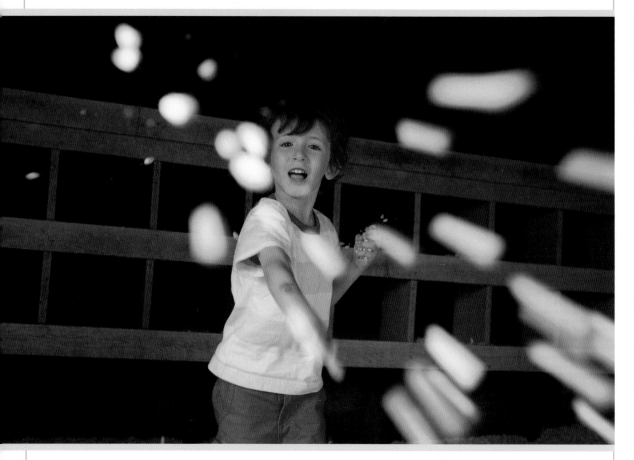

▲ 1/160 · f/4 · ISO 1000 · 38mm

129. Don't Forget to Duck

This picture of Jackson was shot at a family-friendly farm in a shed full of hard corn kernels that kids play with. It was completely dark save for the doorway, with late-afternoon light streaming in. I told Jackson to throw the corn at me. At a fairly slow shutter speed for fast action—1/160th of a second—the corn became blurs of light coming at the lens while Jackson stayed fairly sharp. My kids throw things at the camera all the time: footballs, water, food. I try to snap the shots before ducking.

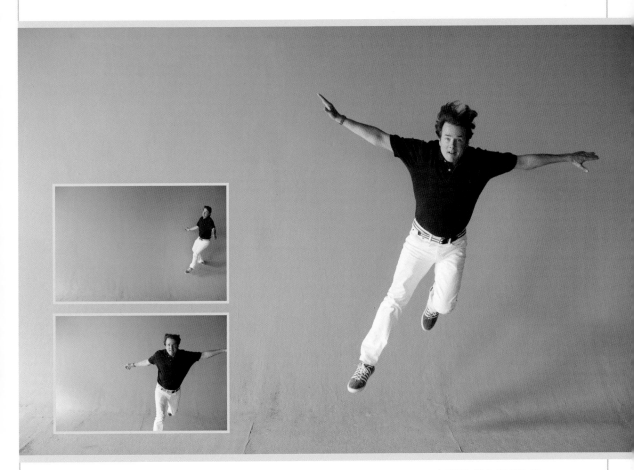

▲ 1/1000 • f/2.8 • ISO 2500 • 50mm

130. Play with the Multiple-Shots Feature

Three shots from a sequence: Very fast shutter speed, several frames per second, ISO pushed high—but the pictures are sharp. I used an expensive camera, but this is where the technology is heading for everyone. You could shoot something like this at a skate park or in an empty swimming pool with sloped sides.

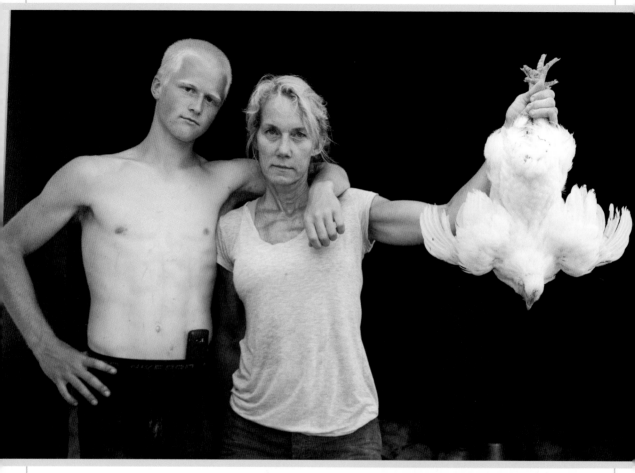

▲ 1/320 • f/4.5 • ISO 500 • 54mm

131. Use Photo Effects Carefully

Except for fun apps like Instagram, I'm not a big fan of photo effects: Manipulated pictures usually end up being more about the effect than the photo. Besides, effects can crowd out telling details. In this case, it's tempting to convert the photo to black-and-white to emphasize the Depression-era/*American Gothic* feel. But I prefer the modern touch that the woman's bright orange running bra brings to the picture. And his cell phone pops more, too.

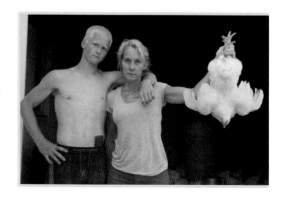

132. . . . But Have Fun with Camera Phone Apps

Smartphone photo-app filters have proved that there is an endless, nostalgic appetite for pictures that mimic the color shifts of old film—as with the two shots on top—or simulate lenses, as with the dark-around-the-corners effect in the two bottom shots. They're fun, and I sometimes use them on Instagram, but effects don't replace a good eye.

WORK WITH PEOPLE

approach every portrait as an intimate experience. I demand the same open-
ness and vulnerability from myself that I expect from my subjects, and often
I'll take the lead by talking about some detail of my own life, sharing a secret,
throwing myself out there. I am always genuinely curious about the person I
am photographing: I want to know who he is, how he thinks and moves. I listen
and watch closely. Many times I pick up clues at odd moments, before the sub-
ject actually gets in front of the camera. I'll ask what music he was listening to
before he came into the room. I'll notice how he looks at himself in the mirror.
This is what's important—to find the truths about people, not obsess about the
camera. I treat the camera as something of little importance in the whole busi-
ness. It cannot be the center of attention. It's the tool, but it's not why we are
both here. All these principles apply with everyday shooting.

There are tricks to loosening subjects up, and to getting the best pictures
as you explore the process of taking a portrait. You'll find some of them in this
chapter.

1/80 • f/5.6 • ISO 200 • 70mm

133. Prepare, Then Improvise

I knew I was shooting Jake Gyllenhaal in a loft in Williamsburg, Brooklyn. I knew we had access to the roof. I knew I loved the texture of this door. That was it: I hadn't worked out anything else.

Visualizing a picture before I start photographing is not my method. I'll make sure that a space feels good, but I want to improvise like Keith Jarrett does at the piano. He's said that he clears his mind before he starts playing; I do the same before I start shooting. Everything I do comes from the interaction with the subject in the moment.

If you tend to over-prepare, try this: Make sure your camera is working, check the batteries and locate the memory cards, and then let everything else go. Take yourself to a place where anything can happen, including failure. Improvise. Here you'll find the heart of your creativity.

134. Try Some Warm-Ups

For the person posing, making faces for the camera is almost like doing vocal exercises. It loosens things up. I often start by having a person work through all kinds of expressions, trying things that would not make good pictures. Going to the extreme like this, and then backing things up, helps you both find the natural place you want to be.

It's easier to encourage this sort of play if you're working with an actor like Ali Farahnakian, but you can practice with any friend who is willing to play along. You'll develop your own techniques, but try opening up by talking about anything you can dream up. The less sense I make—without being weird about it—the more it seems to free up the person.

▶ 1/60 · f/14 · ISO 125 · 100mm

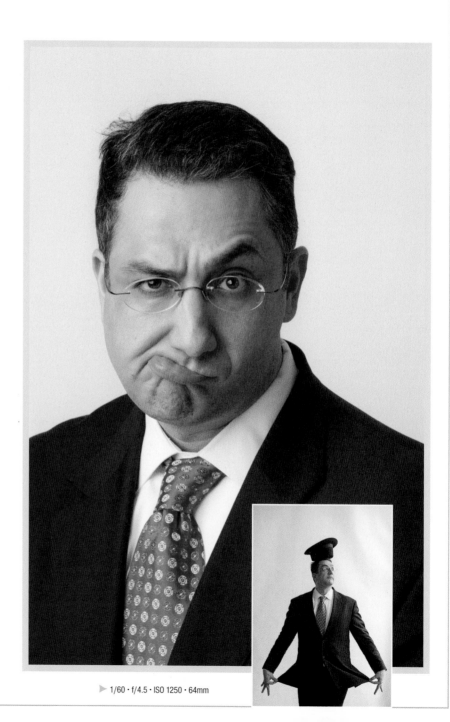

▶ 1/60 · f/4.5 · ISO 1250 · 64mm

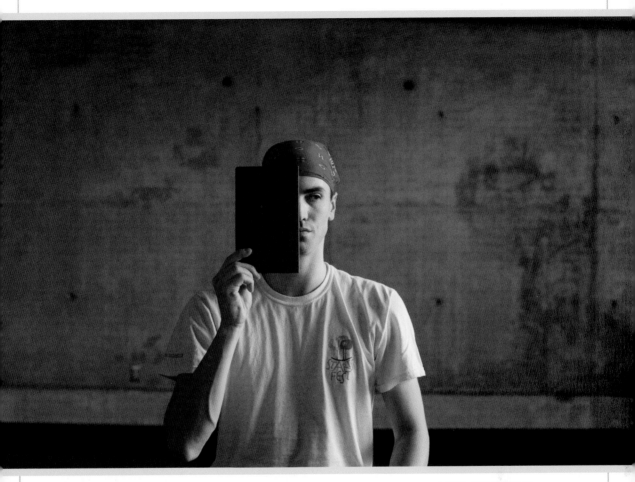

▲ 1/640 • f/3.5 • ISO 800 • 50mm

135. Cover the Face

Exercises like this give the subject something to do besides stare at the camera, and sometimes yield interesting shots.

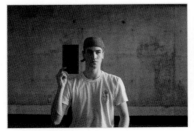

▲ 1/640 • f/3.5 • ISO 800 • 50mm

▲ 1/640 • f/3.5 • ISO 800 • 50mm

136.

A SIMPLE IDEA

Block
the shot

▶ 1/200 · f/9 · ISO 250 · 52mm

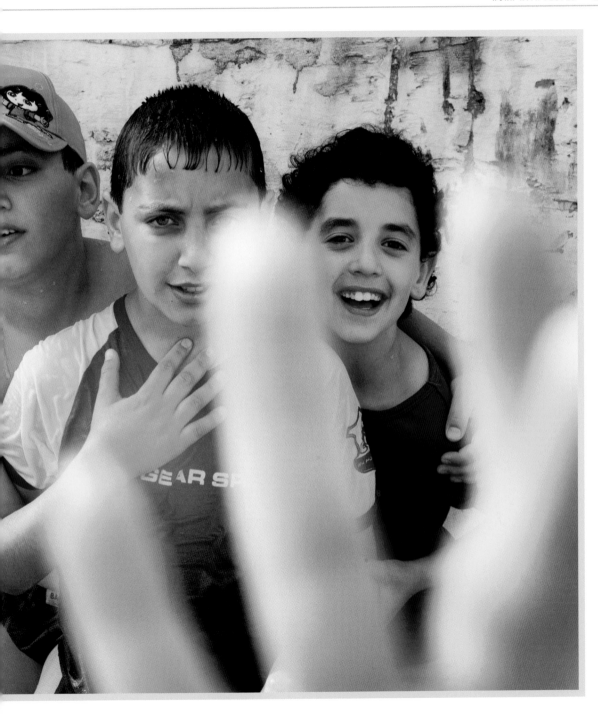

137. Play with Your Subjects

These two gentlemen, the Mast Brothers, make artisanal chocolate in Brooklyn, and affect a magnificent 19th-century apothecary look in both their shop and their appearance. I was stumbling drunk on the chocolate aromas from the moment I entered the door, instantly transported back to childhood memories of Hershey, Pennsylvania. I wanted to play!

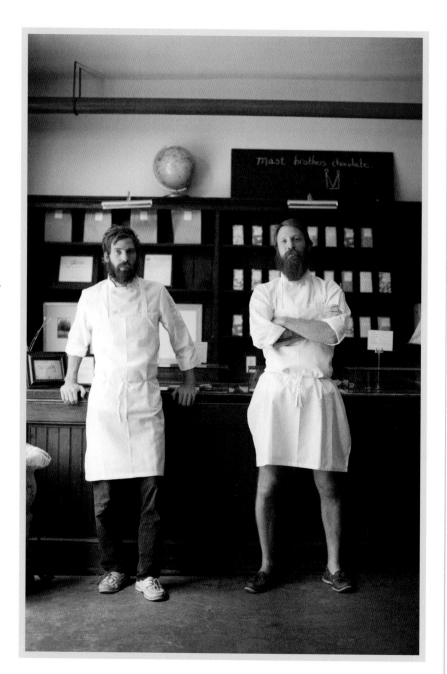

▶ 1/1000 · f/2 · ISO 800 · 50mm

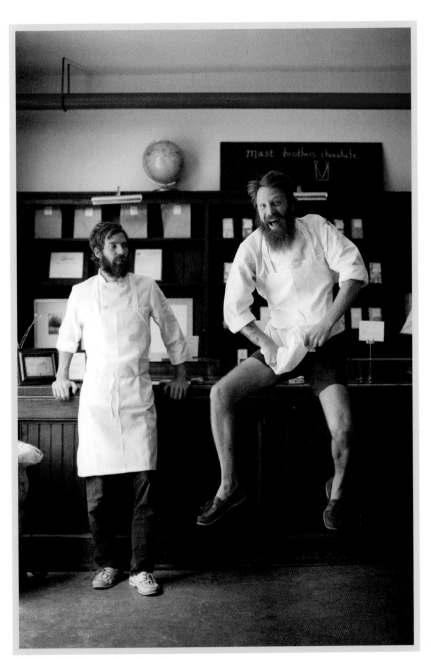

I started joking with them—and suddenly they were in the air. But it wasn't quite right. I realized it was more fun if only one of them was airborne while the other one played the Smith cough-drop brother. That was great.

Usually, getting a subject to do something fun is simply a matter of asking.

◀ 1/1000 · f/2 · ISO 800 · 50mm

138. Know Their Zone

Although you want to push people to a
new place—to a place where it might feel
like the center of gravity has been shifted—
you also need to work in their comfort
zone. Warming up lets you find that zone.
The reason my friend Kevin Sussman
(*The Big Bang Theory*, *Ugly Betty*) is such a
successful character actor is that he has
one of those faces that says a lot without
working too hard. When I put him in front
of the camera, I know he's not going to be
bouncing off the walls. He works within a
narrow bandwidth of expression, packing
in all the emotion. This is his strength.

Get a subject to move his eyeballs around. Sounds goofy, but it will loosen him up.

139. Play with the Dynamics of a Duo

When two people interact for the camera, one person is often playing offense, one person defense. It's easy to push that along. Just remember who plays the straight man and who plays the muse. These shots were part of a long series in which Kevin played the straight man while his wife, Ali Young, was just all over him. When you're shooting a portrait, it's very easy to lock into what you think is the "right" shot and keep working one idea to death. It's important to work ideas to the place they need to go, maybe a little beyond, and then let go. I find moving my subjects through lots of ideas keeps things fresh and fun. I never want the paint to dry.

TRY THIS

140.

Take part in your pictures

Here was a simple storytelling dilemma—how to show how bad a sunburn was. I ended up with a little story about memory: Anyone who was sunburned as a kid remembers pressing fingers into his skin and looking at the fingerprints left behind. In this case, the handprint was mine.

Most pictures involve at least a small intervention.

▶ 1/640 · f/8 · ISO 400 · 50mm

141. Find Their Limits

Sometimes, at the beginning of professional shoots, I ask my subjects to do something I know they won't do. Then we've established a line—and they're empowered by saying no. Later, having drawn the line, they often cross it.

When Joan Rivers saw the plastic boobs, she said, "No, no, absolutely not; I won't wear those." Later, she went into the changing room and came out sporting them like the pro she is. The shot ended up on the cover of her perfectly titled book, *Men Are Stupid . . . And They Like Big Boobs*, and the shoot is featured in the *Joan Rivers: A Piece of Work* documentary.

▶ 1/125 · f/13 · ISO 50 · 55mm

142.
A SIMPLE IDEA

Push their limits

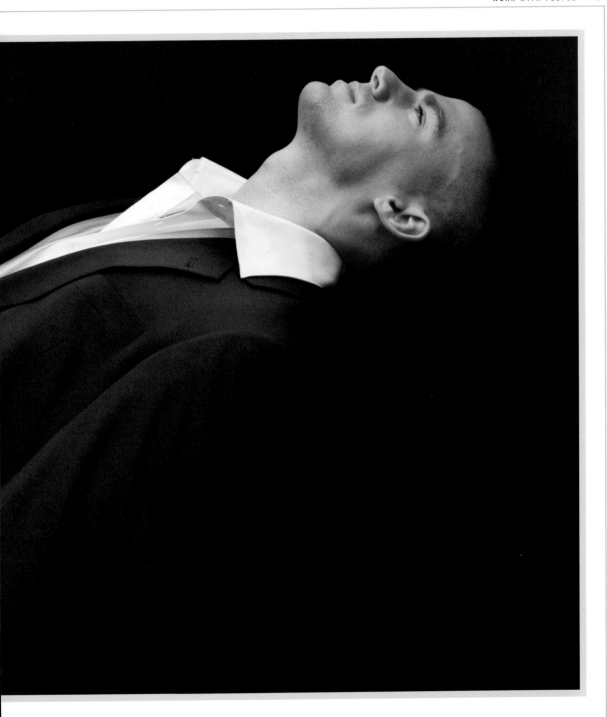

143.
A SIMPLE IDEA

Play with the mystery of water

▶ 1/160 · f/13 · ISO 320 · 50mm

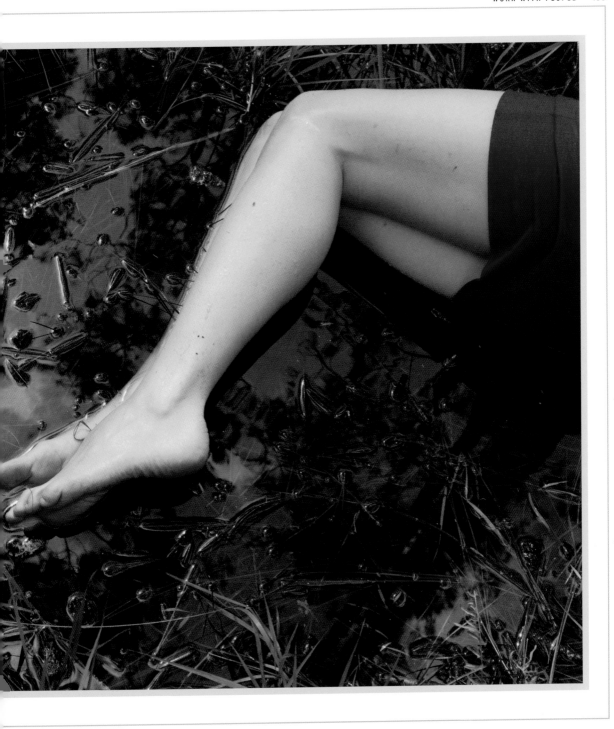

144. Avert the Gaze, Connect with the Gaze

For many people (though not for this handsome French singer), looking into a camera lens can be awkward. Here's a simple trick: Ask the subject to pretend that the lens is a mirror, and that he is just checking himself out. Then, to loosen things up, make looking into the lens a negotiation: "Look into the camera, then look away."

An averted gaze can totally change the picture. When the subject looks away, the photo becomes more voyeuristic— which is what a lot of photography is about. Is looking at someone who is not looking at you more, or less, intimate? That depends on how you feel about voyeurism. Eye contact makes the photographer a conduit between the subject and the viewer. When the subject looks away, a photo feels more about the photographer's own viewpoint.

▲ 1/160 · f/4.5 · ISO 800 · 55mm

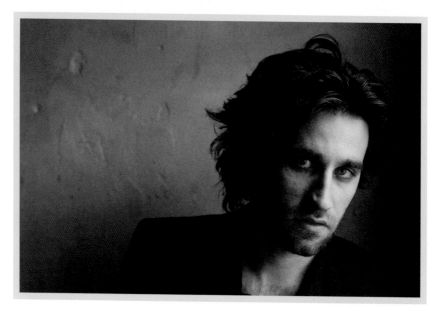

▲ 1/160 · f/4.5 · ISO 800 · 55mm

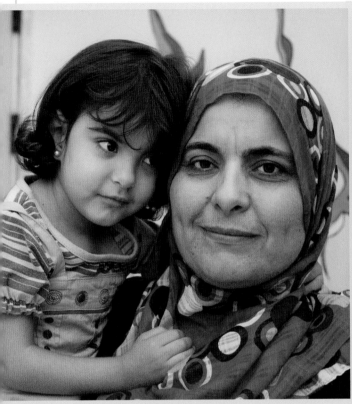

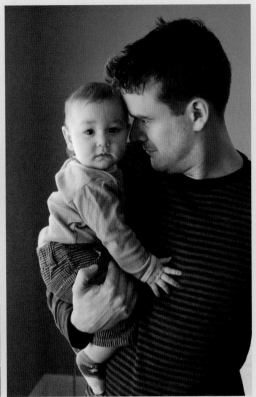

1/100 · f/6.3 · ISO 800 · 50mm

145. Capture Two Gazes in One Shot

These pictures are all about the love gaze, the touch, the bond between a parent and a child. The gaze happens naturally, in an instant. You have to be awake to it happening or you'll miss it. In both pictures, one subject is looking directly into the camera—inviting you into a moment that is otherwise completely private.

☀ ABOUT THE LIGHT

This absolutely gorgeous light in the shot above right came from a single window in an old building. Sometimes, if a single light source makes shadows too dark, you can bounce some light off a reflector—even a white piece of cardboard—into the shadow side. I didn't do that here.

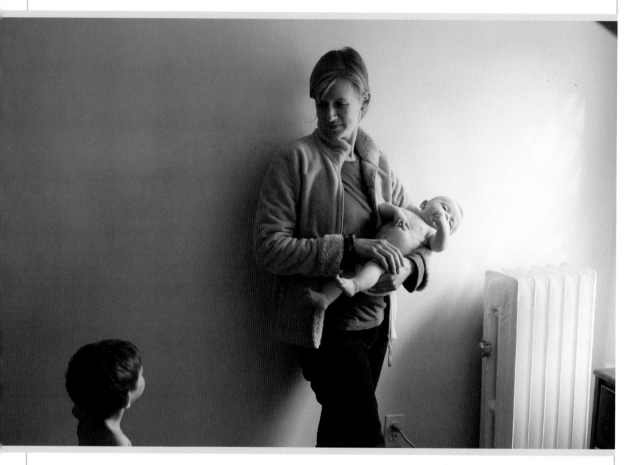

▲ 1/80 · f/4.5 · ISO 640 · 85mm

146. Shoot the Distance Between People

Pictures that show the ways that we can be together and apart simultaneously can be emotionally powerful. A new baby changes things for an older child. There's a new geometry of love to be worked out.

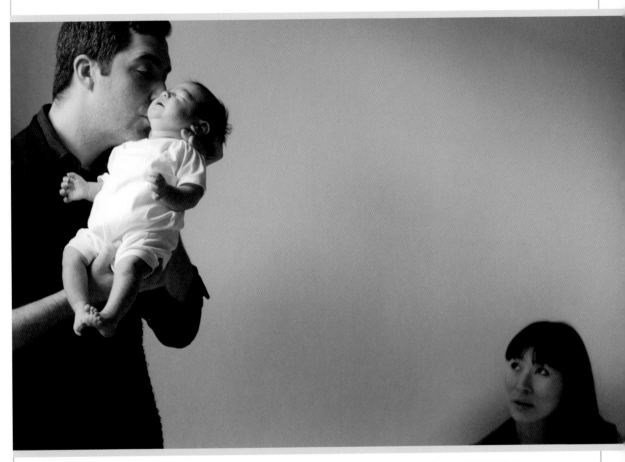

▲ 1/80 · f/5.6 · ISO 800 · 50mm

☀ ABOUT THE LIGHT

In both shots, light comes from a single window. The temptation might be to overexpose—the camera on auto will try to expose for the shadows, and brighten the whole room—but these are quiet pictures, and I wanted the baby's delicate skin tones perfect, with the rest in moody shadow. Close down the aperture on manual or AV setting until you get the right look.

147. Go for a Classic Glamour Look

Photographers in the glory days of Hollywood used stronger, more dramatic lighting for their studied portraits than is common today. Try playing around with this effect, if you discover light like this in your home and have a patient model. My wife isn't a model, actually; she's my creative partner. We collaborate on ideas. Once in a while, though, I'll take a picture like this one, entirely about the light playing on her clothes, her makeup. It is a picture about surfaces rather than a picture of what I find beautiful about her every day.

TIP The room was quite dark, so I set the shutter speed very slow—1/10th of a second. It's not hard for the model to keep still at that speed, but it's very hard for the photographer to shoot without a tripod, which is why I used one.

▶ 1/10 · f/6.3 · ISO 800 · 50mm

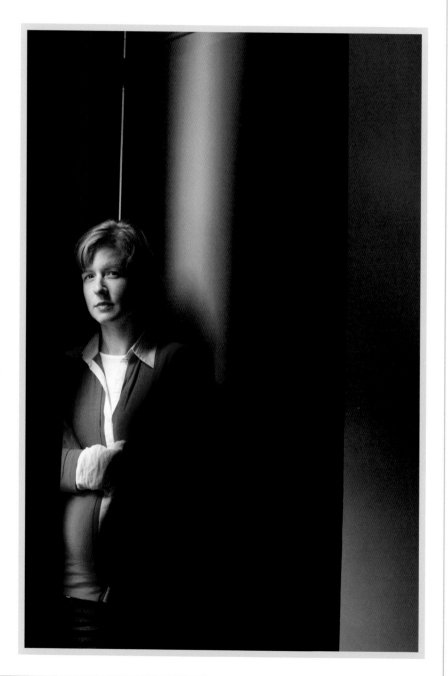

148. Apply Your People Skills to Animals

This shot is here as a reminder that the principles of portrait photography can be applied to anything— a dog, a cat, even a regal chicken. I love this shot because the pose is so human.

◄ 1/100 • f/2.8 • ISO 20 • 70mm

149. Pose People with Their Pets

I don't take pictures of animals very often, probably because, with travel and kids absorbing my time, they haven't been a part of my adult life. The same principles of connection and feeling and creative play apply, though. If your life includes dogs, cats, or other pets, use that connection to document those feelings and joy. The first shot here happened by the back window of a Jeni's Splendid Ice Creams store in Columbus, Ohio. We had been shooting pictures for a while when we decided to ask customers to let us photograph them eating ice cream. This dog and his owner were great—they both wanted a lick.

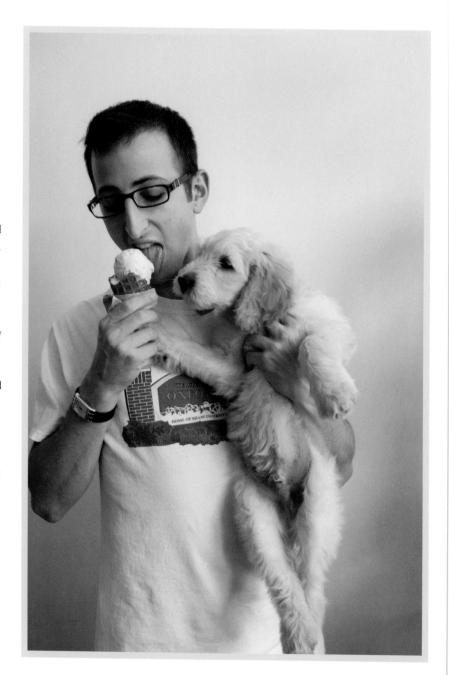

▶ 1/100 • f/5.6 • ISO 640 • 35mm

The second shot happened in a studio. My friend the choreographer Aszure Barton was visiting with her traveling companion, Tummo. They have been all over the world together; home for them is where they are. And when they pose for the camera, it feels as if they're at home, playing together in front of a mirror.

◀ 1/80 · f/5.6 · ISO 100 · 100mm

150.
A SIMPLE IDEA

Play outside with people

1/200 · f/7.1 · ISO 320 · 50mm

151. Shoot Gorgeous People in Gorgeous Light

Outdoor light can mimic beautiful studio or indoor light if it's diffused to eliminate hard shadows: by clouds, by the natural filtering effect of the sky very early in the day or at dusk, or by something you put between subject and sun, such as a sheet of cloth or a tent. Here, Florida swamp light, already interesting, is diffused by the trees, so that the shadows are all soft and flattering. While the background colors are brilliant, the background itself is out of focus. All that is true, but the picture is *entirely* about capturing the beauty of this dancer.

▶ 1/250 · f/5.6 · ISO 800 · 54mm

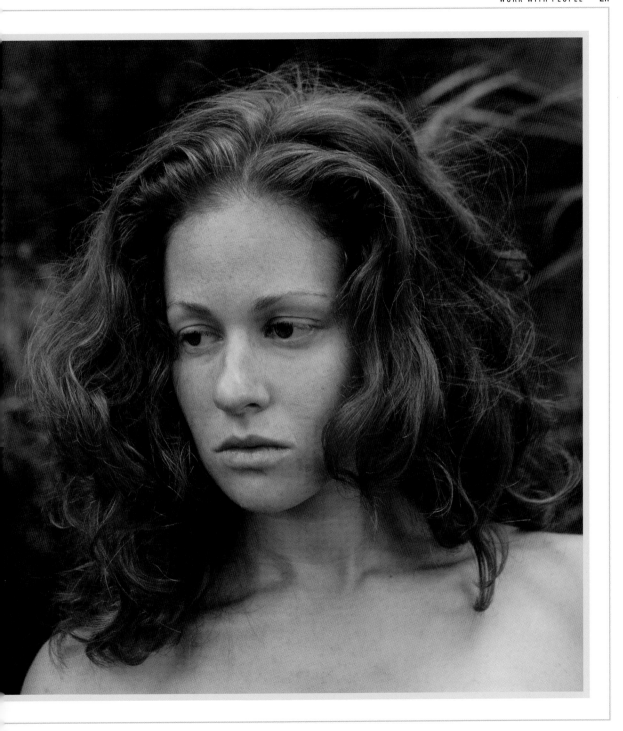

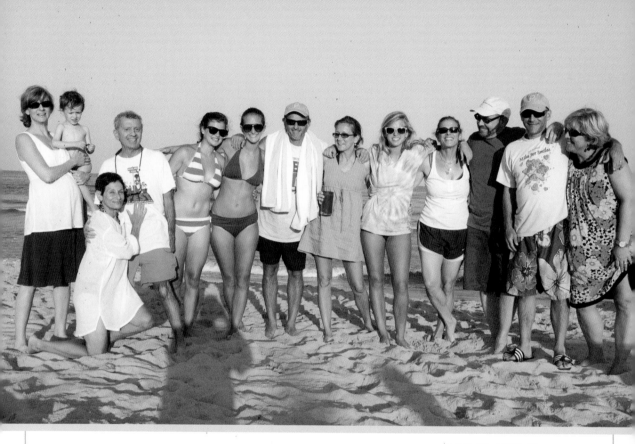

▲ 1/400 · f/11 · ISO 500 · 40mm

152. Don't Sweat the Group Shot

We always go to the beach at the end of July, and we always take these group photos. They do not have to be perfect (and they won't be); they're all about "we are here and happy to be together again." You might think your job is to make everyone look as pleasant as they can look, or to get everyone looking at the camera, but that's not the case. It's simply about the moment.

☀ ABOUT THE LIGHT

Late afternoon. Everyone's relaxed. The light is warm, not harsh. I'm using a wide-angle lens and I'm as close as I can get. My shadow allows me to be in the picture, too.

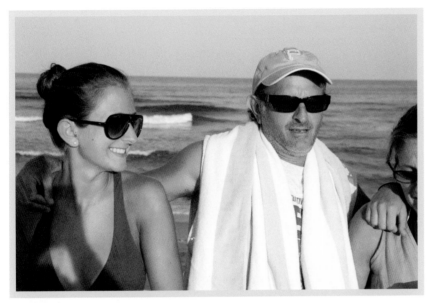

▲ 1/400 · f/11 · ISO 500 · 63mm

TIP Get people as physically close together as you can. After taking a few shots, move in close and take some tight ones, which are often the most interesting. (Set the camera to one exposure and just keep shooting down the group, as if you were shooting pieces of a necklace.) Then step back and take another group shot: It's often better the second time.

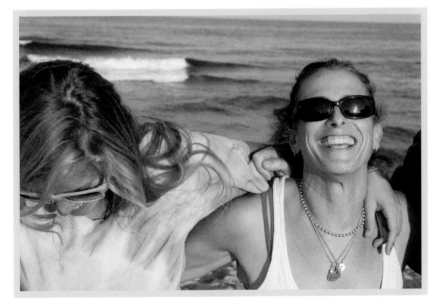

▲ 1/400 · f/11 · ISO 500 · 63mm

153. Set Up a Quick Portrait Series

In a place you love, surrounded by people you love, people who trust you: In such a situation, you start from a totally different place than you do with strangers or acquaintances, and it provides a great opportunity for a series of portraits—such as these towel shots at the beach house. Defenses are down on vacation. No one is in a hurry.

Planning is minimal. Just get out of the hard light; your light should be indirect—making late afternoon, when the sun is no longer beating down and everyone's relaxed, a good time for this project. Find a background that is simple but interesting. Then focus completely on your subjects.

▶ 1/80 · f/2.8 · ISO 250 · 62mm

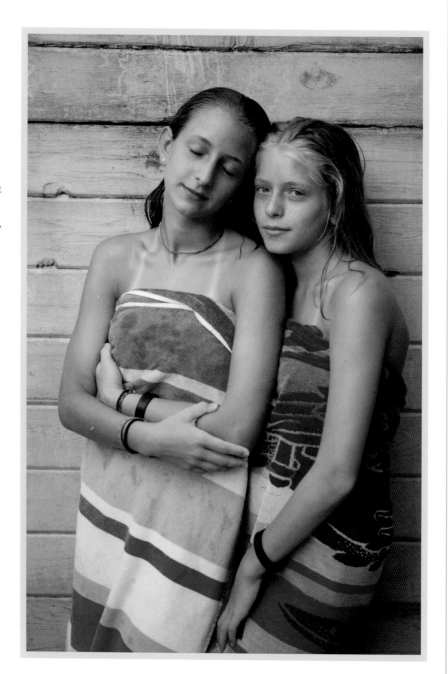

▲ 1/80 · f/4 · ISO 250 · 58mm

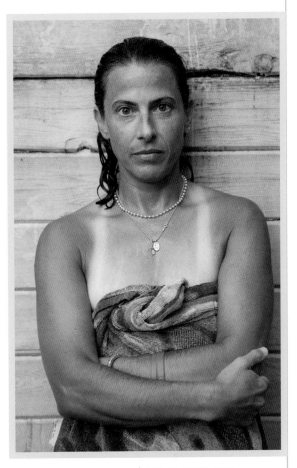

▲ 1/80 · f/4 · ISO 250 · 64mm

☀ ABOUT THE LIGHT

With an even light source like this, you don't have
to fiddle with the exposure once you've got things
set up.

154. Take a Fast Family Portrait

This shoot of a family in Des Moines was taken quickly during off moments on a magazine assignment. You could easily try something similar in an interesting room with good, indirect light. Notice the details of your subjects—their feet, the colors of what they're wearing—and work fast to get past the predictable. Use the camera in an unconventional way, moving into a detail, changing angles, pulling back; the pictures will get better as you go.

I can't reiterate enough how important it is to keep taking pictures even when you think you might be done. People often present themselves to the camera in a way that is self-conscious and not revealing. You have to work through that and let them get past their agenda. Some time after you've taken ten or twenty pictures, they'll start to run out of frozen looks and move to a more interesting place.

▲ 1/400 · f/4.0 · ISO 640 · 50mm

▲ 1/400 · f/4.5 · ISO 640 · 50mm

Kids are programmed from birth to smile for a camera, but notice how beautiful this girl is when she's serious.

COMPOSITION

The girl is almost centered left-to-right, but her eyes are well above dead center. The strong lines of her arm and of her mom's arm take your eye to the natural joining of their hands. A wide-open lens produced a shallow depth of field.

◀ 1/640 · f/1.4 · ISO 640 · 50mm

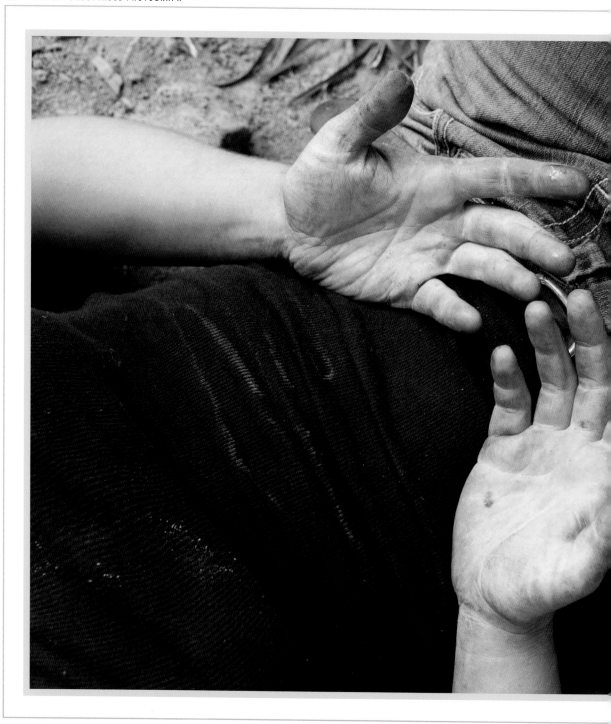

155.
A SIMPLE IDEA
Shoot
the dirt

◀ 1/200 · f/8 · ISO 400 · 63mm

TRY THIS

156.
Go in close. Keep it simple.

This is the actor Shawn Ashmore, shot as part of a series for a magazine. I was shooting several actors for the story, but split between New York and L.A. I needed a simple concept to tie them together. I found a place in Brooklyn that made incredible handmade wallpapers, and built walls with them to use as backgrounds. This was shot in Los Angeles, and lit by strobes diffused with a large soft box to keep the light soft.

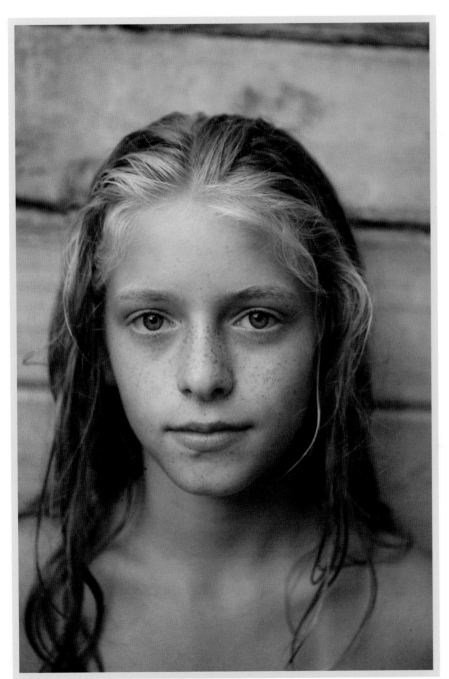

A wide-open lens reduced the depth of field in this shot, drawing the eye to her beautiful face. Contemplative expressions tend to bring out a sense of a calm soul behind the beauty. The trick is getting the subject relaxed enough to let that shine through.

◄ 1/80 · f/2.8 · ISO 250 · 64mm

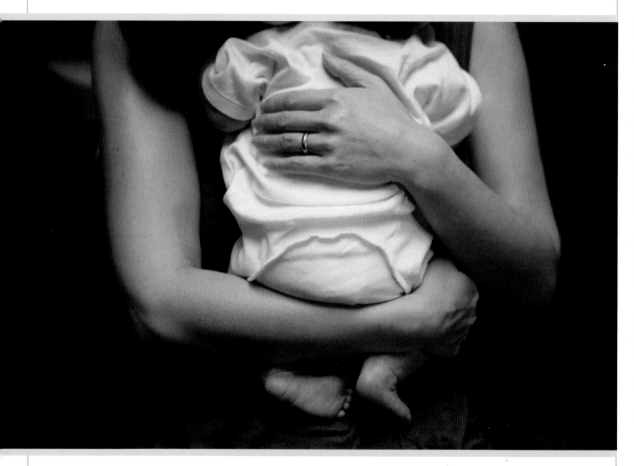

▲ 1/60 · f/4 · ISO 640 · 70mm

157. Cut Off Their Heads

If you cut out the subject's face, a picture can become more universal: Here we feel comfort, love, touch, quiet. You don't have to know the subjects to feel that connection. And if you do know them, a picture like this can distill your feelings into something potent and unforgettable.

Cutting off a subject's head can also make a photo funnier. At right, the little boy marching to keep up with an older girl is cute, but making her headless focuses your eye on the real subject of the picture: him.

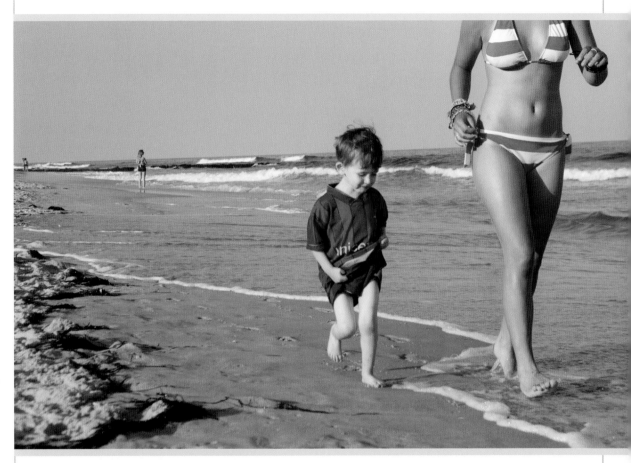

▲ 1/800 · f/9 · ISO 500 · 70mm

TIP There is very little Photoshop work in the pictures in this book, but removing an annoying thing, like this intrusive leg, is easy, even with a home version of the program like Elements.

PLAYING WITH BABIES AND CHILDREN

I love to photograph children, but I like to be on their level. Some are hams, some introverts, many much smarter than I am. They've been taught to smile and pose for the camera from day one, and you have to work past that to get to the good stuff. It's not difficult, and the principles are the same as with adults: Talk to your subjects, play with them, surprise them, get them off-balance, keep shooting until they relax and have fun.

While I could look at babies forever, I am not that interested in photographing what babies simply look like. Rather, I am trying to capture what is going on in the first days and months of their lives. How are they negotiating the world? What are they taking in? Their joys and their fears interest me, as much as their innocence. Babies *always* have something on their minds. They're thinking all the time, trying to figure out who they are in the world.

158. Get Past the Baby Colors

Most of the time babies are bathed in white or pastel, all innocence. Here my son is wrapped in a soft black cashmere sweater that absorbs the light, making for a photo that is quite dramatic, but not at all harsh. The buttons are the only thing giving shape to his cocoon.

◀ 1/100 • f/4.5 • ISO 640 • 50mm

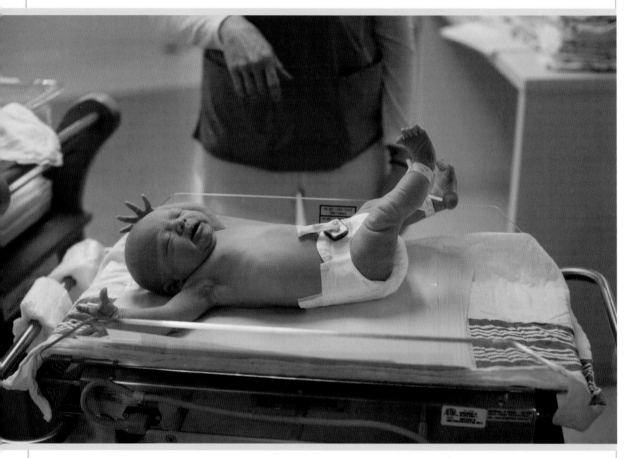

▲ 1/100 · f/2.8 · ISO 800 · 50mm

159. Ask, and Ye Shall Get Permission (Usually)

Don't be limited by what you think you can photograph in a maternity ward; simply ask to go where you think you're not allowed. Most times the answer will be "yes," which is a good thing, because afterward, you will remember so little! Most mothers aren't even there when the baby is weighed, so the mom's partner can fill in the story with a camera.

☀ ABOUT THE LIGHT

Hospitals generally have horrible light, but the new digital cameras can be set to compensate for fluorescent glare, often the least flattering light of all, and a program like Photoshop Elements can also adjust for fluorescent, tungsten, and other harsh light.

▲ 1/100 · f/4 · ISO 800 · 50mm

160. When in Doubt, Hold Them Upside Down

I like pictures of babies being held and suspended—without showing who's holding and suspending them. Take advantage, carefully, of that short period when children trust and love your total control. Always provide safe landing just out of the frame; cropping tight creates the illusion that they are much higher than they actually are.

◉ ABOUT THE LIGHT

Because of the backlighting, I carefully exposed for his face at f/4. Being close up at that exposure put the rest of the room nicely out of focus.

161.
A SIMPLE IDEA

Play with scale

◄ 1/125 · f/10 · ISO 640 · 30mm

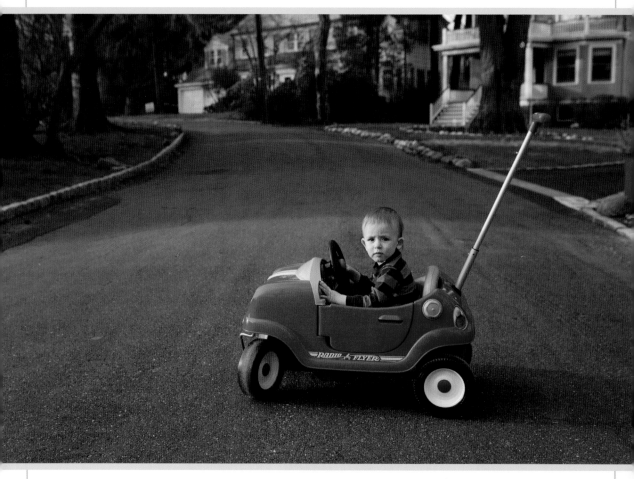

▲ 1/160 · f/5.6 · ISO 400 · 40mm

162. Create a Bit of Imagined Peril

Moving kids out of their usual environment causes disorientation—in them, and in the viewer. If my son had just been playing in his plastic car in the backyard, he wouldn't have looked at me quite the way he does in this shot. Out on the road, he knows something's up. I would never put him in real peril, but the *suggestion* of risk touches something at the heart of a child's (and of a parent's) reality. This is actually a very composed picture, very put together: the road curving off, the sunlight on his face.

TIP Most portraits of children benefit from being shot at their eye level. Here, taking the photo from the perspective of an adult adds to the "danger"—it almost reads as if it were shot by someone in a real car who had stopped on the road.

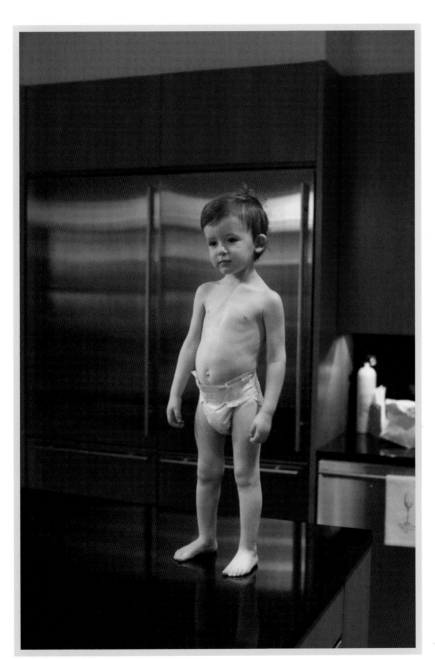

163. Counter Poise

Variation on a theme—again, a bit of imagined peril. Here, Jackson is brought up to adult eye level by placing him where he's not supposed to be. He's not posing, but he's also not in a situation where any of his normal expressions or actions come out. He knows he can't run around. He knows I'm taking the picture. He knows he's not supposed to be there. And he knows he's incredibly handsome.

◀ 1/60 • f/3.2 • ISO 800 • 50mm

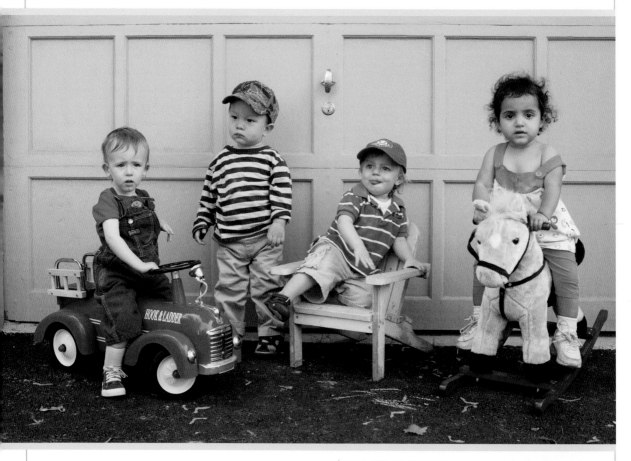

△ 1/250 • f/5.6 • ISO 400 • 50mm

164. Submit to the Chaos

Group shots of kids become a lot less nerve-wracking when you realize you can't control the gathering. They don't need to be looking at the camera, or behaving, or smiling. The best you can usually do, especially with kids this young, is to let them deconstruct your idea of the picture and hope for something fun. Here, trying to capture a reunion of kids born to parents who shared a birthing class, I failed to get half of them to even look at me!

TIP As I almost always do with group shots, I moved in and took individual shots, mindful that I might need to change the exposure as the angle changed. Then I moved back to take the group again.

➤ 1/250 • f/7.1 • ISO 400 • 50mm

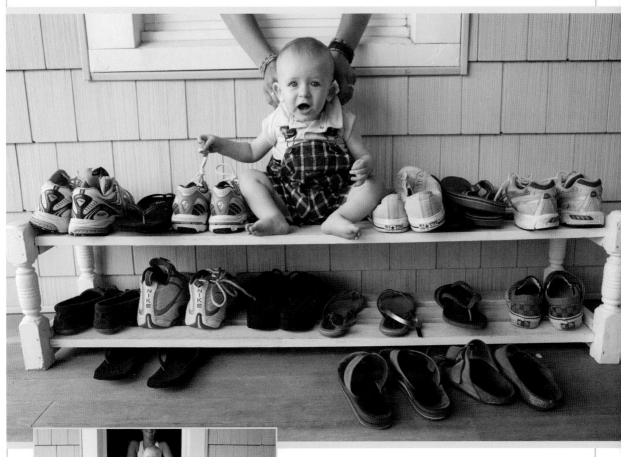

▲ 1/125 • f/7.1 • ISO 500 • 30 mm

165. Hold the Poser

Summer at a crowded beach house: the futile attempt to keep the sand out of the house, the inevitable shoe pile-up. I wanted to have my son there, but he couldn't sit up. Problem solved by engaging a helper—and seeing the helper's arms makes it a lot more fun.

▲ 1/125 • f/7.1 • ISO 500 • 27mm

166.
A SIMPLE IDEA

Isolate
the baby

▶ 1/400 · f/4 · ISO 160 · 32mm

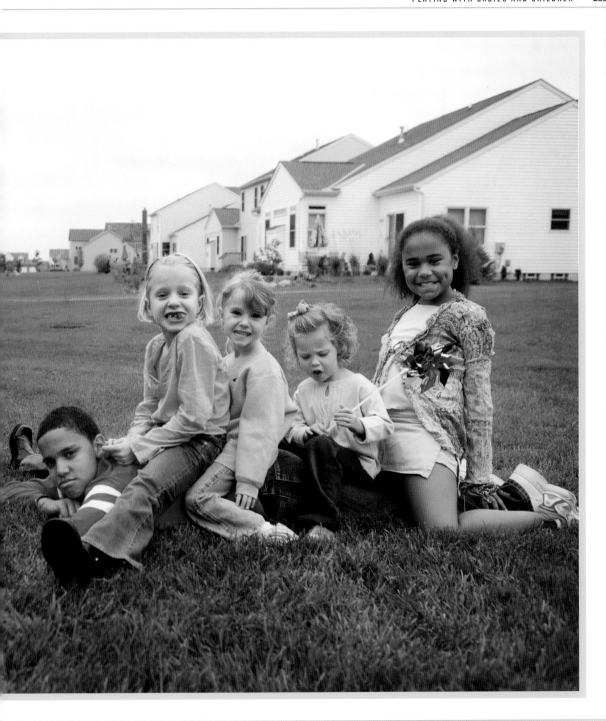

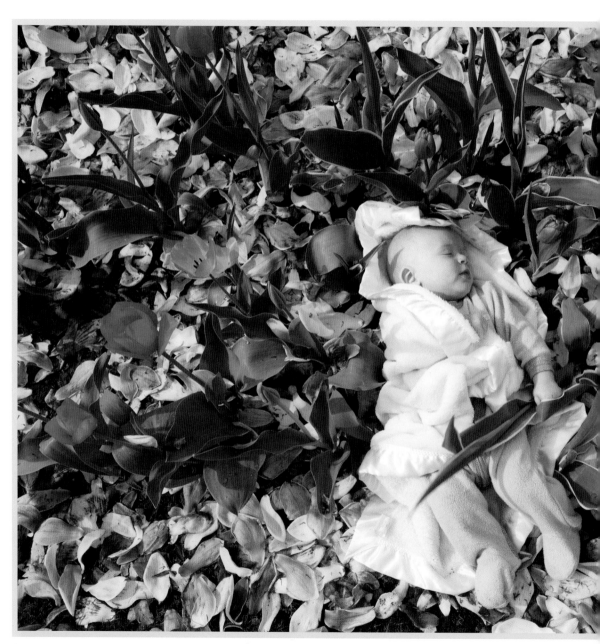

▲ 1/250 · f/10 · ISO 200 · 27mm

167. Put Babies in Surprising Places

We were in Pittsburgh during the wild spring magnolia explosion; the garden on a neighbor's piece of property was begging for more attention than I was able to give it from the sidewalk. No one was around, so I just lay my son down and shot from above. He kept snoozing while I kept shooting. Trespassing with a camera (especially when a baby's involved) is generally not a problem; at worst, a person may be curious about what exactly you're seeing.

When Jackson was older, he looked at this picture and noticed the most important detail: "Dad! I still have that blanket."

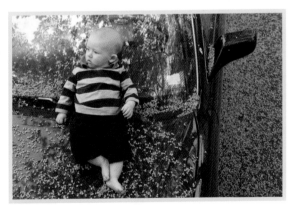

▲ 1/80 • f/18 • ISO 400 • 48mm

TIP When you put a child someplace unexpected, you have only a moment or two to get a picture. Exposure and focus are set up ahead. For this shot, our car was sitting under a tree in spring when the early buds were falling. I was on a ladder looking down—but Stephie's hands were just out of the frame, ready to stop a fall.

168. Let the Kid Work the Picture

It's amazing how creative kids can be if you just get out of their way. This little girl was walking down the street with her parents while I was doing a shoot in Brooklyn. There was something really special about her: Although she didn't engage my camera at all, she teased it plenty. The more I wanted to see her in my shots, the more she hid under the table, insisting that the pictures be taken on her terms. I took maybe twenty photos of her; in each one, she's moving, trying different things; none of the pictures is the same. You never control kids; just set a stage where fun things can happen.

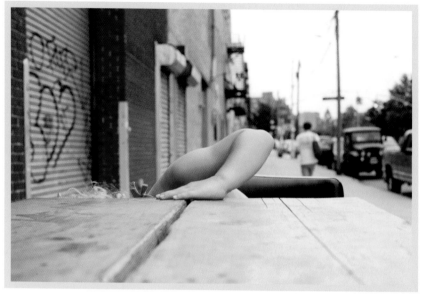

▲ 1/160 · f/7.1 · ISO 800 · 50mm

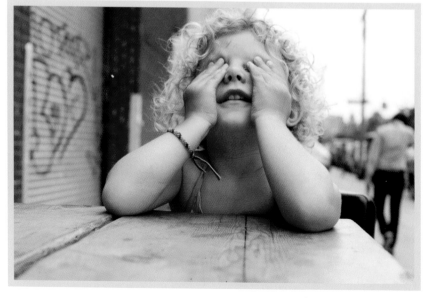

▲ 1/160 · f/7.1 · ISO 800 · 50mm

▲ 1/160 · f/4 · ISO 400 · 50mm

169. Find Beauty in the Everyday

You have to be awake to the beauty of every moment to realize there's something worth photographing in the first place. On the surface, these shots take something normal and make it kind of funny. There's a deeper meaning to capturing the everyday stuff like this: Life is precious, it's extraordinary, it moves by much too quickly.

TIP Getting these shots wasn't hard for me because I know these girls so well; I used the "pretend my camera is your mirror" trick.

▲ 1/160 · f/4 · ISO 400 · 50mm

170. Reenact Fun Shots

When you hit a home run—as I did with the beach shot to the left—it's fun to try again and make the second shot (below) a riff on the passage of time.

The original picture works for several reasons: Jackson's relaxed posture; his deadpan look (he has no idea how lucky he is); the colorful bikinis; the happy, unforced expressions on the girls' faces; and the fact that most of those faces are cut off, which takes the viewer's eye back to Jackson, who sits pleasingly off-center.

It was so good that I tried it again two years later. The result is fun but not as successful, partly because Jackson is now in on the joke—he's looking away while two girls, whose faces are fully in the picture, are looking at the camera. The viewer's eye becomes a bit restless: What's the picture about?

The second shot is one you'd be happy to have, but compared to the original, it falls a bit flat. Still, worth the try. You might have more luck than I did.

▲ 1/250 · f/16 · ISO 500 · 50mm

◀ 1/1000 · f/6.3 · ISO 400 · 50mm

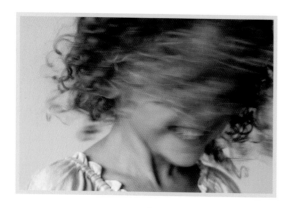
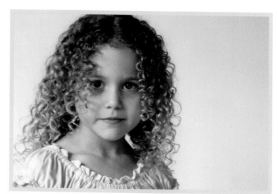
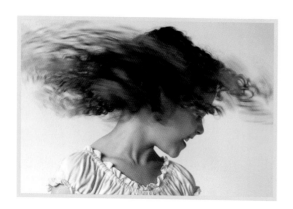
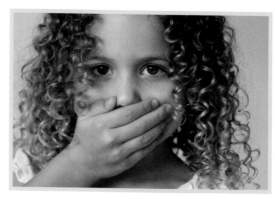

▲ 1/80 • f/6.3 • ISO 320 • 100mm

171. Shoot a Portrait Series with a Child

Find a simple background and nice light, set your exposure, get in close to your subject, and have fun.

TIP A fairly slow 1/80th of a second shutter speed captures the motion blur I wanted as she tossed her head back and forth. A camera that shoots several frames per second is ideal; even most point-and-shoots can manage more than one shot per second.

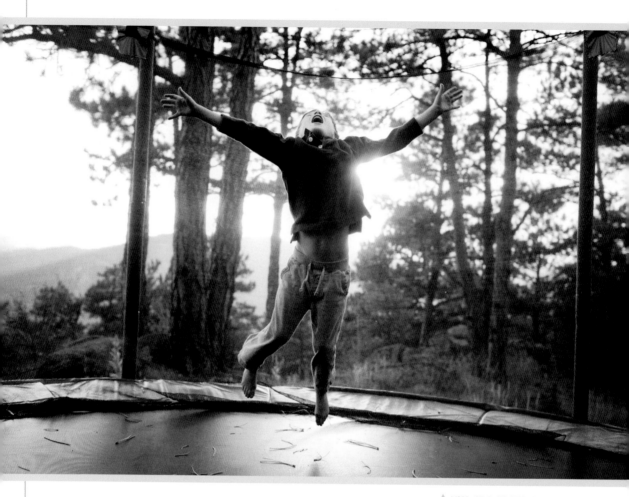

▲ 1/800 · f/3.5 · ISO 1250 · 35mm

172. Shoot a Sequence Against Backlight

This one was tricky: I wanted to freeze the action of my son circling and bouncing on a trampoline while shooting directly into the sun. I used a fixed wide-angle lens, set the ISO high enough (1,250) that I could push the shutter speed to 1/800, and then set the aperture so I was exposing for his skin (on automatic, the meter would expose for the sun and plunge the picture into darkness). In the best shot, above, his face is perfectly exposed despite the brilliant light behind, and there's a fine golden glow around him.

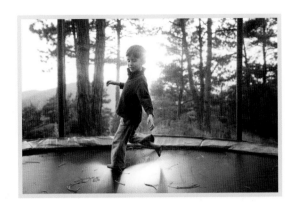
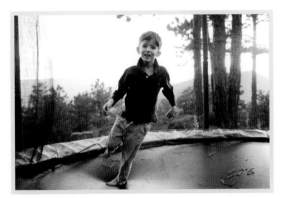
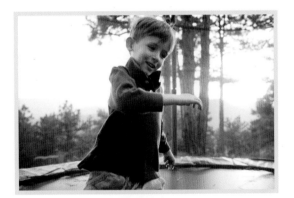
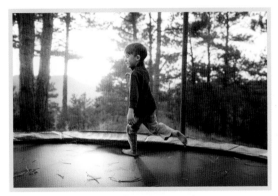
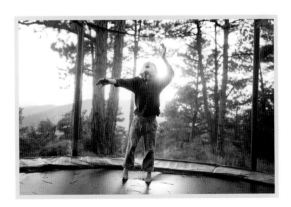
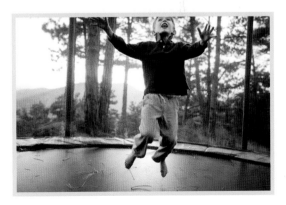

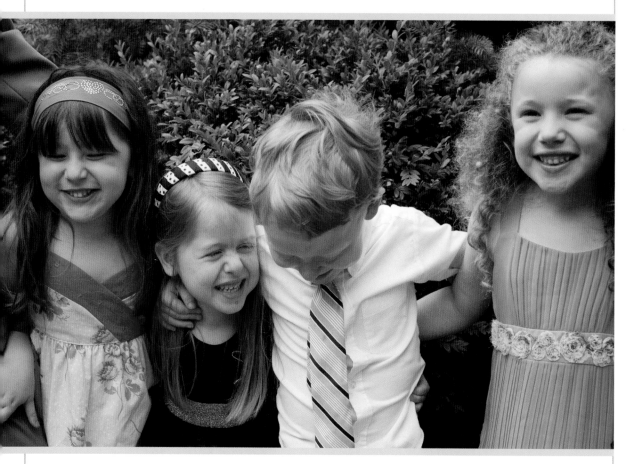

▲ 1/800 · f/7.1 · ISO 500 · 50mm

173. Capture Kid Energy

Only one kid here is actually looking at the camera, but there's so much energy, so much great energy, in the photo. When I'm photographing a group—especially a group of kids—I never say, "Look at me and smile." Generally I make up complete nonsense, so everyone is trying to figure out what I'm getting at; my goal is not to confuse, rather it's to have them fall into being themselves.

I have two options: Engage the subject and create a place where we can free ourselves, or be the quiet observer. There is a time for both.

174. Capture Kid Cool

Here, with a boy I happened to spot in a London park, was a subject who radiated so much attitude that I had to treat him like I would a movie star. I put him dead center in the picture, which I usually avoid, heightening the formal drama of the shot.

TIP The foliage makes for a good backdrop, but when it's busy like this, it's good to try a version in which it is out of focus.

◀ 1/500 · f/4 · ISO 400 · 63mm

▲ 1/100 · f/2.8 · ISO 800 · 59mm

175. Portrait of the Child as a Serious Person

When I went to art school, we were discouraged from taking any pictures of people smiling—that wasn't art. I don't buy the obsession with the glum, but, on the other hand, children, who we're "supposed" to shoot as happy beings, are often pensive. Serious portraits of kids do not mean they are unhappy; rather, they honor the wholeness and depth of their personalities.

This was shot in Cowboys Stadium, against the backdrop of a simple black curtain—no flash.

◀ 1/125 · f/7.1 · ISO 1600 · 63mm

176. The Kid Doesn't Have to Be in the Picture

Jackson and I are big Steelers fans, and we went together to Dallas for a football game. I picked the hotel we stayed at as much for photographing as for comfort and price. Our room was a loft with a huge window behind the bed and curtains that I thought would look good in the pictures. Jackson had other ideas, and this shot is a good example of why I find it's usually best to take his lead. He peeked out, then almost disappeared, leaving me to shoot this picture.

▶ 1/320 · f/28 · ISO 1250 · 70mm

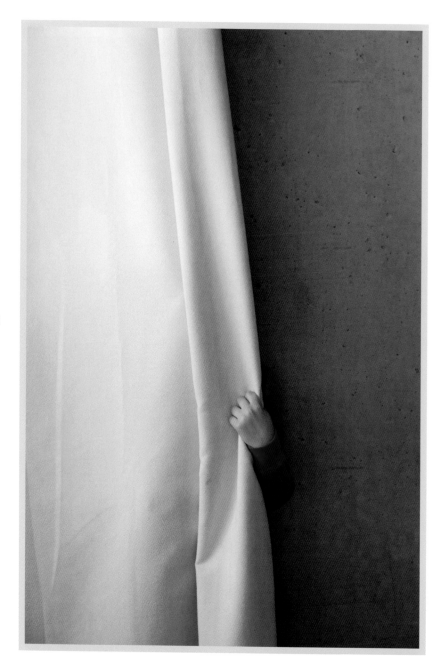

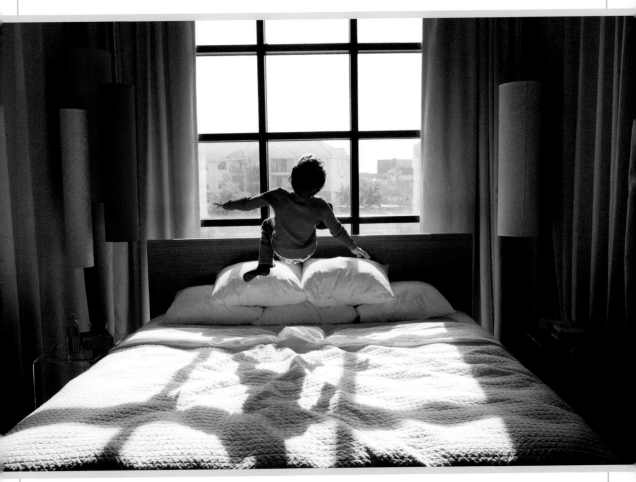

1/1000 · f/10 · ISO 1250 · 33mm

177. Let the Kid Play!

Another shot from the Dallas trip. While there, we went to the Perot Museum of Nature and Science, where there was a slow-motion camera that allowed you to see your athletic form at 600 frames per second (my pro camera takes, at best, 14 frames per second). Jackson kicked a football and was able to watch how his leg went up over his head. Here he is after that, in our hotel room, practicing his form on the bed. This was taken at 1/1,000th of a second, with the ISO set high so that the aperture could be closed down for lots of depth of field.

USE PROPS AND BACKDROPS

If you've been to the theater, or in a TV studio for the taping of a show, you've seen the power of props and backdrops to set a scene, frame a shot, imply a world, and create a dramatic or funny interaction between a subject and an object. Propping portraits is almost as old as photography itself.

I scavenge many props, or buy them cheap: chairs, ladders, an old tin tub from an antiques store, a piece of architectural detail from a salvage shop. You, too, can go to thrift shops and yard sales just looking for things to use in your photographs: hammocks, fabrics, objects whose practical functionality is long gone but whose photographic potential is totally untapped. I also make backdrops. In my studio and home, I will have surfaces painted and distressed. We're not afraid to put holes in the walls, to paint and repaint things. I'll buy a blanket to use as a backdrop, or flatten a cardboard box, paint it, and hang it on a wall.

Always be on the lookout for great surfaces and unexpected light. Beautiful walls are everywhere: in abandoned buildings, down streets and alleys, around the corner of your own home. In big cities at midday, watch the wild reflections of light off the tall glass buildings as they fall on walls.

The world is your set, your prop closet.

178. Use Things the "Wrong" Way

A chair is just a chair until you use it the wrong way, and then it's an interesting prop. Too-small chairs, tilting chairs, chairs in grass and snow, chairs picked up so that they're not even functioning as chairs—they are all clay for you to mold (and for Channing Tatum to have fun with).

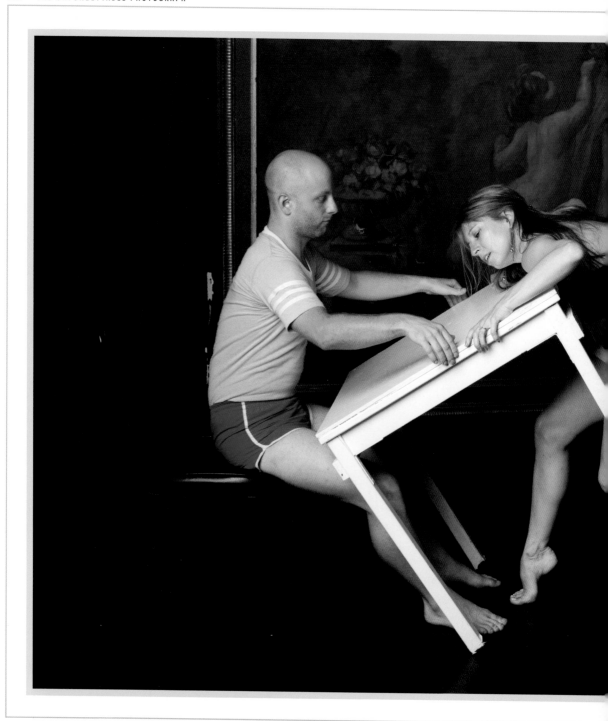

179.
A SIMPLE IDEA

Anything is a prop

1/125 · f/11 · ISO 100 · 50mm

180. Use Props for Scale

I love the fact that one of these sisters has outgrown the box and one hasn't. A prop can do its job simply by showing scale. Before you throw out an old box, think about how you might use it.

☀ ABOUT THE LIGHT

I was shooting this in my garage, so I turned the box slightly toward the door to admit some light; I didn't want the shadows to be too dark. I didn't use a reflector, but that would have been another way to get light into a dark space.

▶ 1/4 · f/5.7 · ISO 100 · 90mm

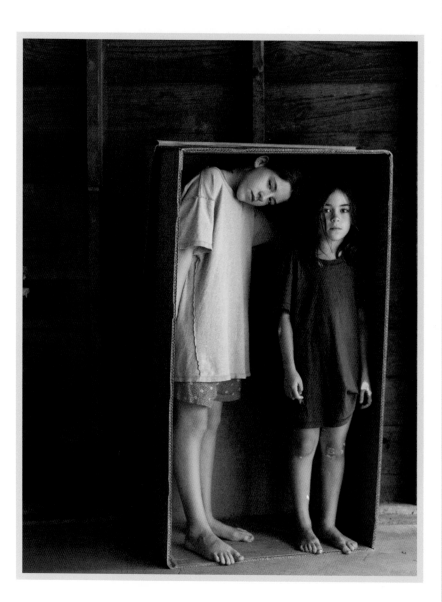

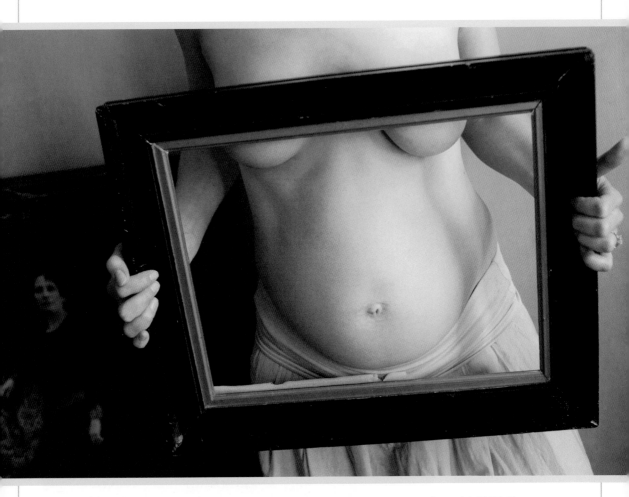

▲ 1/50 · f/4 · ISO 500 · 50mm

181. Use Props for Discretion

This was from a series of pictures about the arrival of our second baby. The frame provided an elegant solution: how to show Stephie's growing belly while allowing her some modesty.

182. Use an Object Out of Context

Props often make portrait-taking easier by giving subjects something to relate to and play with, distracting them from the camera. Props taken out of context—a dining chair on a lawn, even in a snowstorm—immediately add interest and fun.

TIP A simple chair that doesn't call attention to itself is best for pictures like these.

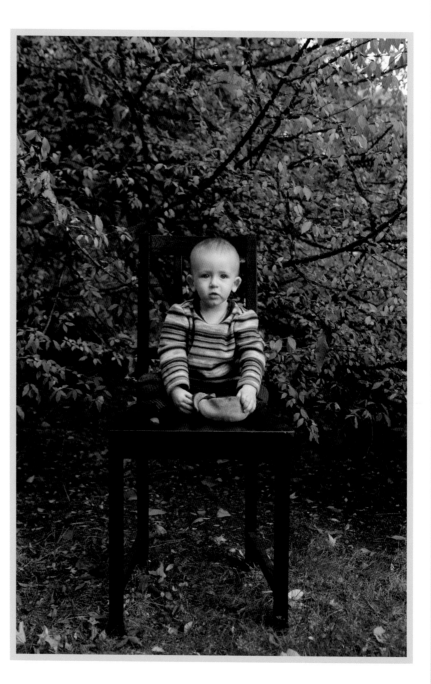

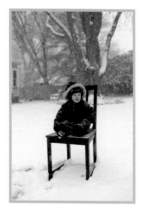

▲ 1/125 · f/4 · ISO 200 · 40mm

▶ 1/125 · f/5 · ISO 400 · 42mm

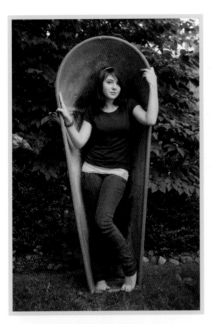

▲ 1/400 · f/2.8 · ISO 400 · 48mm

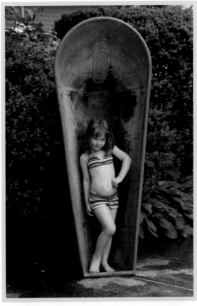

▲ 1/125 · f/7.1 · ISO 320 · 62mm

183. Prop the Passage of Time

When I bought this metal planter at an antiques store in Pittsburgh, I decided I would shoot kids in it for years. The idea was to have photos in which the size of the prop remains constant, but the size of what I put inside does not. Any container in which you can frame the subject, even an interesting corner of a room, will work the same way.

The photo on the left hasn't been rotated, but the camera was, creating the tilting lawn effect.

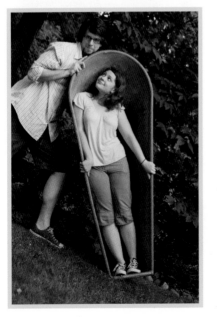

▲ 1/100 · f/5 · ISO 400 · 58mm

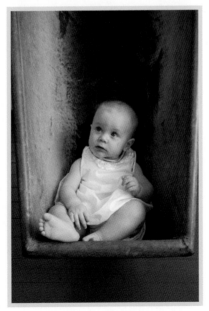

▲ 1/100 · f/4.5 · ISO 500 · 38mm

184. Blur the Prop

I put my camera on a tripod and asked our young friend Eve to get inside an old box I had painted that morning for just this purpose. I told her to move around, but not *how* to move. She explored the way the box moved for herself, with this beautiful and mysterious result.

The great thing about this photo is that her upper body is moving but her feet are still. You don't have to direct things like this; you just let them happen.

▶ 1/8 · f/13 · ISO 100 · 95mm

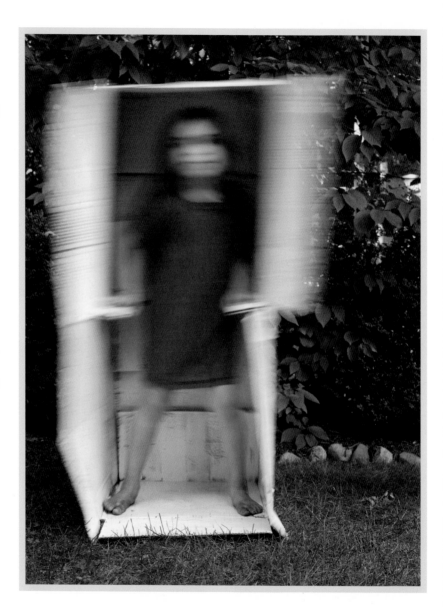

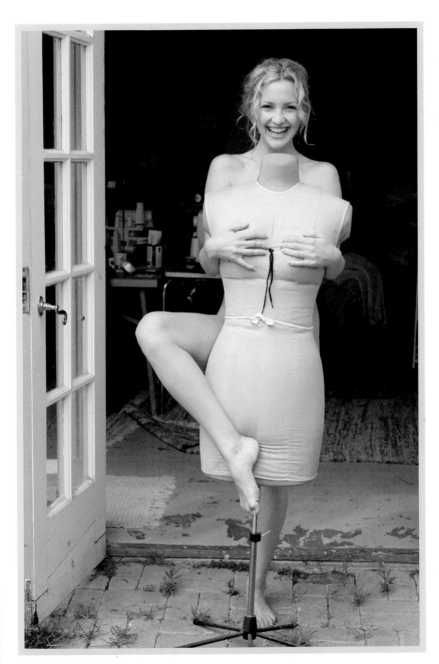

185. Play with Props

I got a call from *InStyle* magazine: "Would you like to photograph Kate Hudson naked this weekend?"

Yes, I would! I found a great location—an artist's studio up in Malibu. Kate arrived, took off her clothes, and said, "What do you want me to do?" First we tried an old tin bathtub as a prop. And then we started goofing around with this mannequin. Nothing was planned—I was just looking for ways to cover her up enough for the publication. Which you will probably want to do with your friends, too—if you can get them undressed in the first place!

186. Obscure Faces with Props

Above is my friend Christine in a London hat shop, where she pulled out her camera to take a picture of me. Totally unplanned. Right: a girl at a wedding and a hotel doorman in Rome.

△ 1/60 · f/5.6 · ISO 640 · 70mm

▷ 1/250 · f/4 · ISO 400 · 63mm

▷ 1/100 · f/11 · ISO 640 · 50mm

▲ 1/160 · f/5 · ISO 800 · 35mm

187. Use Old Pictures as Props

I am still friends with my girlfriend from seventh grade, Susie Feldman. On a visit to her home in Los Angeles, she showed me an old Polaroid from a party when we were young. I held it up, focused on the print, and let Susie go out of focus in the background.

188.
A SIMPLE IDEA

Shoot
young
people
with old
things

◀ 1/200 · f/5 · ISO 320 · 70mm

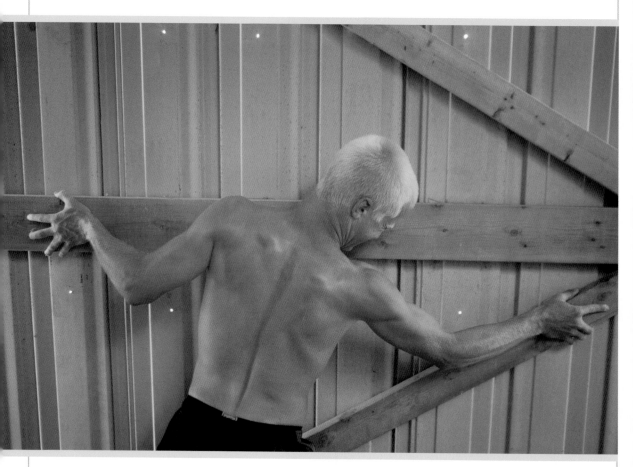

▲ 1/250 · f/2.8 · ISO 640 · 40mm

189. Play People Against Geometry

As you move your eye around a room or street, watching for the meeting of lines and shapes, you'll suddenly feel things click into place; these are spots where you can shoot people particularly well. Sometimes these lines create a feeling of energy, of motion; other times, a "this must be the place" feeling of intersection. Often, shapes and lines simply provide a great framing device, as with the orange rectangle pictured on the opposite page, where a client and an assistant played, after a long day of shooting in Helsinki.

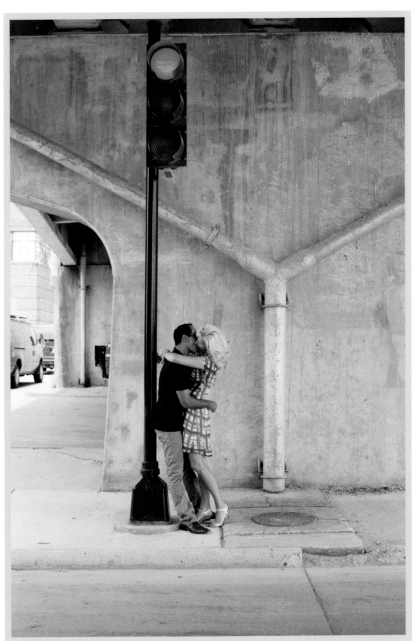

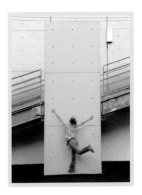

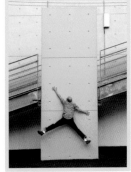

1/200 · f/8 · ISO 320 · 50mm

190. Shoot Through Fabric . . .

. . . or foggy glass, dusty windows, screens, shower curtains, or gauze. Putting something between your eye and the subject doesn't necessarily distance the viewer; sometimes it brings the viewer into the scene in an intimate way.

☀ ABOUT THE LIGHT

This is backlit, but, importantly, not quite a silhouette—you can see my wife's face. Since the room was quite bright and I was using a point-and-shoot, I put it on manual so I could prevent overexposing the scene.

▶ 1/60 · f/3.5 · ISO 80 · 60mm

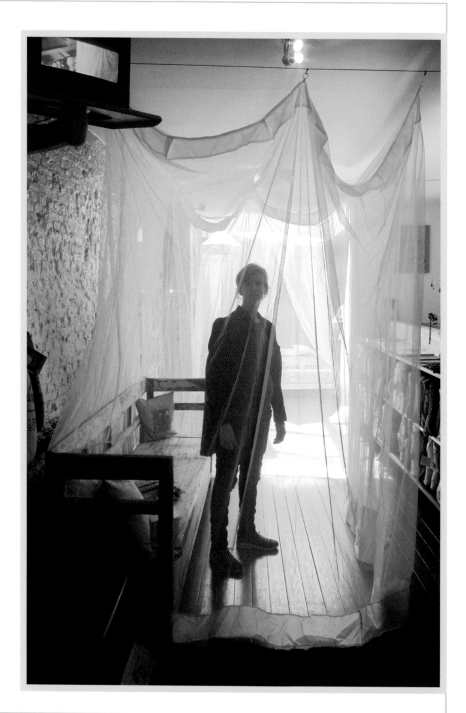

191. Shoot Through the Mess

We were in an ice storm on our way to a commercial shoot. I took the top shot from inside the car when the driver got out to wipe the windshield, and the one at right once we got going. (Or try the opposite: My first assignment for *Rolling Stone* was shooting the rock band Violent Femmes in a freezing Milwaukee winter. I had them stop one night on an abandoned highway, squeeze in the front seat, and I shot from the outside in.)

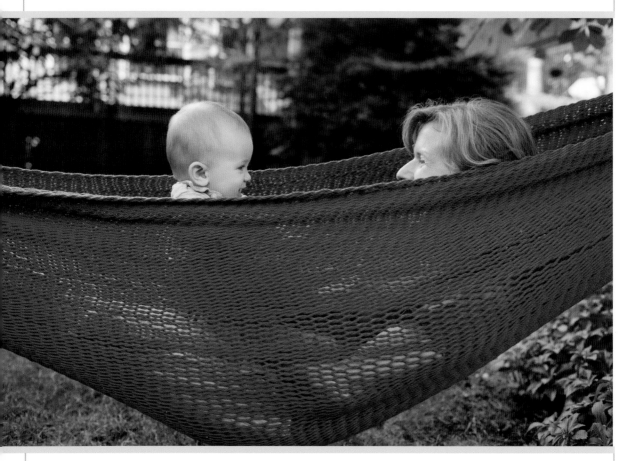

▲ 1/320 · f/2.8 · ISO 800 · 35mm

192. Wrap Up the Subject

Containing a person in fabric—sheet, blanket, towel, curtain—often works a kind of magic. Hammocks are nothing short of fantastic: They flow with the body while partially enclosing it, and if made of mesh, they let light through. If you have one, hang it and get shooting.

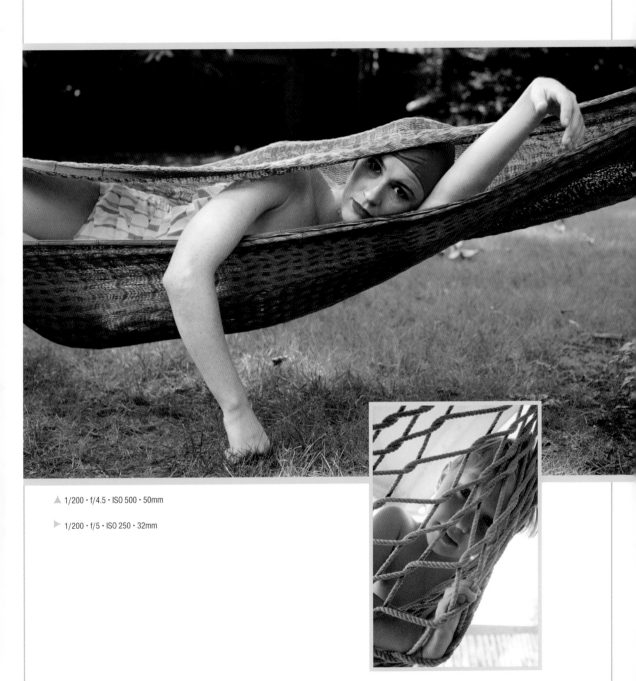

▲ 1/200 · f/4.5 · ISO 500 · 50mm

▶ 1/200 · f/5 · ISO 250 · 32mm

TRY THIS

193.

Use a dramatic sky as your backdrop

Underexposing a sky makes it richer, more dramatic.

▶ 1/640 · f/11 · ISO 400 · 65mm

▲ 1/50 · f/3.5 · ISO 50 · 12.5mm

194. Use the Street as Your Studio

All the texture, light, colliding surfaces, and shapes—all the architecture of the
street: Cities are big, raw spaces just made for your private photographic use
and pleasure. Street art is everywhere, with much of it—say, an Obama poster,
or a movie ad, or graffiti—acting as a time stamp. Old cities are rich sources
of background and inspiration; all you have to do is play with the layers of
overlapping history.

**The off-center pose is important
for the balance of this shot.**

▲ 1/125 · f/7.1 · ISO 320 · 35mm

◀ 1/125 · f/7.1 · ISO 320 · 35mm

195. Write on a Blackboard

Blackboards are both props and backgrounds. The quality of a blackboard—or blackboard paint that you can slather on an old surface—is really beautiful. You can get people to draw or scribble on it, and the patina quickly builds as the chalk is rubbed away.

I carried an enormous blackboard with me for a series of portraits of people attending a rally.

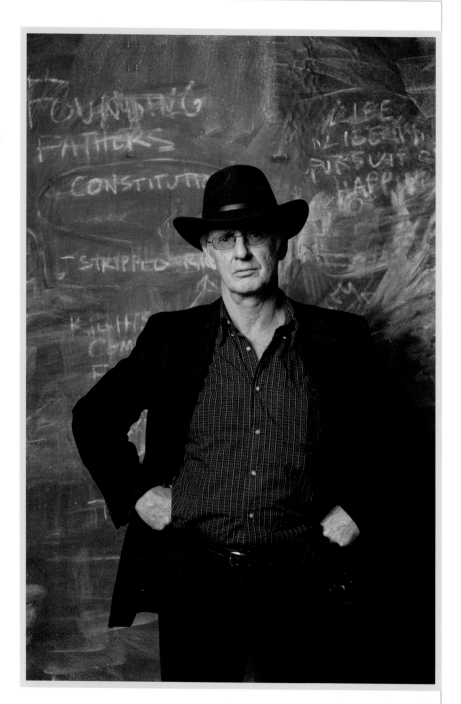

▶ 1/250 · f/10 · ISO 100 · 80mm

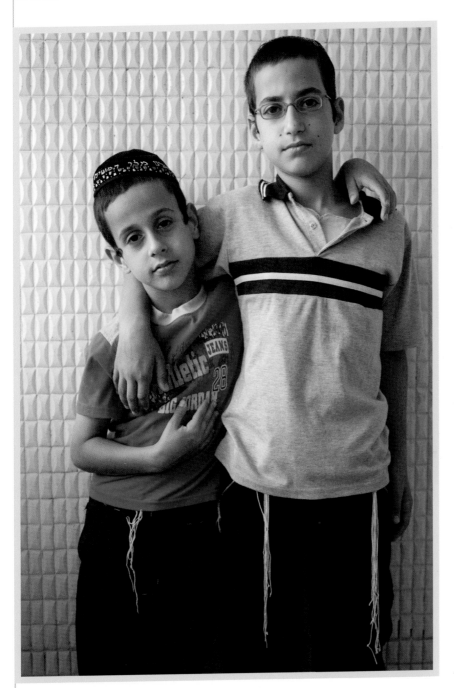

196. Use a Patterned Background to Emphasize Detail

The repeating patterns of tiled walls make for perfect backdrops. In this case, the viewer looks at the wall and then down, to what I think is the wonderful detail: the tzitzit hanging out from beneath the shirts of these boys in Israel.

◀ 1/60 · f/4.5 · ISO 200 · 55mm

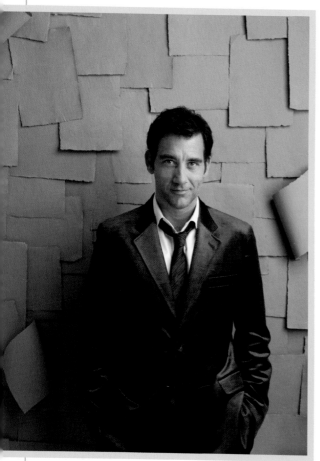 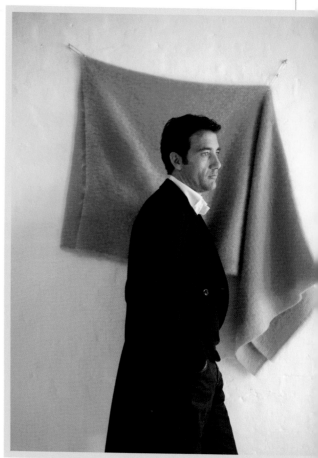

▲ 1/60 · f/2.8 · ISO 320 · 50mm

197. Make Your Own Simple Backgrounds

In the studio, we often make backdrops by simply painting a wall or board, or wallpapering a surface. The idea is to control the background in a way that creates the right mood for the subject. White is good, but color and texture add a lot.

When shooting Clive Owen in London, we simply stuck sheets of construction paper to the wall, loosely arranged for a more interesting effect. I shot some close-up. Then, when I pulled back to show the background, it also worked: The paper climbs up the wall in no apparent pattern.

Next we tried a piece of cloth. The folds of this simple background prop catch the light (he's facing into it) and frame his face. You could easily do this against soft window light in your home. Indeed, everything here could be duplicated in a few minutes just about anywhere.

198. Even the President Can Sit in the Corner

I had photographed President Clinton twice in the White House and was very excited to shoot him at his New York office in Harlem. But when I scouted the office, I found it busy, not terribly interesting visually, and not right for a magazine cover at all. So I had this wall built and wallpapered, and we installed it in the office the morning of the shoot.

Sometimes you need to control a setting, to find a way to create an environment that is neutral and yet unexpected. Putting Bill Clinton in a corner contained him, but it couldn't possibly upstage him.

HAVE FUN

Life for the lucky is a series of games: Let's play honeymoon; let's play vacation at the beach; let's play grown-ups out on the town.

My wife, Stephie, and I just push our play a little further, and we take pictures along the way. Our play involves props and string and Sharpies and paint. It happens at home and on the road. When we walk into a new hotel room, we get giddy with the possibilities; often we pick a hotel based on some idea of how it will photograph.

People who see the photos we take of the games we play say we're "so creative." It's a matter of choice, really. It's a matter of putting aside the daily obligations that clog our lives and making play a priority. Travel is play, vacation is play, and almost everyone connects the play of travel and holidays with photography. So carry that instinct into your daily life. It can be as simple as spending time in a part of your house you rarely visit, such as the attic, or going to a place in your town that is abandoned part of the day, or to a friend's lake cabin or beach house. Get into a playful state of mind, grab your camera, see what follows.

You can also, as we do, channel this play into projects that document an important event, like a pregnancy and the arrival of a child—and then share that project with the people you love, giving them a glimpse not only of the event but of its celebration.

The ideas here aren't prescriptive, obviously, but maybe they will inspire you to tell some stories and to push your own boundaries.

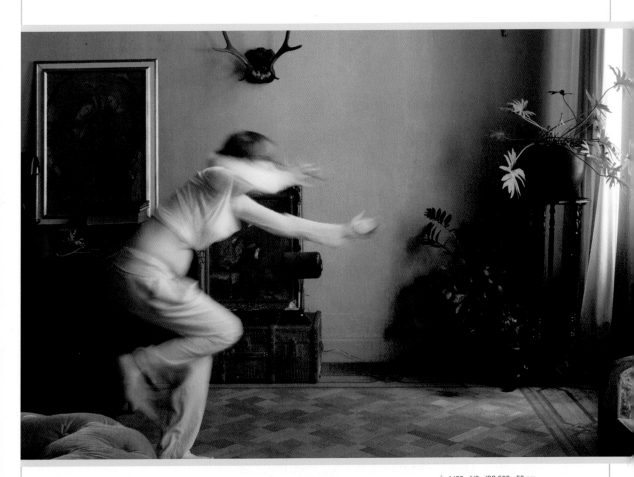

▲ 1/60 · f/8 · ISO 500 · 50mm

199. Find Your Creative Partner

Picture-taking is part of our family's experience of life—at home and while traveling. I'm particularly blessed: Stephie is my creative partner, my playmate, and often my muse. If you want to do your version of the kinds of projects that inform our life, you'll have to find your own creative partner—spouse, friend, sibling, child—who shares your passion for pushing the boundaries of personal photography.

Project #1 **Celebrate a Life Event**

Our projects often begin with one idea that we can riff on. In this case, we wanted to capture Stephie's second pregnancy using a word: *Inside*. We shot maybe fifteen or twenty ideas over the course of the pregnancy. At its simplest, this is a typography project, taking one word and creating many kinds of treatments. For us, it was a way of processing each stage of the nine months in the most personal way, but also in a form we could share.

The "Inside" project eventually consisted of hundreds of still photos taken in Europe and back home in the United States, which we stitched together as a video "flip-book" to tell the story of our joy. (To see it, visit langestudio.com/videos/inside.)

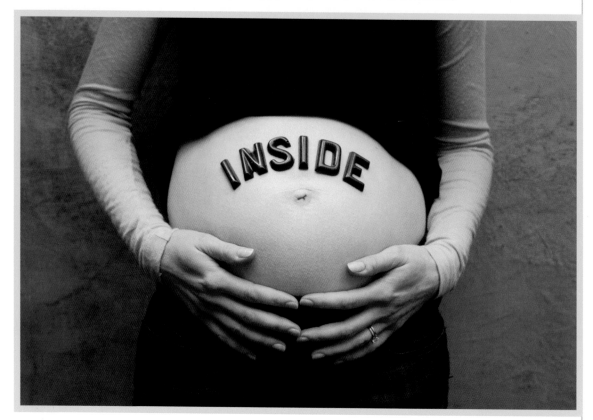

▲ 1/60 · f/6.3 · ISO 640 · 50mm

200. Find Collaborators Everywhere

At one point, on vacation in Belgium, we talked our way into a famous chocolate kitchen and convinced them—really, it wasn't that hard, after I showed them some other project pictures—to create what we needed. Then, chocolate letters in hand, we went out on the shop's balcony to shoot. Doors swing open when you are enthusiastic and share your excitement. People are usually happy to be invited to share in the play.

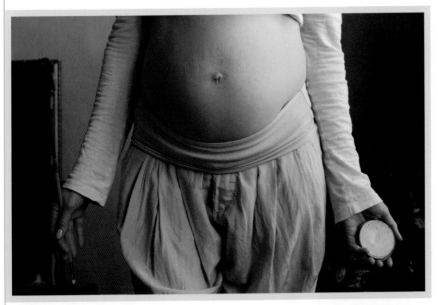

201. Take "Why Not" Pictures

Stephie just wrote on her round belly using face paint she picked up in an art store. Most people wouldn't think of doing that or, after thinking about it, wouldn't actually do it. *Why not?*

We all need a lot more "why not" pictures in our lives.

▲ 1/60 · f/6.3 · ISO 500 · 50mm

▲ 1/125 · f/7.1 · ISO 640 · 50mm

▲ 1/125 · f/6.3 · ISO 640 · 50mm

202. Finish with a Punchline

These two shots are from the tail end of the video. Baby Asher arrives, and "Inside" is now "Out," painted on an old blind. Note that he's far from a newborn, though. It took a few months to complete the project: Diapers, feeding, and sleeplessness got in the way.

▲ 1/125 · f/4.5 · ISO 100 · 42mm

Project #2 **Play with a Repeating Idea**

I wanted to make two enormous, iconic cities a little bit our own—and at the same time photograph new pajamas designed by my friend Kay Unger. Stephie is not a model, she's an artist, with an artist's nerve. So she simply wore the pajamas out into the streets of Paris and London. With each picture, the cities became ours in some new way.

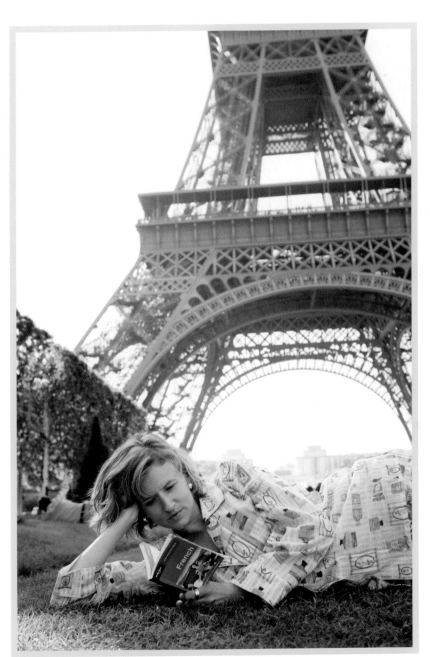

203. Don't Worry: People Won't Mind

A funny thing happened along the way during our project: No one, French or English, said a word. *C'est normale*, apparently, lying on the grass in front of the Eiffel Tower, reading a book in your pj's as if you're at home on the couch. At a fancy café in Paris (next page), there Stephie was—and no one said a word. The space for play is usually larger than you think it is.

◀ 1/80 · f/6.3 · ISO 100 · 38mm

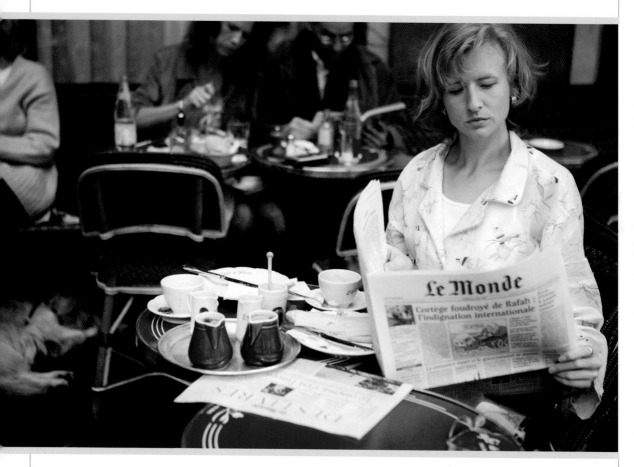

▲ 1/100 · f/2.8 · ISO 160 · 59mm

204. Provide a Location Cue

We wanted to convey a sense of place without overdoing it.

Le Monde is the visual full-stop on that idea.

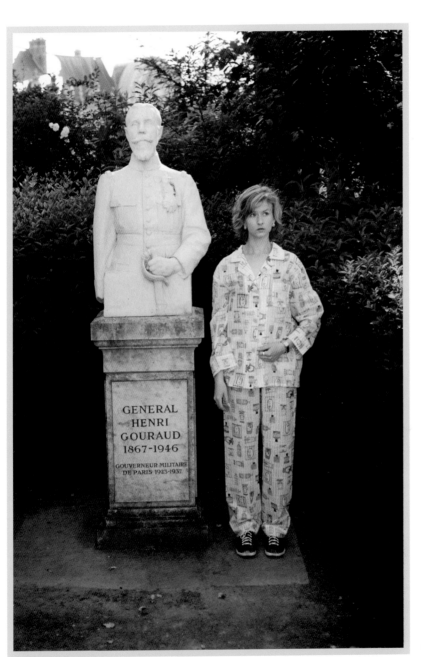

GENERAL
HENRI
GOURAUD
1867-1946

GOUVERNEUR MILITAIRE
DE PARIS 1923-1937

205. If This Makes You Nervous, Try Something Less Nervy

An idea like this is an excuse to step outside your normal boundaries. Of course, your creative partner may be less willing to walk around foreign cities in pj's than my wife is. A pair of red shoes would work, or a crazy hat. My friends Craig and Lu took their shoes off everywhere they went on their honeymoon in Italy and photographed them. They ended up with a story of their honeymoon told through the progress of two pairs of shoes.

◀ 1/100 • f/5 • ISO 100 • 55mm

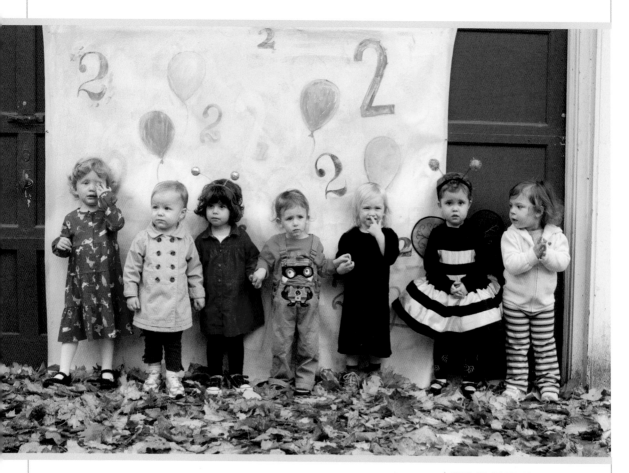

▲ 1/160 · f/9 · ISO 640 · 50mm

Project #3 Make a Party Backdrop

For a birthday party, I like to define an area for picture-taking ahead of time. I make sure it's lit well, out of the bright sun; when anything happens there, I'm pretty sure I can get a good shot. Things get more focused if you have a backdrop. In this case, Stephie designed a small pattern of numbers, then projected that on a large canvas and painted it. Kids like the theatrical aspect. Gather them there, but don't count on any sort of cooperation. In the shot above, I have the attention of only one in seven kids—the bee! But that's all in the chaotic spirit of a two-year-old's birthday.

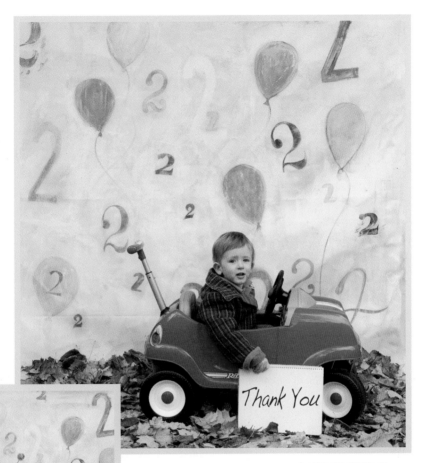

1/125 · f/9 · ISO 640 · 50mm

TIP With a little planning, we were able to make a thank-you card to send to the guests.

206. Shoot Single Portraits, Too

After various group shots, with and without parents, I also shoot kids against the backdrop alone. That year Lia, our bee, was a great subject.

◀ 1/160 · f/10 · ISO 640 · 50mm

Project #4
Shoot a Concept

Many pro photographers spend their lives creating conceptual photos that are designed to stop you in your tracks as you flip through the pages of a magazine. Annie Leibovitz, for whom I once worked, is the acknowledged master at turning a concept into a showstopper.

This picture, of two dancers, plays with scale to evoke not only dance but the act of *watching* dance. The woman's hand beautifully mimics the step of a disciplined dancer, which is very hard to do—try it with your own hand! There's no reason you cannot work with ideas like this, pulling inspiration from the passions of your subjects, playing with scale, props, and motion.

207. Keep the Background Simple

The backdrop of the gray wall heightens the magic; the table is her stage.

Shallow depth of field focuses your eye. Light comes in from a single window, softly.

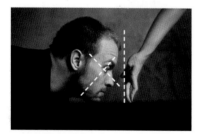

COMPOSITION

A rare case when the subject's eyes are almost the dead center of the picture. It isn't really his eye you look at: Your eye, like his, is drawn down to the "dancer" that seems ready to walk out of the picture.

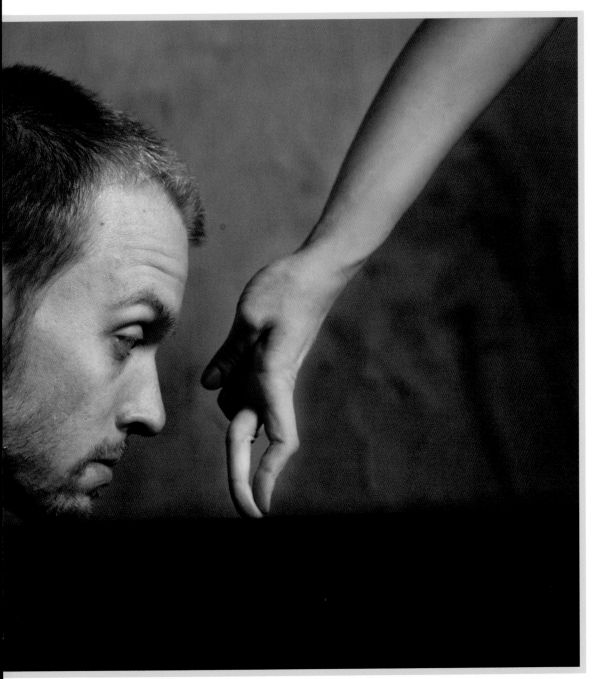

▲ 1/160 · f/3.2 · ISO 1000 · 50mm

208. Shoot a Concept Start to Finish

This photo, shot to promote TLC's *Cake Boss*, ended up on huge billboards in Times Square and all over the country. It was fun to do, as you will find out if you try something like it yourself. Start by finding a willing friend—or maybe your world's-best-pie-baking mom, if she's game. Simply find a dark wall (or paint one) or hang a large dark drop cloth behind your subject. Have the person look right at you and not react at all to anything you pour on him or her. Shoot as a sequence.

Flour doesn't have to be your medium. Try leaves, dirt, milk, confetti. . . .

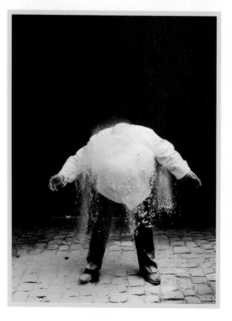
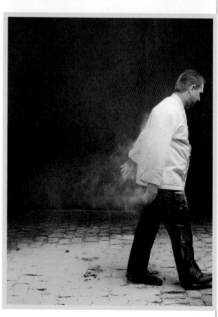

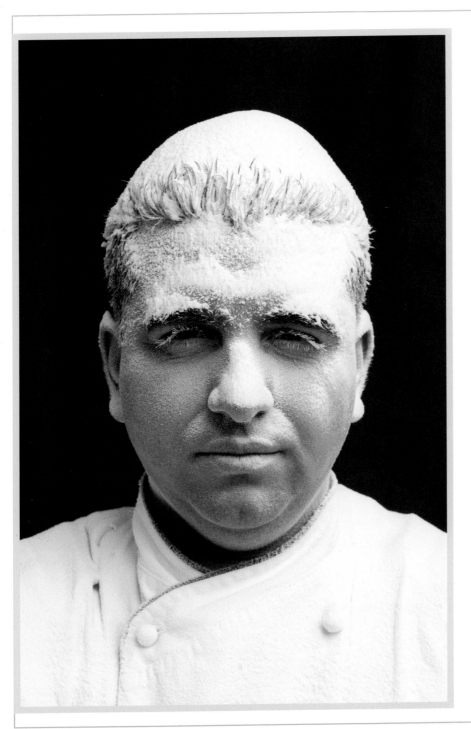

Me at work, with an assistant sifting flour on the victim.

◀ 1/125 · f/13 · ISO 100 · 80mm

Project #5 Do a Fast, Sexy Photo Shoot

These pictures are the product of pure creative play, taken over a period of less than an hour. We try to get to the place where children go so easily, because the best pictures happen when you're most unselfconscious. As I've said, for us, a hotel room is a perfect blank canvas for this kind of play. You're in a suspended reality. You can mess up the room. Nothing has to be put away. You're playing with light that you don't live with every day. Music is on, very loud. And pressure is off—this is all just for fun. For this to happen, though, you have to be with someone who wants to go there too, who trusts you, and then you have to follow your instincts.

▲ 1/400 · f/2.8 · ISO 800 · 58mm

209. Play the Fashion Model

There were no studio lights on, but this looks like a fashion shot. I had window light at my back, and Stephie stood in front of a curtain that provided privacy for the bathroom. Lipstick, a vintage coat, glinting earrings. Gorgeous.

These pictures were inspired by this pea coat, which my wife had just bought at a consignment shop, and after having run into Patti Smith, a hero of ours, at a restaurant. We wanted to push things.

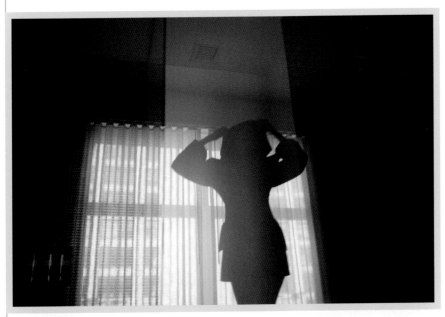

▲ 1/640 · f/1.8 · ISO 800 · 35mm

210. Find All the Angles

All three shots on this spread were taken in one room, but look at the different light—you have to move around constantly to find that. Here, Stephie is standing on the bed with the big window behind her, and I'm shooting her reflection in a large plate of glass. The exposure is for the window, so she is silhouetted.

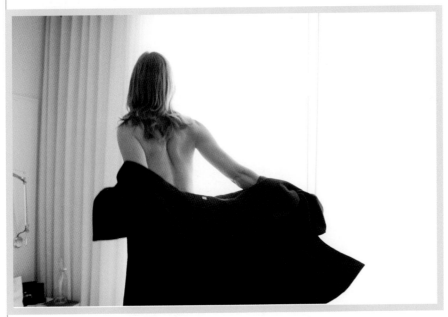

▲ 1/250 · f/2 · ISO 800 · 35mm

211. Just Dive In

The scariest thing is not the prospect of lousy pictures, it's getting up the nerve to get started. My wife says of the process: "You get to the work through the work. Quit thinking about it and just dive in." She is always right.

Project #6
Try Portraits without People

These photos tell stories of two generations' very different relationships with things. But they are really about the people, not the things. Try a series of portraits of people you love— without them in it. You'll find yourself shooting things you might never have shot.

212. Capture the Well-Ordered Life

This is the pantry of my wife's great aunt and uncle. They were 90 and 92 at the time, and although I took the picture in 2006, it could have been 1950. Something quintessentially American is captured by this shot: the neatly stacked foods, the food labels, the wallpaper behind. When I see this photo, I see the two people who inspired it.

▶ 1/5 · f/2.8 · ISO 200 · 100mm

213. Capture the Attitude

This is London. We went to this great home, where a very hip family lived. The teenage daughter had collections of everything; the words she had written on her dresser provided a bit of ironic commentary on her own life.

◀ 1/100 · f/7.1 · ISO 640 · 70mm

Project #7
Direct Some Funny Pictures

When you have a funny idea and (much more important) playful partners, it's worth trying to choreograph some shots.

214. Shoot in Funny Places

Here I was at a theater in Kansas City, photographing Glenn Beck. The bathroom was fantastic. I said to him: "We have to take pictures here," and he was more than game. What's funny is that you think, from the odd angle of the feet, that there is someone else in the stall with him, but there isn't.

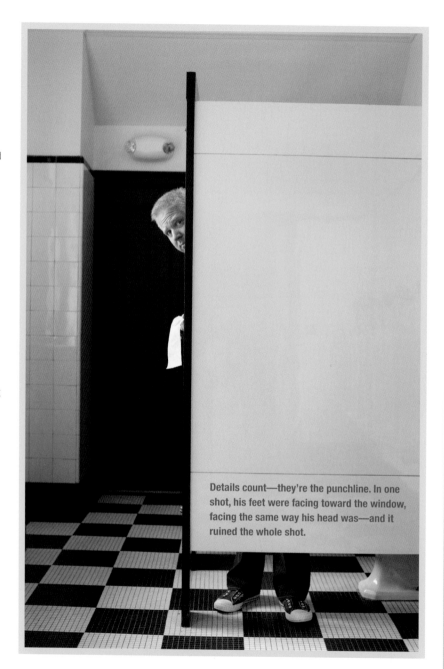

Details count—they're the punchline. In one shot, his feet were facing toward the window, facing the same way his head was—and it ruined the whole shot.

▶ 1/100 · f/4.5 · ISO 640 · 50mm

215. Don't Be Afraid of an Old Joke

I don't even remember if this was Luke's idea or mine—it's such a chestnut of a concept, a visual borscht-belt picture. But it works! The key was to get high enough that I wasn't aiming the camera up at the face of the boy, who is the son of one of my best friends.

▲ 1/320 · f/2.8 · ISO 500 · 50mm

216. Keep the Funny Simple

The shot above would not have been as goofy without the mug-shot treatment. The pictures on the opposite page have been diminished by the fact that no shot of vegetables with genitals goes unshared on the Web these days, but I still love it. It resulted from a bit of spontaneous fun on a pro shoot; I like the stray bits of peel on the cutting board, which keeps it messy and loose.

1/80 · f/6.3 · ISO 800 · 70mm

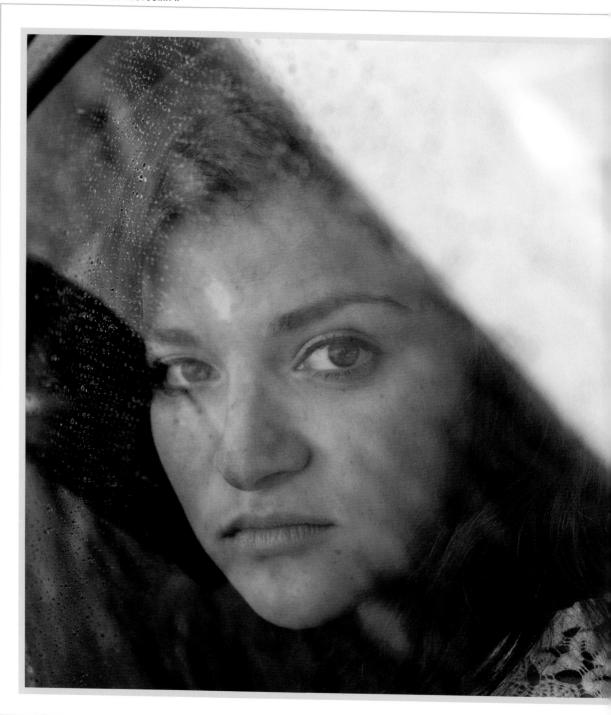

Project #8
Do a Portrait Shoot on Location

These photos, of my dear friend Kate Meyers's older daughter, Annie, were shot in a Colorado pumpkin field in October 2012, over a period of about an hour. (Kate is married to my coauthor, Scott; Annie is his stepdaughter.) A high school senior at the time of the shoot, Annie is not a model, but she is a skilled dancer, and game for pretty much anything—ready to go before the camera without any special hairstyling or makeup, using only natural light, which is the way I like to work.

This is the kind of shoot you can easily do. All you need is a willing model—and a willingness to apply some of the ideas in this book: Keep your eye on the move; always look for fresh angles; collaborate with the model in an open and fun way; take lots of pictures; apply a few simple technical tricks; get into the rhythm of things; and shoot all the moments as they unfold.

217. See the Beauty in the Most Ordinary Things

The pumpkins in the field are reflected, mysteriously, as blurry orange dots in the glass of the car window. The camera is focused on the subject's beautiful eyes; a narrow depth of field creates this effect.

◀ 1/160 · f/4.5 · ISO 1250 · 50mm

218. Move with the Model

I had Annie running so much she could not possibly stop to be self-conscious, or think what she was doing. She was totally free and trusting in front of the camera. I was running, too, backward. The shot above is weak, almost clumsy. The one at right is gorgeous and spirited. They were taken seconds apart.

▶ 1/1000 · f/5.6 · ISO 640 · 50mm

As a dancer, Annie knows how to look great in the air. It's critical to a series of shots like this that you shoot over and over, because you can't possibly know when you have the right intersection of background with body moves: a hand out of place, a leg not quite in rhythm. Small things separate a weaker shot, like the one above, from an exuberantly stronger one, like the one at left.

◄ 1/1000 • f/6.3 • ISO 640 • 50mm

219. Make a Scene Dreamy

This may seem like an unlikely location for a shoot like this, but the muted earth tones and gray sky—it's gorgeous. Here, Annie holds her skirt, making it a bigger, more interesting shape. The line of her arm, matching that of her falling hair, is beautiful, and I love the meditative effect of her downward gaze.

TIP Make the most of your weather! A cloudy afternoon is perfect for shots like this: The pumpkins are brilliant, but there's no problem with harsh shadows. Far better than a sunny day.

1/640 • f/5.6 • ISO 1250 • 35mm

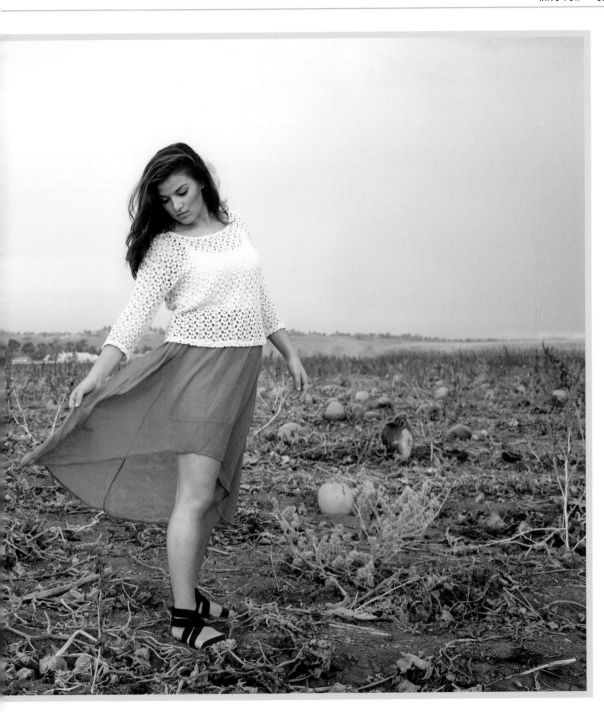

Project #9 **Display Pictures Creatively**
Projects and Text by Stephanie Lange

As you shoot your pictures, so should you hang them: playfully. Printing costs just pennies, especially for the small pictures used in the ideas here, so there's no need to treat photos with archival reverence. Cut them, fold them, glue them. Use found objects and antiques-shop curiosities to create visual surprises. Here are some ways to pull picture series and themes out of your hard drive and liven up the house.

 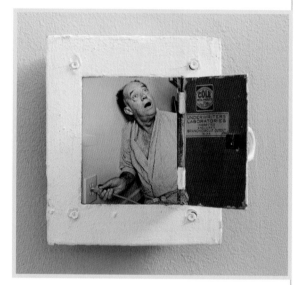

220. Put Pictures Behind Doors

This is a beat-up old electrical box with a hinged door. I put in a funny picture of my dad goofing off by a wall socket—and I usually leave the door closed, waiting for a curious person to open it and find the photo inside.

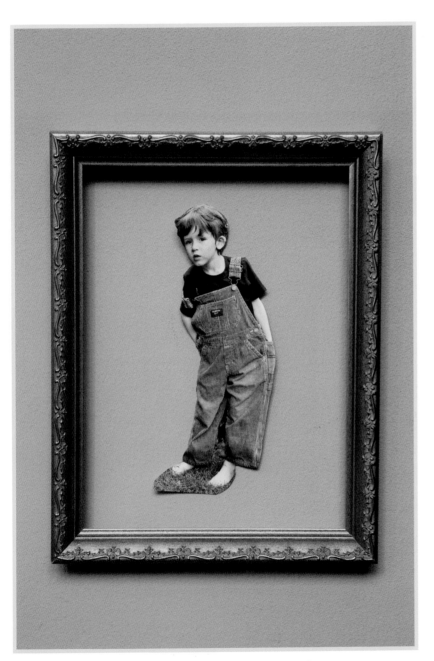

221. Cut Up a Picture

I hung an old frame on the wall with no glass or mat, and taped a cutout of my son directly to the wall. You could also tack one up with a sweet-looking old stickpin.

222. Try Folding Paper

This is a long strip of handmade art paper, folded into an accordion, to which I glued some photos. You can leave one folded up on a table for people to discover, or stretch it out and display all the pictures at once.

223. Make a Rummage Box

I love the idea of a small box filled with small prints of small people. These prints are no bigger than two-by-two inches. It makes for an intimate way to look at family pictures—shuffling through and holding them in your hands rather than looking at them on a wall or screen. Leave the box open and let others play.

224. Create a Picture Mobile

A Google search of "photo mobiles" will turn up a lot of great ways for displaying pictures. This one, by Kikkerland, was elegant but simple and made the photos stand out.

225. String Up Your Shots

Curving lengths of string hang between nails, with clothespins holding the pictures. In this kitchen example, all the photos are food-themed, but you could do a similar thing in a baby room, a reading room, a dining room, or a bedroom.

226. Repurpose Tin and Tile

These are old tin ceiling squares from a junk shop—beautifully textured. Little super-magnets affix the shots to the metal, so you can swap in new pictures whenever you like.

A larger piece of antique metal is ideal for a photo series.

227. Prowl Art and Gift Shops

I found these hangers and clips in a small gift shop in my town. I think they are replicas of vintage hangers for drying socks or lingerie, but the idea can be easily reproduced using materials from your closet and an office-supply store. It was nice to display a series of pictures whose colors contrasted dramatically with the wall.

228. Be a Scavenger

This misshapen ladder-like object is something I found on a walk one day as I was wandering the neighborhood to clear my head. I love it. Mini clothespins—available in various sizes from craft stores—allow me to change the pictures as often as I want.

A BIT OF NITTY-GRITTY

How digital cameras work, and which kind to buy

Cameras are so smart today that you may ask how smart you have to be about cameras: Just buy a new, compact model by one of the big manufacturers, set it on automatic, and shoot. That frees you to make better pictures using the principles in this book. A pocketable camera is much more likely to be at hand—a key to improving your everyday photography. Later you can buy a fancier, bulkier model.

Still, a basic understanding of digital photography can help with creative decisions when you want to shoot in very low light or into backlight, blur the action, pan a shot, and the like. You may also find yourself tempted by the power of a DSLR (digital single-lens reflex camera).

HOW DIGITAL CAMERAS WORK

These are incredibly complex machines, but the basic concept is simple: A glass lens focuses light from a scene onto a sensor, which measures the intensity of the light and sends that information to a small computer for processing it into digital bits that can be stored on a removable memory card. Sensor and processor do the same job that film did in the pre-digital era.

Aside from focus, the camera juggles three things to get the picture:

Shutter speed: The amount of time the shutter allows light to fall on the sensor. Most compact digitals can snap a photo at speeds faster than 1/2,000th of a second and slow things down to a second or slower. Faster shutter speeds allow you to capture quick action; slower shutter speeds are necessary for low light, but risk blur from shaky hands.

Aperture, or f-stop: Refers to the adjustable lens opening that light passes through after you press the shutter. A higher number means a *smaller* opening in the lens; f/8 is smaller than f/2. So f/8 is used in brighter situations more than f/2. Most compact cameras will have a maximum aperture size of f/2.8 to f/2. SLR lenses go as large as f/1.2.

Aperture also drives an aspect of focus called depth of field—the degree to which things that are close to and far from the camera are actually in focus. The *higher* the aperture number, the larger the depth of field: the more likely it is that things close to the camera and far from the camera will both be in focus. With removable-lens SLR cameras, you can easily manipulate depth of field by adjusting the aperture on big lenses. The smaller lenses of point-and-shoots allow for much less depth-of-field adjustment, but it can still be done through manual controls.

ISO: The setting that adjusts the camera sensor's sensitivity to light. Pushing the ISO number higher means you can take shots in lower light without lowering the shutter speed too much. However, pushing the ISO too high—say, above 800—starts to produce graininess or "noise" in the image, especially in compact cameras with smaller sensors. Note that as digital sensors have improved, the noise problem has diminished, even on small cameras. The sensors on pro cameras are unbelievably sensitive.

On auto, the camera juggles these three variables—shutter speed, aperture, and ISO—to achieve the best approximation of what its software says is the ideal exposure. You can pick scene settings—such as Beach or Portrait—that tell the camera to change its assumptions about what that ideal exposure is.

WHAT'S ON THE CAMERA MARKET

For most of the digital era, photographers have had two choices: a big camera with detachable lenses (a DSLR) or a compact point-and-shoot. The DSLR has an internal mirror, which shows you the exact picture you're going to take through a viewfinder before you press the shutter. DSLRs are bulky and versatile, cost anywhere from hundreds to many thousands of dollars, and are almost always what professionals use. Until recently, the compact point-and-shoot traded away many of the DSLR's features to give the consumer a small, affordable device.

Today's cameras, though, are packed with features and power at every price point. Compact point-and-shoots produce great pictures. There are also some new cameras that blur the lines between compacts and DSLRs. Here's a very simplified breakdown:

- One notch up from the compact point-and-shoot is a relatively new class of small "prosumer" cameras with better (though not removable) lenses, larger sensors, and slightly bulkier bodies. These are feature-rich and much smaller than DSLRs—they'll fit into pants pockets or purses, but not shirt pockets.

- The next step up is a class of cameras that do feature interchangeable lenses but don't have the mirrors that DSLRs have. These are smaller than full-sized DSLRs, but they are too bulky to be pocket or purse cameras. They have bigger sensors than point-and-shoots, and their lens options make them more customizable.

- There's also a "superzoom" category of camera, built around honking-long, nonremovable zoom lenses. These resemble DSLRs in shape and size,

and they appeal to photographers who like to take pictures of things very far away (like bears) or get dramatically close to things that are moderately far away (like football players). But, for all their size, they lack the true flexibility of interchangeable-lens cameras.

7 THINGS TO CONSIDER WHEN BUYING A POINT-AND-SHOOT CAMERA
These core features pertain to most cameras up the food chain, as well.

Don't wait until you get to a camera store to figure out which camera you want. General electronics stores aren't staffed by experts, and photo stores can bombard you with staggering amounts of bafflegab, often reflecting the seller's personal brand preference. Start with an Internet search, consulting sites that actually test cameras and aren't just regurgitating manufacturer data. Then visit a camera store, to see if the model you want feels good in your hands.

1. Don't worry too much about megapixels.
In the early days of digital, photographers relied on the megapixel count of a camera's sensor (a megapixel, MP, is one million pixels, or light-measuring points) to determine the camera's quality. Increasing megapixel counts became an arms race. The war was real: As cameras moved from 3 or 4 megapixels to 6 or 8, photographers found that images were less likely to deteriorate (pixelate) when photos were enlarged. The more pixels in a digital picture, the better it was.

Today, most good point-and-shoot sensors have plenty of megapixels for everyday shooting—

10 MP at least. At this level, the quality of your photos depends just as much on the accuracy of the autofocus system, the low-light performance of the sensor, the quality of the lens, and how well the camera's processor handles all this picture information—all things you can investigate before buying.

Keep in mind that the megapixel count doesn't refer to the *physical size* of the sensor; DSLRs have larger sensors, able to capture more information even if the megapixel count is the same. That said, the best tiny-sensor compacts are plenty good, and the photographer will tend to flub more pictures than the equipment will. But all compacts are not equally good, so it's important to see what camera-rating sites on the Web say about a camera's *overall picture quality.* Performance of the sensor in low light is especially important. Sensor performance matters for many of the shots you see in this book because they use natural light, with no flash.

2. Buy the best lens you can.
Until you get into the costly world of detachable lenses, you're stuck with the lens you have on a point-and-shoot camera. Make sure camera-rating sites rate the lens highly. Then pay attention to how much light it can let in, determined by the maximum aperture on the lens—f/2.8 is common, but f/2 is better and f/1.8 is very good. This allows you to shoot with less light without pushing the ISO too high.

Rather than look at aperture, many people dwell on how wide and long a lens is—how it moves from wide-angle setting to a zoom setting.

Camera sellers especially like to point out how long a lens is because they know the seductive power of the telephoto in making a sale.

But most of the sort of shots featured in this book did not require a long zoom lens, and many are shot at 50mm (normal) or a slightly zoomed setting (around 60mm). When you get physically close to your subjects—right in their faces—a zoom becomes unnecessary.

3. Look for good image stabilization.
When you're taking pictures in low light with a compact camera, you'll often need to use a slow shutter speed. Image stabilization systems reduce the blur caused by shaky hands at slow shutter speeds. Hard to believe, but they do this by using tiny motors that either move a glass element of the lens to compensate for detected camera movement, or move the sensor itself for the same purpose; that is, you shake one way, and some tiny part of the camera shakes the other way to compensate. Most advanced compacts have some sort of stabilization, referred to as IS in Canon, VR (Vibration Reduction) in Nikon, etc. Make sure yours does, and check how well it's rated. DSLRs, by the way, also have image stabilization.

4. Look for advanced controls.
Beyond their fully automatic settings, advanced pocket cameras now come with a boatload of scene settings. Some have smart features, including facial recognition and even smile and blink recognition. Some cameras automatically figure out what your scene is; others require that you manually select it with a dial and/or button. (In the latter case, make sure you don't leave the camera on that setting after changing scenes.)

Manual settings on point-and-shoot cameras can be tricky to access, but are important. Cameras are programmed to favor a happy middle ground for an exposure. Sometimes you want more control, for darker shadows or a blown-out background. The better point-and-shoots make manual controls relatively easy to use (such as a ring around the lens that you twist to change aperture, shutter speed, or even focus).

Another feature to look for: bracketing. Cameras that bracket will take one shot at the chosen exposure, and then take images one stop brighter and one stop darker. Bracketing is useful because a camera's little LCD screen (the screen on the back of the camera) just does not reveal exposure very accurately. If you bracket, you'll have more options to work with in your computer, and less risk of underexposure or overexposure.

5. Look for logical buttons and menus.
What use are manual settings buried within layers of hard-to-navigate on-screen menus? Faced with such a camera, many users will rely on the default automatic features, which tend to sit at the top of the hierarchy. The other consequence of complicated menus is that once you have tuned the camera for a specific shot, it can be hard to walk it back for a different shot.

Camera companies have realized that buttons and dials—tactile and intuitive—are good, while endless submenus navigated on a tiny screen are bad. It's impossible to have buttons for dozens of features, however, so the best designs allow

the user to *assign* his or her favorite features to certain buttons or dials—like programming favorite stations in a car radio.

Bottom line: Try to find out how easy it is to get to the features you want on any camera you buy. At a good camera store, you can simply ask: "How do I adjust shutter speed or aperture on manual?" Ask for a demo. Repeat the motions yourself. The process should not resemble stumbling down a hall of mirrors.

6. Pay attention to burst rate.

You need to shoot lots of pictures to maximize your chance of getting a great shot. You can't do that with a camera pokier than a Death Valley mule.

A fast camera is one that will quickly take its first picture after you turn it on, and quickly take another shot without a lot of hemming and hawing (called shutter delay). A fast camera has a continuous-shoot option that will take two or more pictures per second when you hold the shutter down. This "burst rate" of two per second is slow compared to many bigger cameras, which can manage eight or more, but still better than the agonizing pace of a few years ago, when you could unwrap a stick of gum while the camera got around to the business at hand. Bottom line: Play with the camera before buying to test how fast it is.

7. Look for a camera that shoots RAW images.

A RAW image is one that contains *way* more information than the smaller, compressed JPEG images generated by most compact cameras. JPEG is the file format of most photo sharing. To produce a JPEG, the camera compresses the information

it collects (the RAW data) into a smaller, more manageable file, throwing out a lot of data.

If you shoot in RAW, you can darken, sharpen, change the color profile, and do much more on your computer before converting the image to JPEG or another format for printing or emailing. You can edit JPEG files on your computer as well, but the power of RAW images will blow you away.

RAW files are huge. They can slow down the operation of a small camera. Transferring a lot of RAW files from camera to computer can be slow work. Hundreds can slow down an underpowered computer while gobbling up hard disk memory space. It's wise to buy an external hard drive to store pictures, and to buy large-capacity photo cards. You can get hundreds of RAW images on one 8-gigabyte memory card.

CARRY EXTRA BATTERIES AND PHOTO CARDS—AND BACK UP YOUR PICTURES

Lots of shooting eats up battery capacity, and every photographer has faced the dreaded "empty" icon at the worst possible moment. An extra battery and several photo cards take up almost no room. Also consider having a second backup hard drive for your pictures and storing it outside the house. Upload photos from your camera to the computer frequently, not just when a card is full. These are the habits of the pros, and they're worth emulating.